IMAGES
of America

HAMMONTON

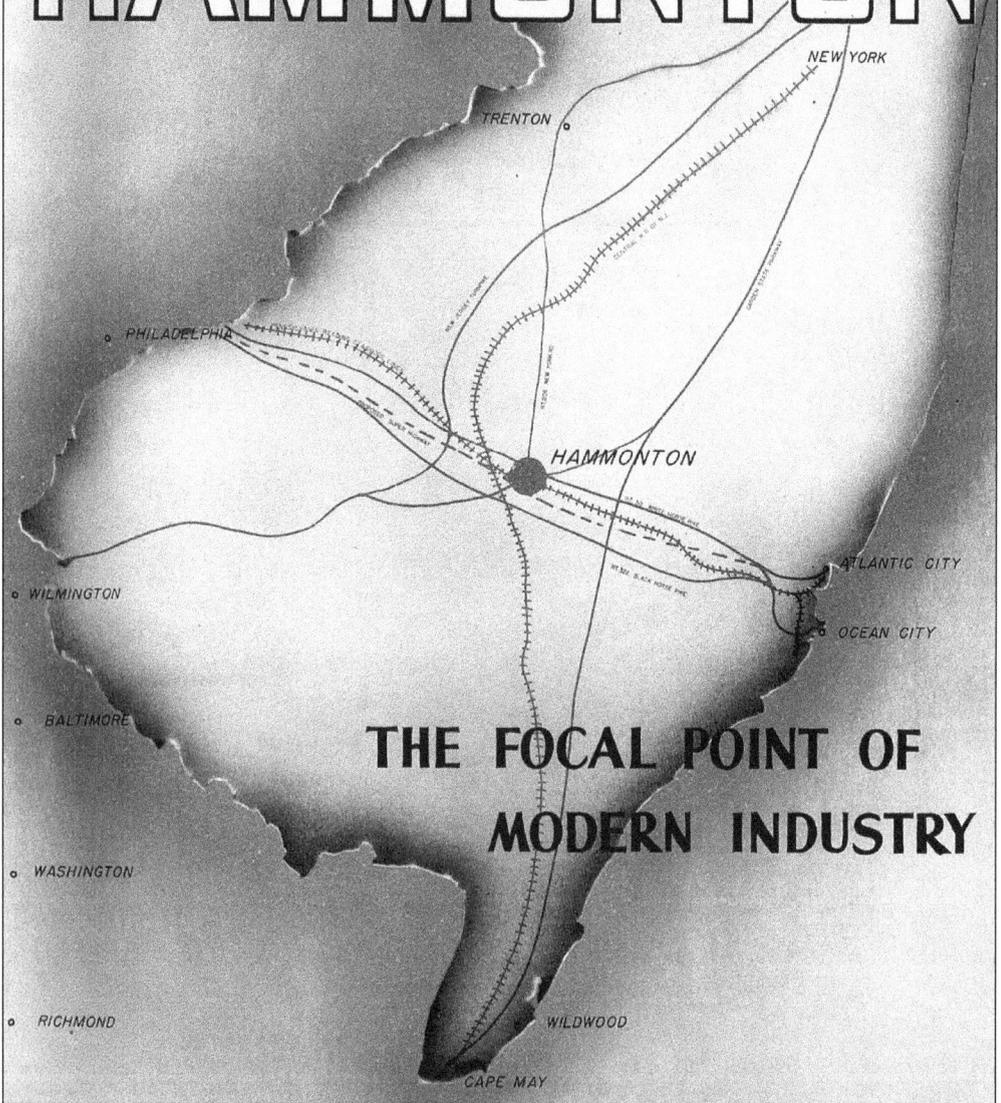

According to this Hammonton Chamber of Commerce guide from the 1960s, "All Roads Lead to Hammonton, New Jersey." Because of its central location in the middle of the southern part of the state, the town was known as "the Hub of South Jersey." (Courtesy of Gina Rullo.)

IMAGES
of America

HAMMONTON

Gabriel J. Donio

ARCADIA
PUBLISHING

Published by Arcadia Publishing
Charleston, South Carolina

Library of Congress Catalog Card Number: 2002103926

For all general information contact Arcadia Publishing at:
Telephone 843-853-2070
Fax 843-853-0044
E-mail sales@arcadiapublishing.com
For customer service and orders:
Toll-Free 1-888-313-2665

Visit us on the Internet at www.arcadiapublishing.com

For Gina: Amor vincit omnia.

CONTENTS

ACKNOWLEDGMENTS

Without the constant support, encouragement, and thoughtful suggestions of Gina Rullo, this book would not have been possible. Special thanks go to my family: Jim Donio, who provided great insights and helpful comments; Frank and Angela Donio; Fr. Frank Donio; and John, Jeanine, and Frank Donio. Thanks also go to Dr. John Woods of MainStreet Hammonton; the Hammonton Historical Society; Garden State Color; James Bertino; Benny Mendez; and the staff of the *Hammonton Gazette*, who put up with me while I wrote this and constantly placed photographs under their noses, asking, "What do you think about this one? How about this one?" They all showed incredible patience.

I want to thank every person and organization credited underneath the photographs on the pages that follow, as well as those who donated photographs that, due to space limitations, were not used in the book. These people carry the true spirit of Hammonton within them. Their dedication and passion for the town was evident every time they shared their stories and photographs with me, and I am richer for the experience. I hope this book conveys Hammonton's unique character, its sense of place, and my own love for my hometown.

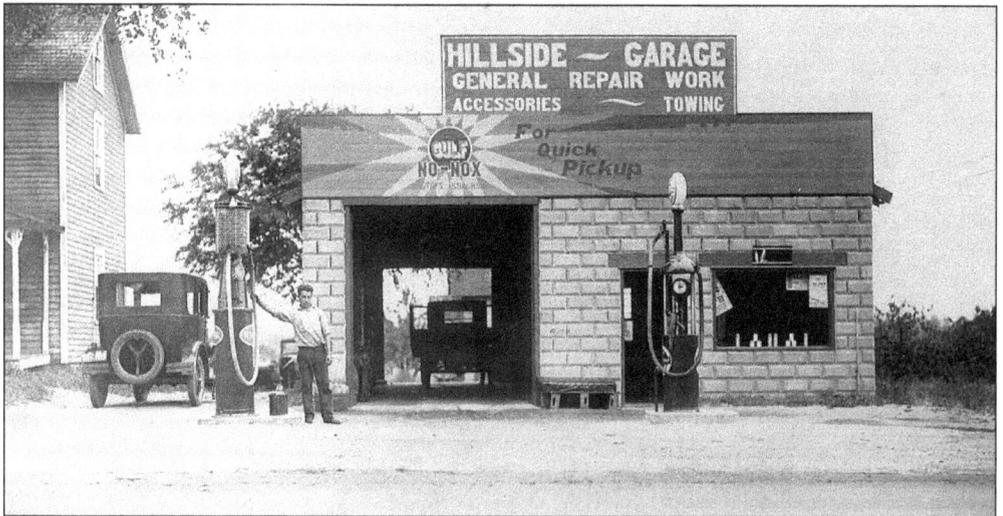

The Hillside Garage was located on the current site of Peach Tree Plaza on the White Horse Pike (Route 30). Angelo and May Penza owned the gas station, garage, and the house next door. This photograph was taken in 1928. (Courtesy of Virginia Bertino.)

INTRODUCTION

*We steam rapidly on to Hammonton, about thirty miles from Philadelphia
(half way on the route) and the liveliest looking town on this part of the road.*

—Walt Whitman, "A Trip through the Wilds of New Jersey,"
Camden Daily Post, January 29, 1879.

Hammontonians have always had a certain spark, a certain life. Our town often feels like one large extended family. It is a special kind of place, where familial and communal bonds are strong. This book is not a definitive history of Hammonton. Readers looking for a more traditional history book, with references to the Native American population and the pre-photographic history of Hammonton should read William McMahon's authoritative work *The Story of Hammonton*, published in 1966, the year of Hammonton's centennial celebration.

In these pages, do not expect to see the latest industry, events, schools, and churches. Most of the photographs date from the period between the 1870s and the 1960s. A few events or occasions are special exceptions: Pres. Ronald Reagan's visit in 1984; the Red, White and Blueberry Festival, which began in the late 1980s; and some of the more recent events and improvements in the downtown area. Those particular exceptions were made because of their historic importance, or because of their connection to the community's past or relevance within a historical context. It is my purpose here to focus on the images from eras that have long since slipped from the collective memory of our town, or will slip away in the decades to come.

I wanted to capture that lively community that was able to woo Walt Whitman in 1879, less than 13 years after the municipality's incorporation on March 5, 1866.

The town had a keen sense of itself back then, as it does today. Our history is filled with signature events and local characters, many of them so unique to Hammonton that people outside of town would not understand the references to them. The Feast of Our Lady of Mount Carmel is an excellent example. It is a tradition rooted in ethnicity and religion—an Italian, Roman Catholic festival replete with food stands, a week-long carnival, and a religious procession of statues of saints pushed through the streets of Hammonton's downtown area. Mention the feast day, July 16, to nearly any resident of Hammonton, and your meaning will be understood immediately. Nearly everywhere else outside of Hammonton, July 16 is just another day. In Hammonton, it is treated like a national holiday. The Feast of Our Lady of Mount Carmel, with its 125-year history, is different. So is the town of Hammonton. It is a town like no other, a place unabashedly and wonderfully different than anyplace else.

Local history is infused with the immigrant spirit. Almost no one who came to Hammonton

was from New Jersey originally. The reason for that strange origin lies in a long-buried semisecret about the town's past. Hammonton was actually founded on a premise that was not completely accurate. In other words, Hammonton began as a real estate con game. When Charles Landis and Judge Richard Byrnes set out to found the town, there was next to nothing here. The two enterprising real estate speculators did not let that fact stop them from promoting the community in major daily newspapers as slightly more completed than it actually was.

The result was that adventurous (and perhaps a bit gullible) pioneers from New England, upstate New York, and other northern areas were lured by the flashy advertisements and the promise of a warmer climate. What they found when they arrived with everything they owned was astonishing: a wilderness. The ones who stayed faced an almost pioneer existence in the post–Civil War years, carving Hammonton out of that wilderness as if it were a town west of the Mississippi.

Although their formative experiences in Hammonton may have been akin to the Old West, there was little doubt that the New Englanders had brought their independent and frugal Yankee sensibilities with them. The municipality was incorporated as a town, not as a township like so many other New Jersey communities.

As in New England, tourism, farming, and clothing factories became a primary source for income for the town. Railroads were another major industry, with Hammonton becoming the largest town between Camden and Atlantic City because of its position as the near center of the rail lines between the cities.

William B. Kessler, a Jewish immigrant from Austria, opened the largest of these clothing factories. His Hammonton Park Clothes brand eventually became internationally known.

Labor was needed for all of these enterprises, and a cheap labor source was soon found in the Italian immigrants. The most significant immigration in Hammonton's history was the relocation of nearly 3,000 people from Gesso, Sicily, to the town during the late 1800s and early 1900s.

In the 1920s, anthropologist Margaret Mead studied the learning patterns of the children of Italian immigrants. It was her second experience in Hammonton. Her mother, Emily Fogg Mead, had studied Hammonton's Italian immigrants for the Department of Labor in the early 1900s.

"My first experience of fieldwork was through my mother's work among the Italians living in Hammonton, New Jersey, where we moved in 1902 so she could study them," Mead once said during an interview.

In time, the Italians adopted many of the concepts of the American experience of the town's original New England and New York pioneers. It turned out that they shared a mutual sense of patriotism and a nearly unquenchable desire to improve their position in life.

During the decades of the 20th century, the Italians went from laborers to owners, many finding fortunes in the fruits and vegetables that grew in the sandy soil. Peaches, strawberries, sweet potatoes, and blueberries became major cash crops.

By the mid-20th century, immigrants from Puerto Rico, Mexico, and other Hispanic countries were working in the fields and factories for many of the same Italian immigrants who, a generation before, were working there themselves. Greek immigrants, who were among the last to own and operate garment factories, also contributed to the clothing industry.

This is the story of the community that was built by all of these people, the ones who shared a dream of making a better life in a better place. They all came to a town called Hammonton, and this is the history they shared.

One

A Town Like No Other

There is no other town like Hammonton, New Jersey. This may sound boastful, but it is backed up by decades of historical evidence. The place and its people are distinctive. Hammonton is no mere suburb. There are local people who have lived here for generations. Many made their fortunes here, met their wives and husbands here, and started families here. Their children, in many cases, have repeated the process.

Hammontonians talk about their hometown as if it were a country, not a community. They speak of it the way native residents of New York City, Boston, or Philadelphia speak about their cities: high reverence one minute, a disparaging comment the next, and then back to praise. It is all right for Hammontonians to talk about their town that way. They are a family.

The town has a spirit that is connected to the land and to the farms that bind so many people in the town. The original New England pioneers, who literally built the community out of the wilderness, were staunch Yankees. They had firm beliefs about democracy and the American dream. Immigrants from many lands followed these original settlers. In the 19th and 20th centuries, those immigrants were of Italian and Hispanic descent, and they had their own view of that dream.

The origins of the local citizens' commitment to religion, family, ethnicity, and community are repeatedly reflected in the images of the past.

Why is Hammonton a town like no other? It never lost its heart, it never lost its hope, and never forgot to honor its past.

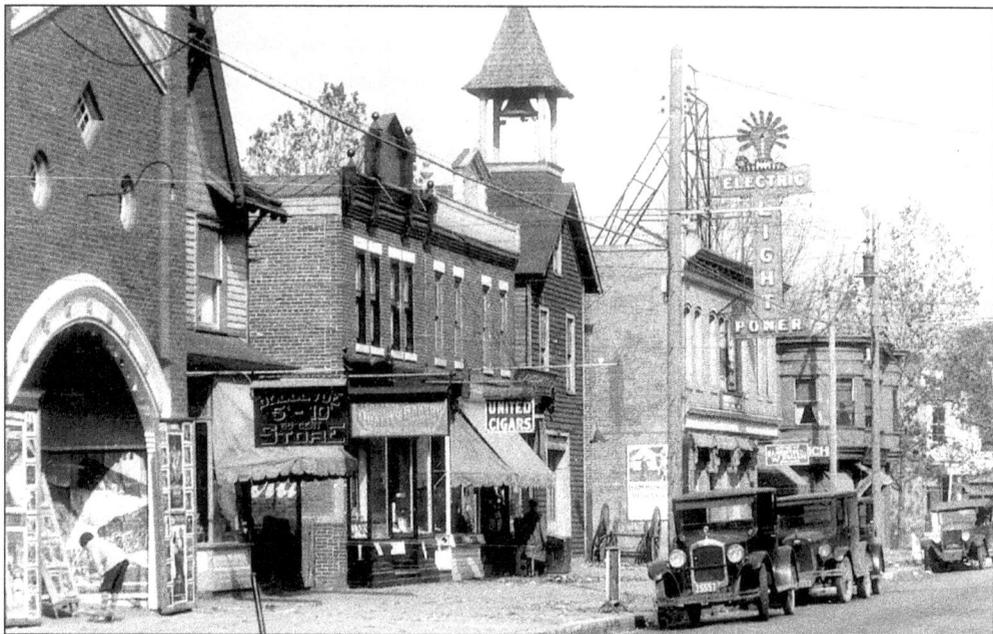

Bellevue Avenue was the center of community life in the 1920s. Pictured from left to right are the Palace Theater, the Bellevue five-and-dime store, Quality Bakery, United Cigars, Hammonton Volunteer Fire Company No. 1, Hammonton Electric Light and Power Company, Hammonton Realty Company, and the Workingmen's Loan and Building Association. (Courtesy of the Hammonton Gazette.)

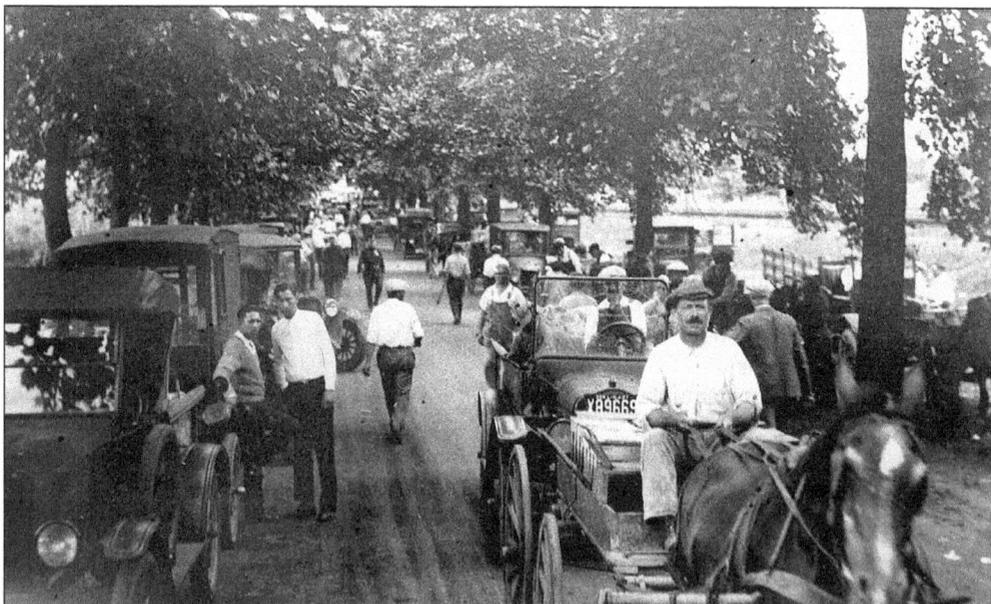

The Hammonton Municipal Market on West End Avenue is pictured in the 1920s. The market was the first fruit cooperative of its kind in the nation, with origins in Hammonton dating to 1867. Farmers controlled their own market for fruits and vegetables—a dangerously communistic and socialistic idea in a capitalist nation. This photograph was taken during the day's fruit auction activity. (Courtesy of John DeLucca.)

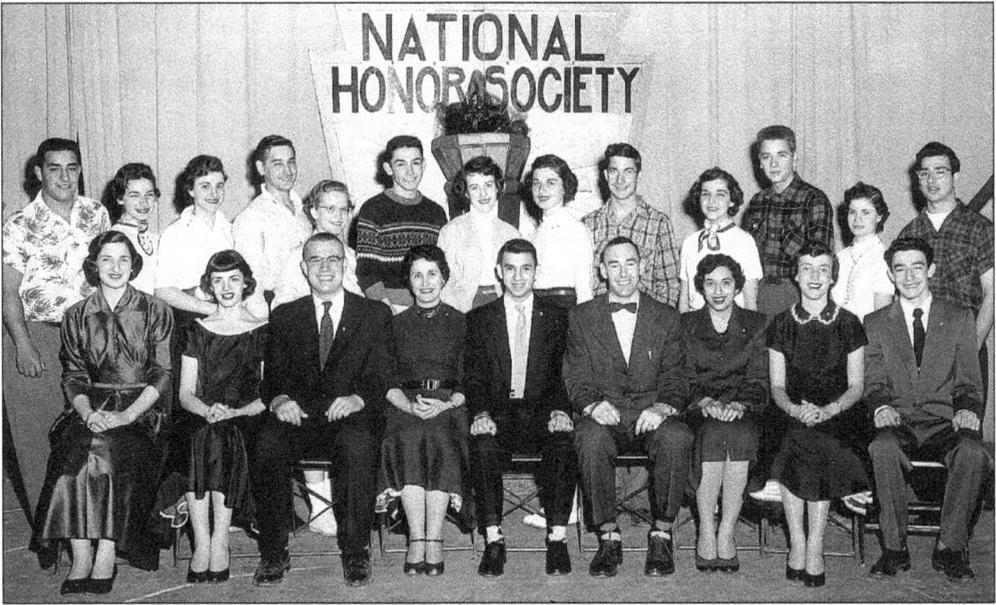

Hammonton High School's National Honor Society members are all smiles in 1955. From left to right are the following: (front row) Hilda Axlerath, Lola Merle Burdick, J. Garfield DeMarco, Mildred Falciani (advisor), Anthony Guerere, John Gower (principal), Rosemarie Galletta, Margaret Eckhart, and Neal Gaston; (back row) Joseph DeSalvo, Grayce Lucca, Kay Cobb, Charles Gazzara, Ruth Ann Walker, Al Salvatore, Eleanor Orr, Betty Crambrone, Frank Provenzano, Joan Caruso, Jack Osman, Jean Sabatino, and Ralph Morano. (Courtesy of Rose Rita and Anthony Guerere.)

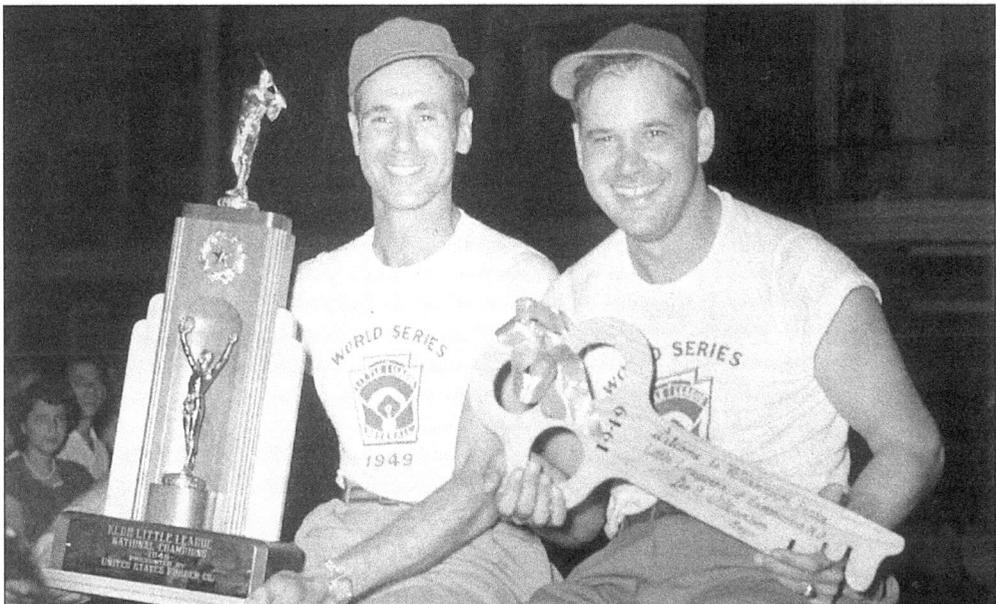

Manager Robert Colucci (left) and coach Barney Ricci hold up the 1949 Little League World Series trophy and the key to the city of Williamsport, Pennsylvania. The two men, who guided the team that took the championship in 1949, are riding in the back of a convertible during a victory parade down Bellevue Avenue. (Courtesy of Toppy Ricci.)

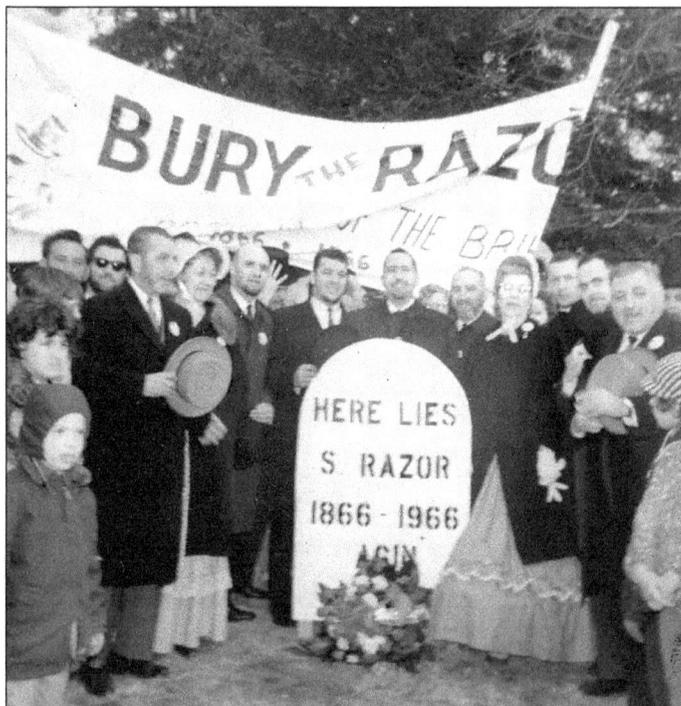

Costumed celebrants "bury the razor" at the town's centennial celebration in 1966. A full slate of events during Hammonton's centennial drew large crowds of locals. The burying of the razor was a reference to the decision of many of the men in the community (known as "the Brothers of the Brush") to grow beards in honor of their 1866 male counterparts. (Courtesy of Rita Benedetto.)

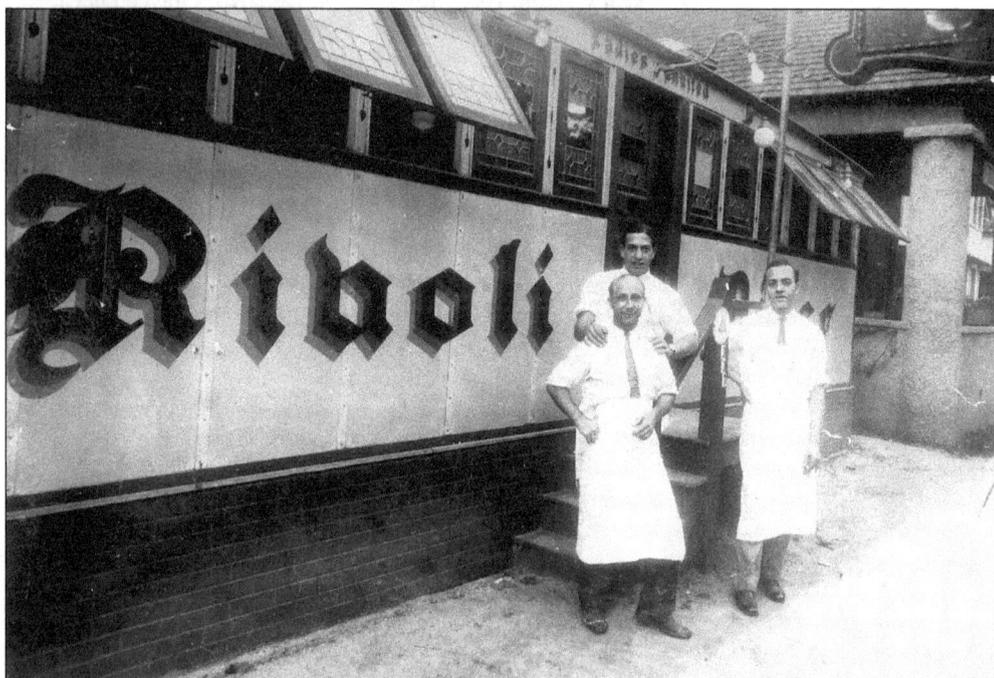

James "Jimmy the Cook" Aschane (left), Angelo "Skipper" LaManna (center), and Charles LaManna stand in front of the Rivoli Diner in the 1920s. The three men, who were brothers-in-law, owned the diner on Bellevue Avenue. Note the Ladies Prohibited sign painted over the door of the restaurant. Diners were places for casual business meetings and for governmental and civic-minded meetings, which at that time were dominated by men. (Courtesy of Angela Donio.)

12

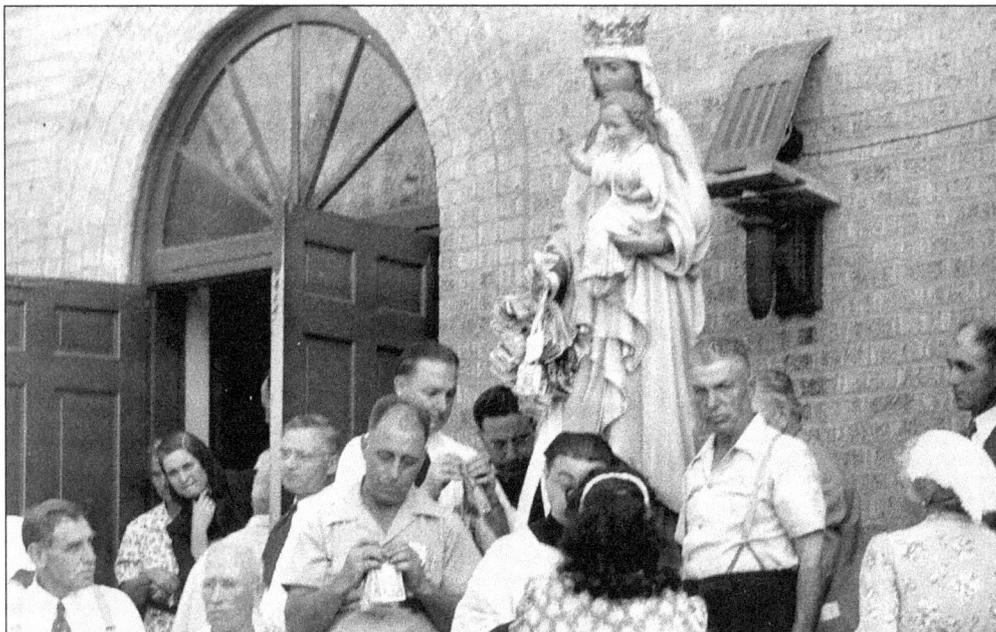

The statue of Our Lady of Mount Carmel leaves St. Joseph's Roman Catholic Church in the early 1950s. Devoted followers, at that time mostly of Italian descent, donated cash offerings that were pinned to a sash wrapped around the statue's right hand. In the 1940s and early 1950s, tens of thousands of people would fill the streets of Hammonton on July 16, the feast day of Our Lady of Mount Carmel. (Courtesy of the Our Lady of Mount Carmel Society.)

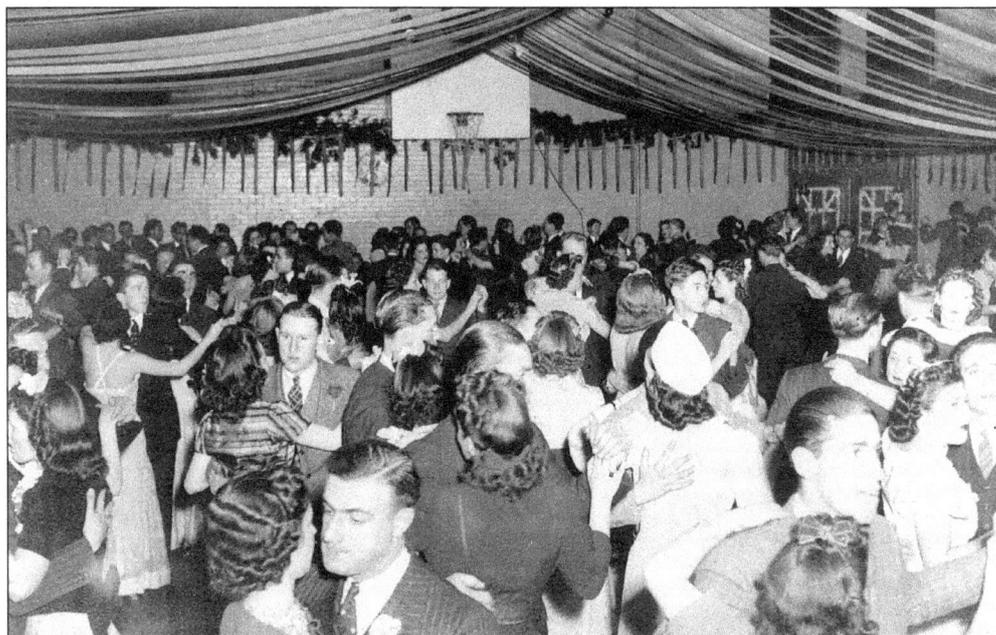

In the 1930s, Hammonton High School held its proms and other dances in the gymnasium. The decorations were not formal (note the basketball hoop), but the dancing was. Live orchestras would play for the crowds, who always dressed in the finest and most glamorous clothes for the occasion. (Courtesy of Augie Sorrentino.)

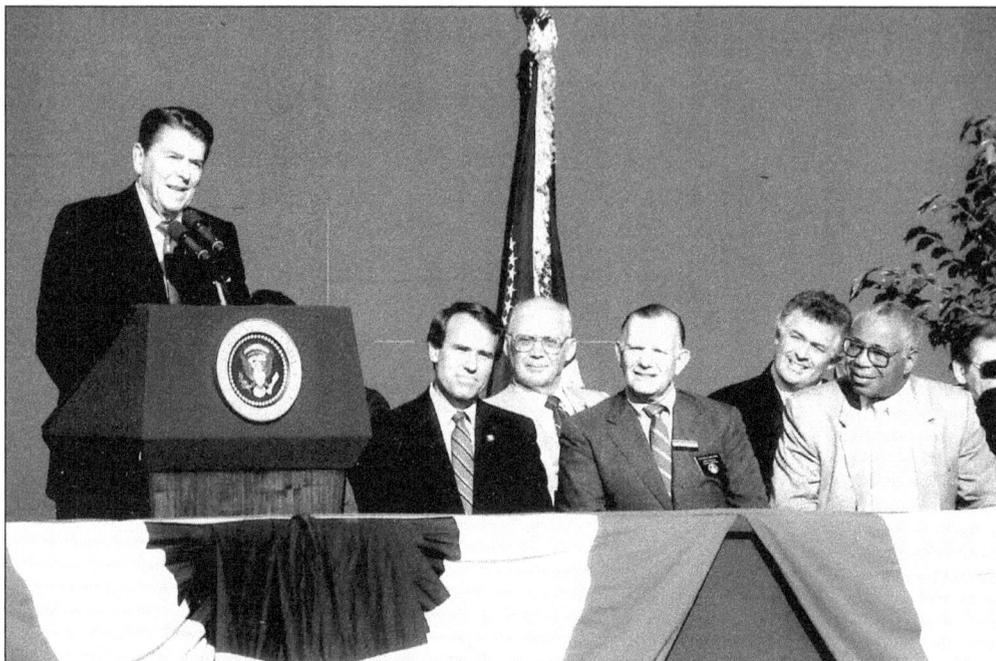

Pres. Ronald Reagan addresses a crowd of nearly 30,000 people (more than double the population of Hammonton) who have crammed the downtown area to hear a campaign address on September 19, 1984. Pictured from left to right are Reagan, Congressman James Courter, Councilman Frank Weiss, County Executive Richard Squires, Councilman Rocco Colasurdo, and Atlantic City Mayor James Usry. (Courtesy of Rocco Colasurdo.)

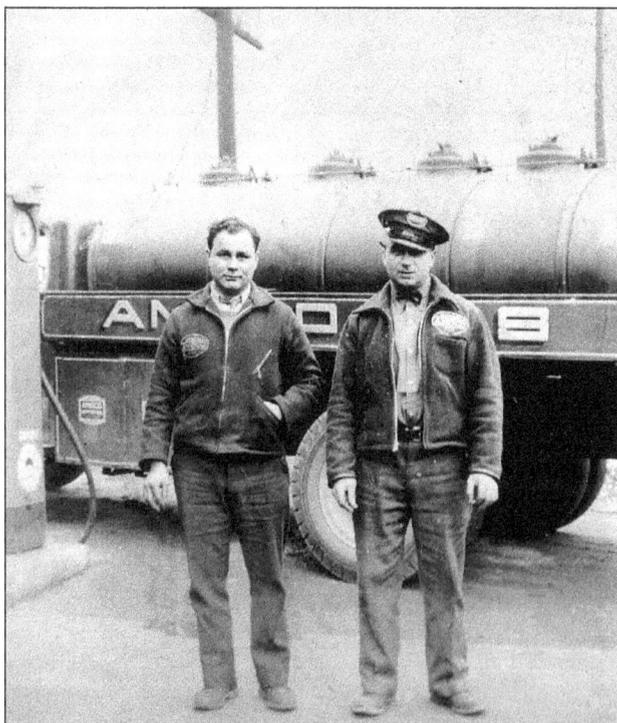

James (left) and William Crescenzo stand in front of their Amoco Oil truck in the 1940s. The two men started the Crescenzo Oil Company and were well known throughout the community for their hard work ethic and dedication to service. (Courtesy of Augie Sorrentino.)

Louis Penza stands in front of an Eastern Beverage truck in 1934. The Penzas started Eastern Beverage, a brewery based on Railroad Avenue in Hammonton, after Prohibition ended in 1933. The brewery became a hugely successful enterprise and was eventually a large local employer. (Courtesy of Evelyn Penza.)

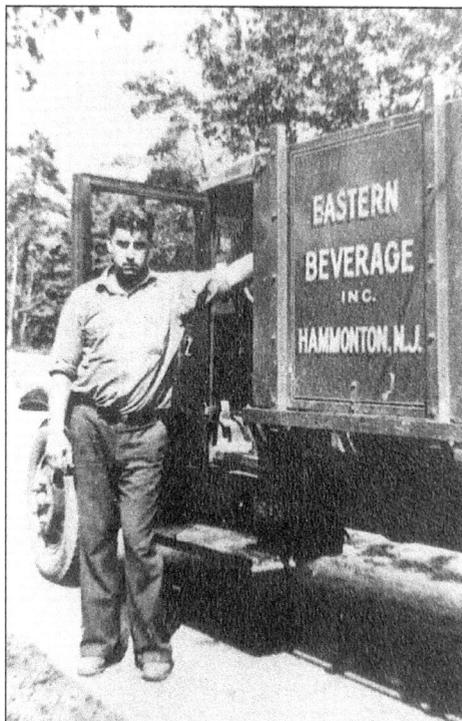

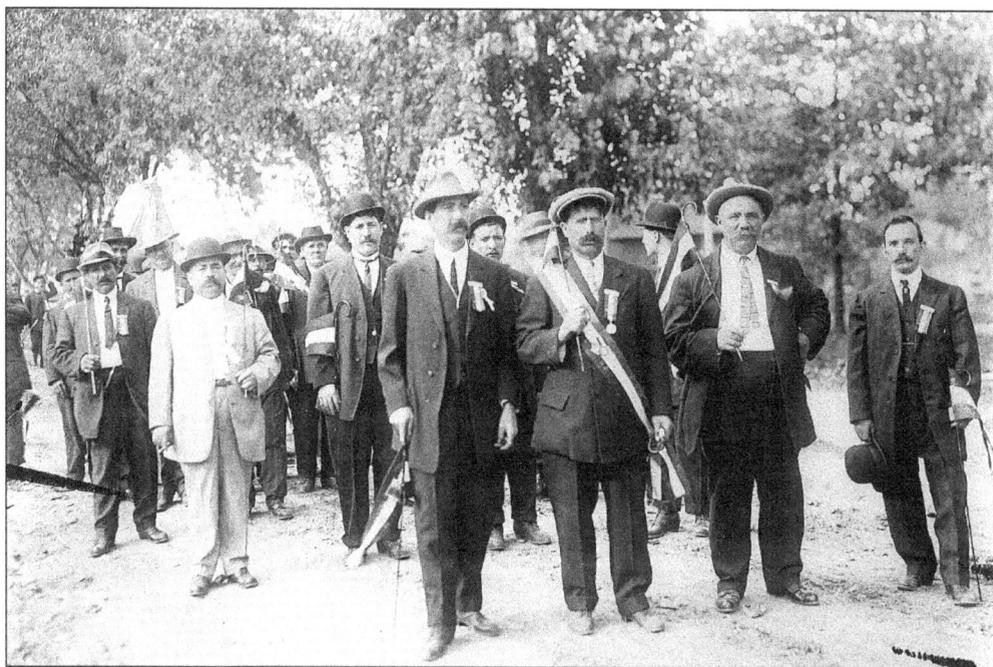

Proud Italian immigrants, including Benedetto Fogletto (left of man with sash), are celebrating Columbus Day by marching along Pine Road on October 12, 1912. Columbus Day was an important day for many Italian immigrants because it gave them an opportunity to show their pride in both Italy and the United States. The leader's sash, the pennants, and the medals were red, white, and green in honor of Italy's national colors. (Courtesy of Rita and Dan Benedetto.)

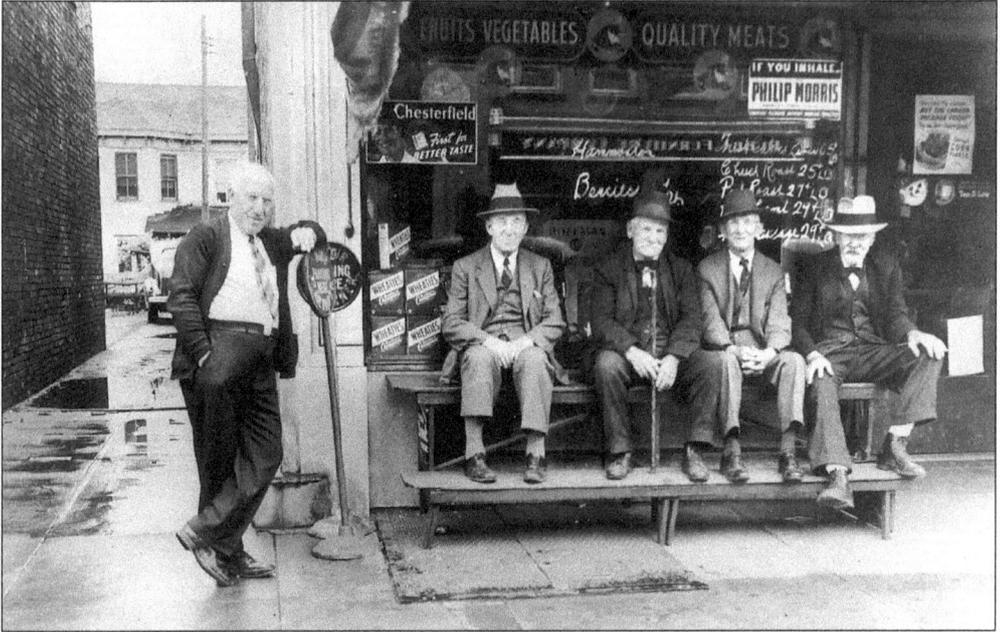

Old, well-dressed Yankees while the day away on a stoop in front of Monastra's Market on Bellevue Avenue in the 1920s. The store was located next door to Godfrey's Drug Store, which was located on the corner of Egg Harbor Road and Bellevue Avenue. The market carried many of the most-wanted goods of the era, such as Wheaties cereal and Chesterfield and Phillip Morris cigarettes. Specials were written on the front window. (Courtesy of Augie Sorrentino.)

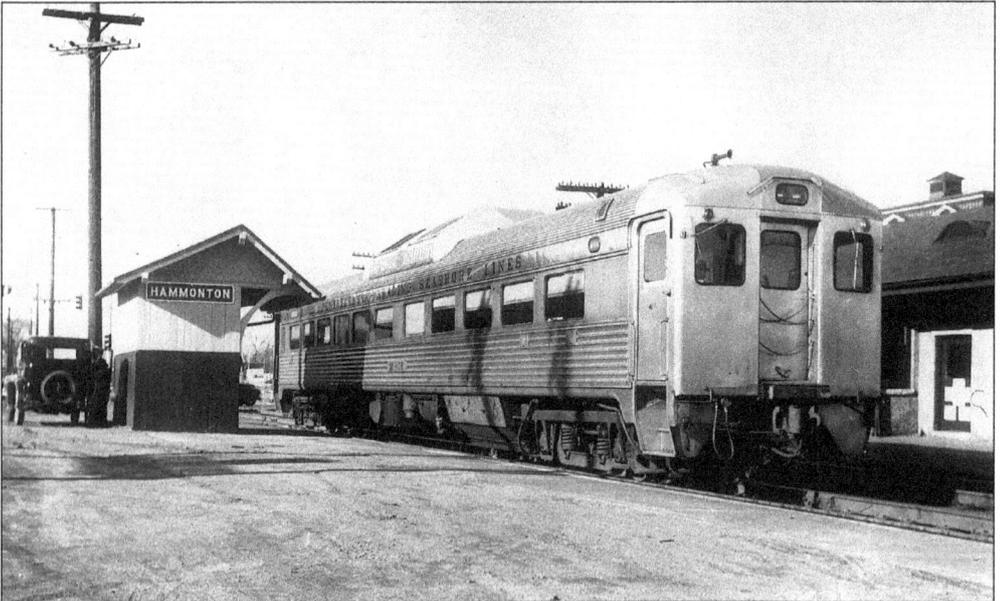

A passenger rail car from the Pennsylvania-Reading Seashore Lines passes through Hammonton in the 1930s. The car has just crossed Bellevue Avenue and is on its way to Atlantic City. In the summer months, trains carrying thousands of people to the beaches of the New Jersey shore would pass through Hammonton several times a day. The railroad played a critical role in the town's development. (Courtesy of Joseph Giralo.)

The members of the Hammonton Town Council look like they are ready for anything on inauguration day, January 1, 1936. From left to right are the following: (front row) Councilman Rudolph Hutt, Mayor James A. Ruberton, and Councilman Samuel Perrone; (middle row) Councilman Charles Penza Jr., Councilman Julius Miller, Councilman Joseph LaRosa, and Councilman Salvatore Arena; (back row) Treasurer George Elvins and Town Clerk Weeden Richard Seely. (Courtesy of the Hammonton Historical Society.)

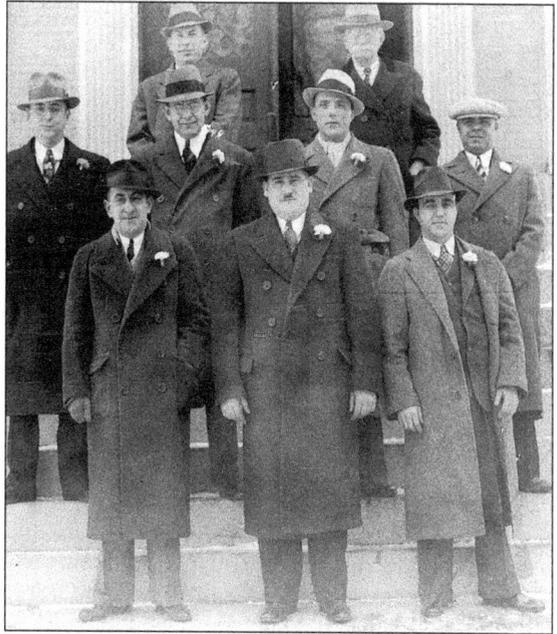

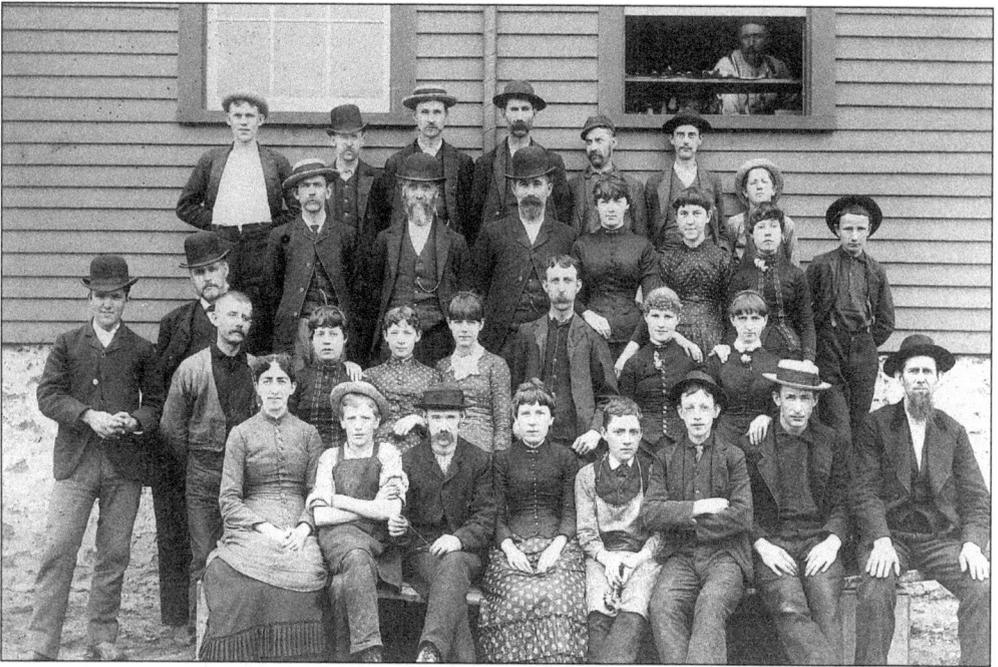

The workers of the Osgood-Smith Shoe Factory pose in 1885 or 1886. From left to right are the following: (first row) Susan Praster, Clyde Smith, Frank Manais, ? Smith, Harry Smith, unidentified, George Dodd, and Hans Miller; (second row) Carl Moore, Charles F. Osgood, Frank Thomas, ? Smith, unidentified, ? Mick, William J. Smith, unidentified, and unidentified; (third row) Rod Thomas, ? Faunce, ? Poyer, Martha Lobdale Austin, Lizzie Bernshouse, ? Smith, Charlie Dodd; (fourth row) John J. Galigne, Wayland DePuy, Elmore DePuy, Mike Fitzpatrick, unidentified, Lon Davis, and Joe Gephert. The man in the window is unidentified. (Courtesy of the Hammonton Historical Society.)

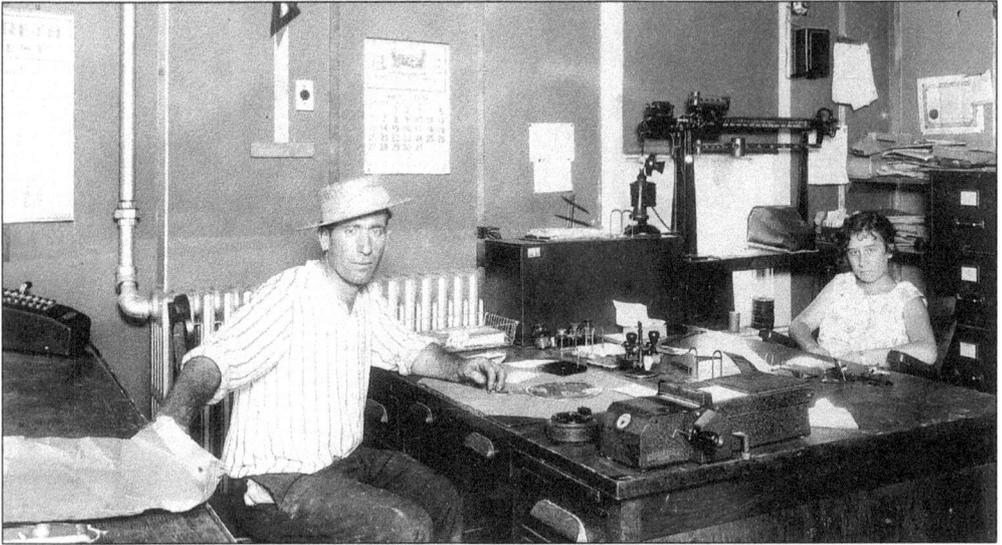

Joseph Monteleone and Ida Bilazzo sit in the office of the Hammonton Building Material Company, on Egg Harbor Road, in June 1930. Monteleone owned the company with Bilazzo's father, Joseph Falciani. Hammonton Building Material supplied a variety of building supplies to local contractors. The company was also involved in construction, working on such local landmarks as the Hammonton High School (built in 1925) and the Hammonton Post Office (built in 1939). (Courtesy of Joseph Monteleone.)

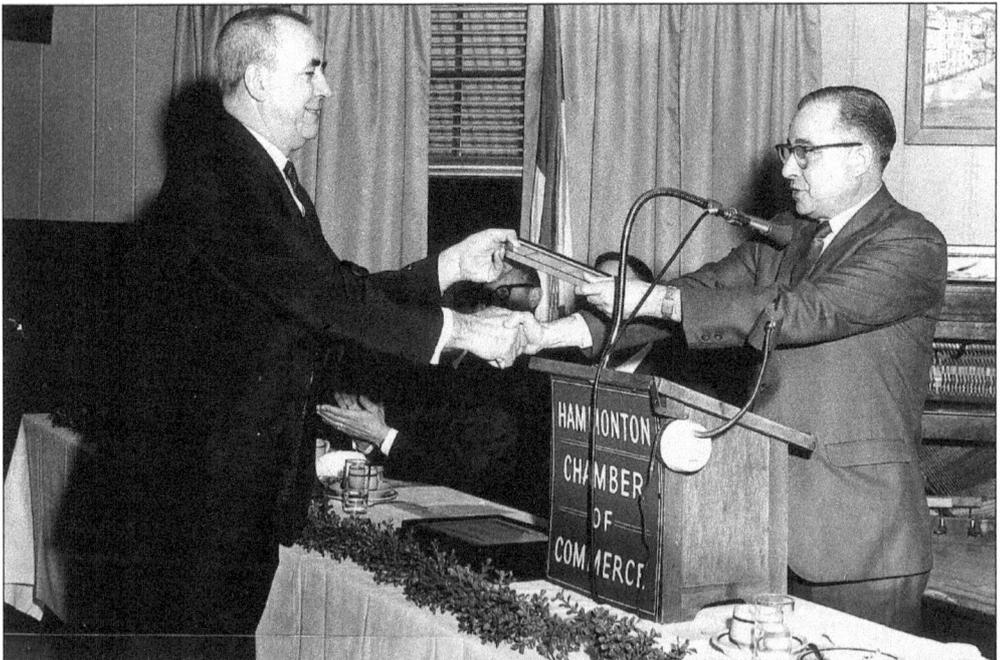

Augie Sorrentino accepts a membership plaque from Hammonton Chamber of Commerce president Ralph Continisio on February 22, 1966. Sorrentino was the owner of dining establishments in several different locations in the Hammonton area for many years. In the 1950s, he had a restaurant on Bellevue Avenue. In later years, he owned and operated Augie's Country House on the White Horse Pike with his family. (Courtesy of Augie Sorrentino.)

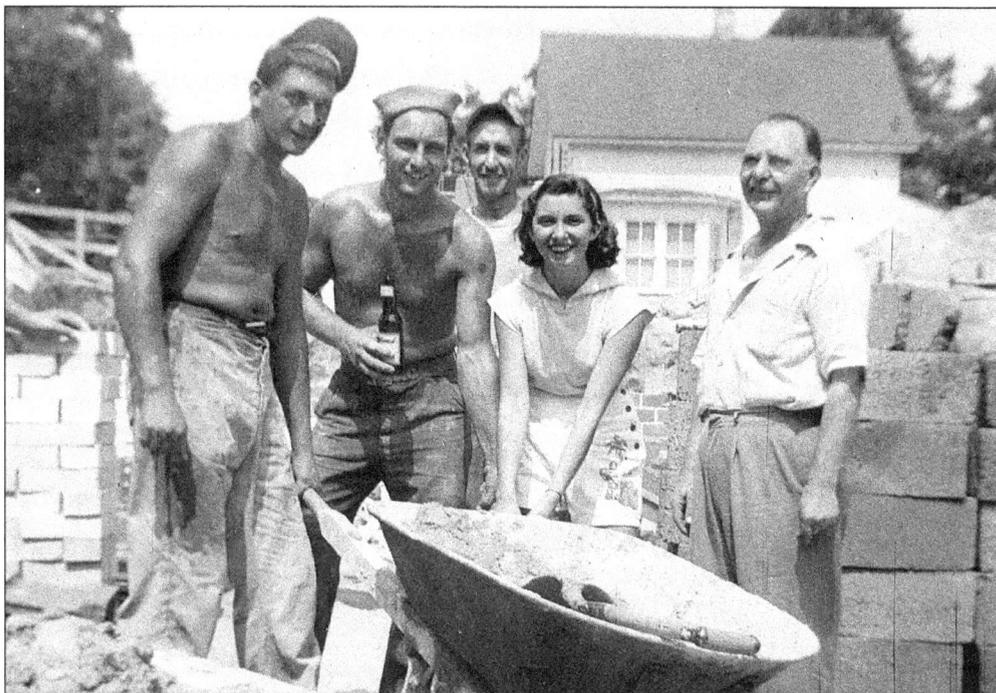

The construction of the Town House, on the corner of Third and Orchard Streets, was hard, hot work, but that did not mean there was no time for some fun, as shown in this 1940s photograph. Pictured from left to right are "Chick" Tomasello, Vince Scardino, Earl Lane, Dottie (Molinari) Cartica, and Anthony Molinari. (Courtesy of Rita and Dan Benedetto.)

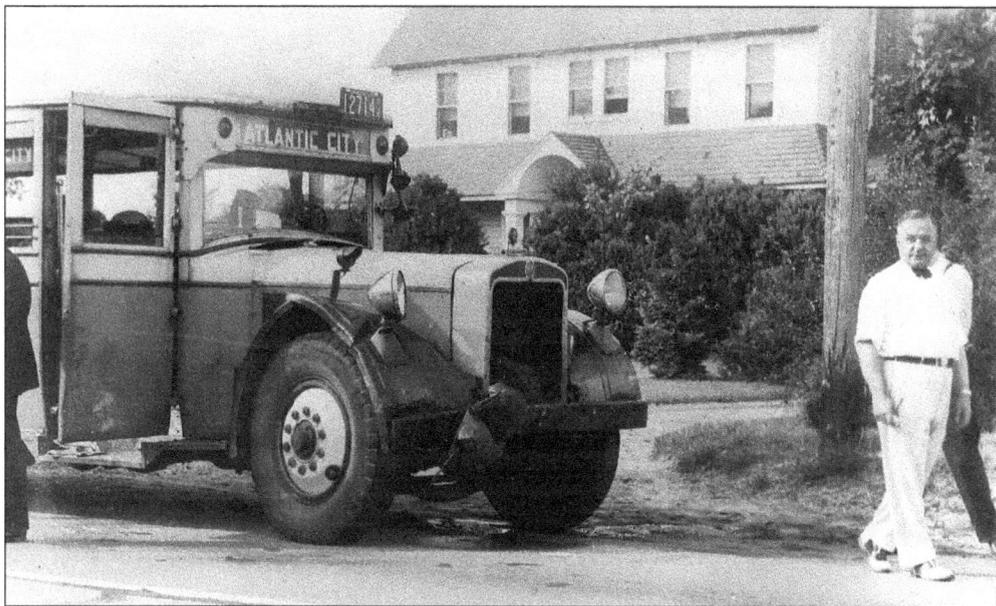

Dr. Anthony "Spotty" Esposito was always ready to aid in the event of an accident. Esposito was one of the best-known of the local small-town doctors and played an important and respected role in the community. The vehicle pictured is an Atlantic City jitney. The photograph is from the 1930s. (Courtesy of Augie Sorrentino.)

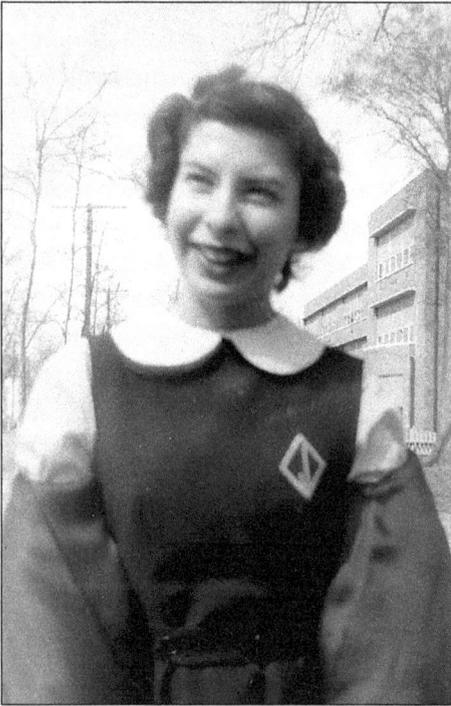

In this 1954 view, Elizabeth Santiano is wearing her school uniform in front of St. Joseph's Roman Catholic High School, on Third Street. The uniform has evolved from the days of the "Peter Pan" collar pictured here. (Courtesy of Josephine and Vince Giannini.)

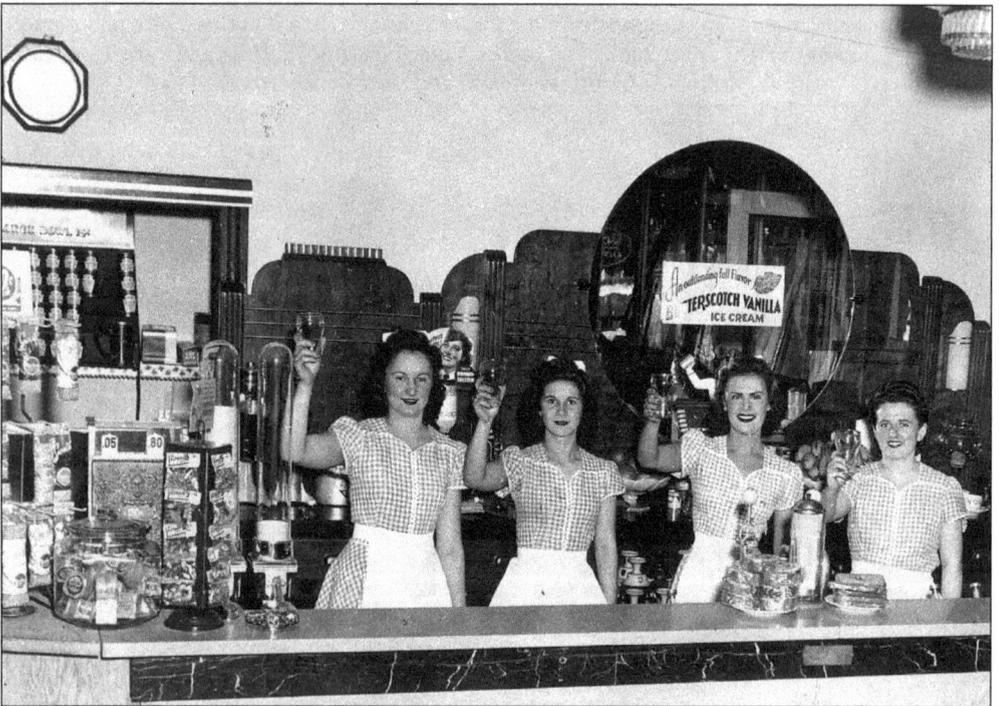

Plenty of good cheer was available behind the counter of Godfrey's Drug Store, located on the corner of Bellevue Avenue and Egg Harbor Road. A soda fountain was a staple in nearly all corner drugstores, and corner drugstores were staples of downtowns. Theresa (Esposito) Donio is standing on the far left. The others are unidentified. (Courtesy of Augie Sorrentino.)

Two

DOWNTOWN

It was the place where you would meet for a movie at the Rivoli Theater and then get something to eat and go dancing at the Sweet Shoppe next door. Maybe you would buy a suit at London Men's Shop or buy your groceries at a market owned by the Olivo family or the Monastra family.

Hammonton High School and St. Joseph's Roman Catholic High School were once both located downtown, and the "Joeys" and the "publics" would gather at places like the Dairy Lunch, the Gem, or the Central. Friday nights were something special, with the streets filled with cars and the sidewalks bustling with people.

Most of the churches were, and are, downtown as well. The historic post office, a Works Progress Administration (WPA) classic, opened in 1939. The municipal government has been downtown since the first town hall was built in 1887. That original building is now home to the Hammonton Historical Society Museum.

Parades down Bellevue Avenue, Hammonton's main street, have always drawn crowds. Festivals like Cruisin' MainStreet and the Red, White and Blueberry Festival are held downtown. The Roman Catholic religious processions, old-world parades of statues of saints, have wound through its streets for generations.

After a period of decline, the Hammonton Revitalization Corporation and MainStreet Hammonton led a successful organized effort to revitalize the downtown area and preserve its historic architectural and cultural treasures for generations to come.

The downtown is the heart, soul, and mind of Hammonton. Geographically and socially, it is the center of the community.

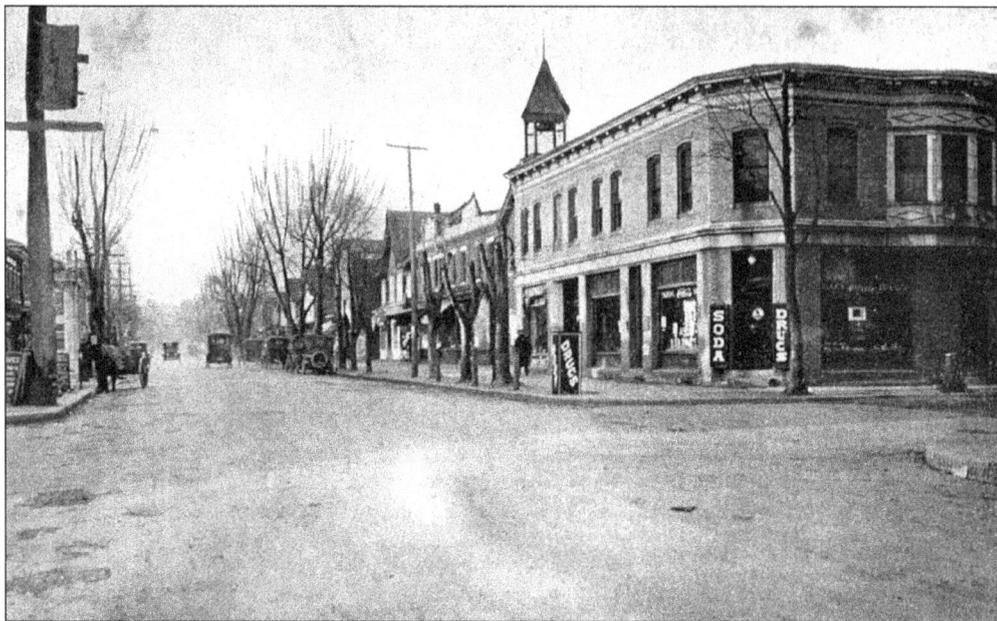

This view from the corner of Bellevue and Central Avenues looks toward the railroad tracks in the early 1900s. At this time, the town's main street was paved with concrete, one of the first of its kind in the nation. The corner building to the right is still standing at the intersection of Horton Street and Bellevue Avenue. (Courtesy of Dorothy Orlandini.)

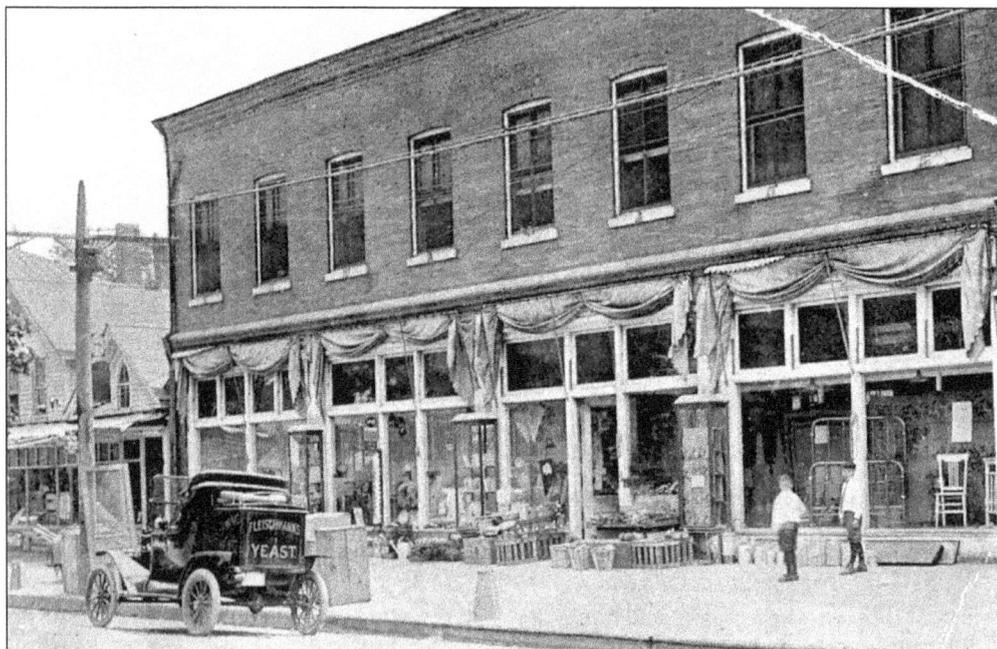

William Black's store was Hammonton's main department store by 1915. It carried a variety of items, including furniture. The small truck in front of the store is delivering Fleischmann's Yeast. Black's store has long since disappeared from the downtown, but the building that housed it is still located on Bellevue Avenue between Second Street and Egg Harbor Road. (Courtesy of Dorothy Orlandini.)

22

The Hammonton Emergency Hospital, run by Dr. Anthony "Spotty" Esposito, was located at the corner of Washington Street and Bellevue Avenue. The town's relative isolation meant having a local hospital was extremely important, particularly when it came to birthing babies. (Courtesy of Jack Pagano.)

Rice Hardware Company was located on Bellevue Avenue, on the block between Central Avenue and Second Street. By the 1950s, the store had, like William Black's before it, become more of a department store, featuring such items as sleds, refrigerators, trash cans, and paint. They also sold hardware. (Courtesy of Sue Reese.)

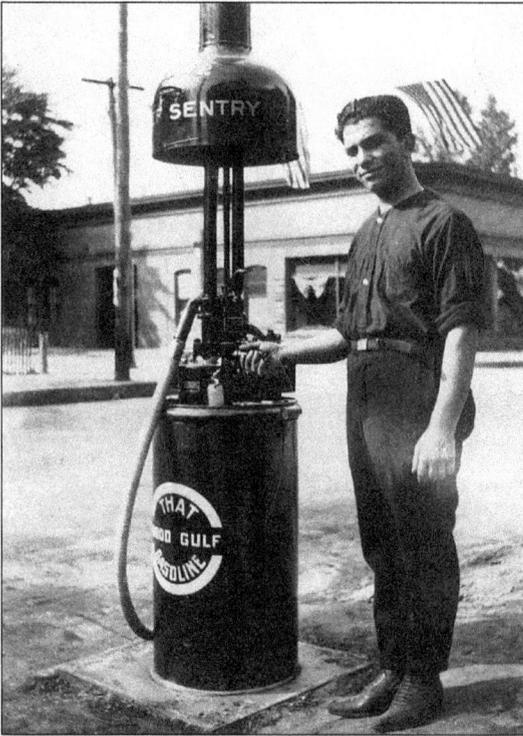

In this early-1920s view, Frank Bruno stands beside a gas pump that filled cars with "That Good Gulf Gasoline" on Bellevue Avenue. The building in the background was located on the corner of Third Street and Bellevue Avenue. (Courtesy of Angelus and Frank Weiss.)

Jennie Bruno mans the counter inside the Sweet Shoppe, at 249 Bellevue Avenue. With its candy counter, soda fountain, and dance floor (and its location next door to the Rivoli Theater), the Sweet Shoppe was the place to meet for local teenagers in the 1930s, 1940s, and 1950s. (Courtesy of Angelus and Frank Weiss.)

Pete Capella and his sister stand in front of the Sweet Shoppe on Bellevue Avenue in the 1940s. The marquee of the Rivoli Theater is behind them. Many local residents fought and died in World War II. (Courtesy of Angelus and Frank Weiss.)

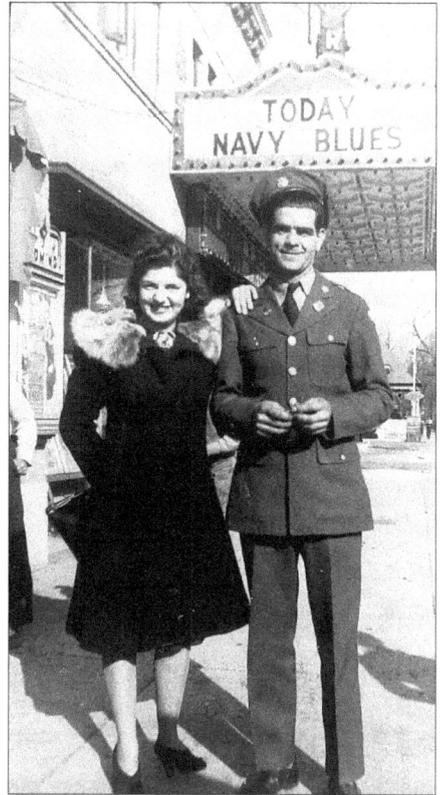

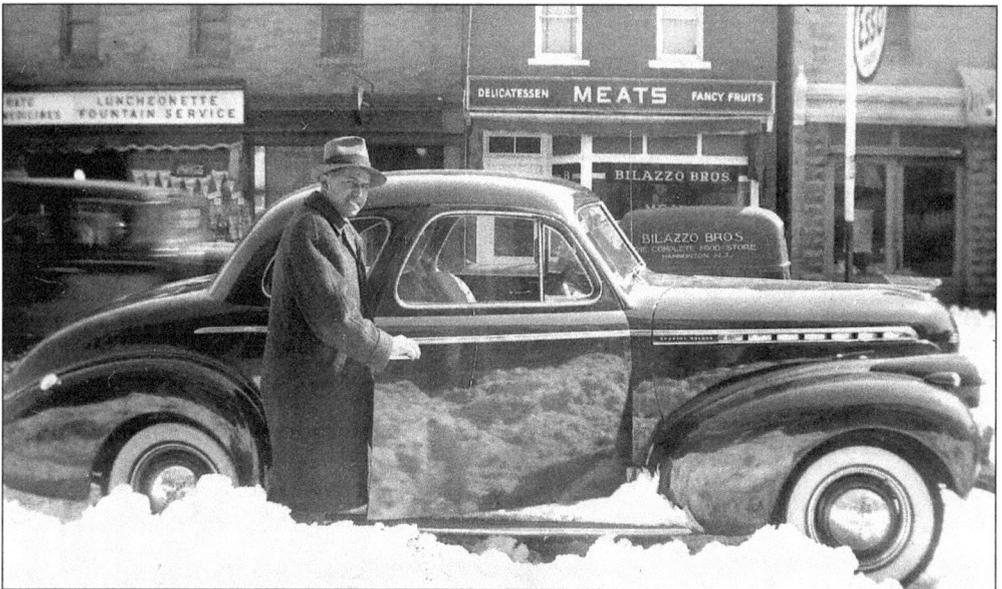

Anthony Gelona's brand-new car looks pretty good, even if there is still a lot of snow on the ground in March 1941. P.T. Ranere's Buick dealership, Bilazzo Brothers' Meat Market, and Bellevue Drug Store are seen in the background. The dealership and the market were later demolished to make way for a parking area. (Courtesy of Angelus and Frank Weiss.)

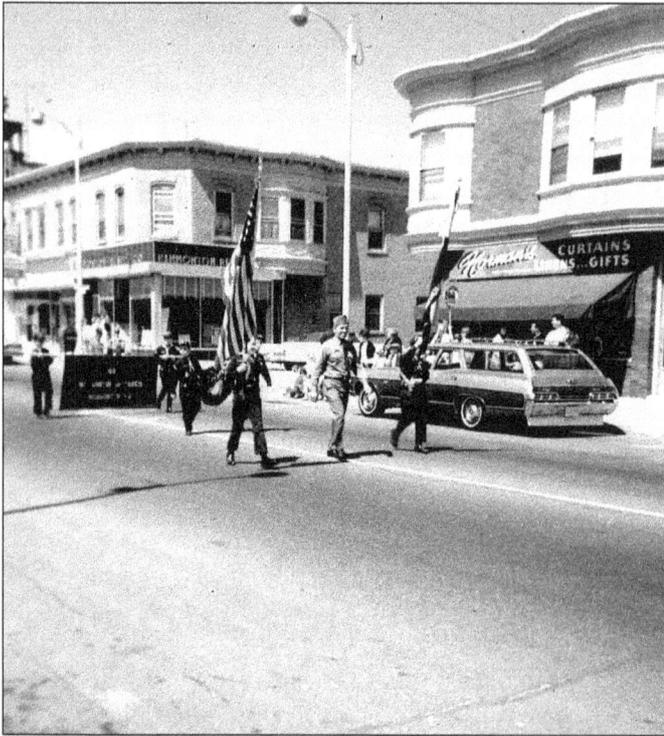

A Memorial Day parade moves down Bellevue Avenue in 1967. Norman's was located at 231 Bellevue Avenue. Built in the late 1800s, the corner building across Horton Street has since undergone some remodeling. At the time of this photograph, Hammonton Realty Company was located at the corner of that building. (Courtesy of Josephine and Vince Giannini.)

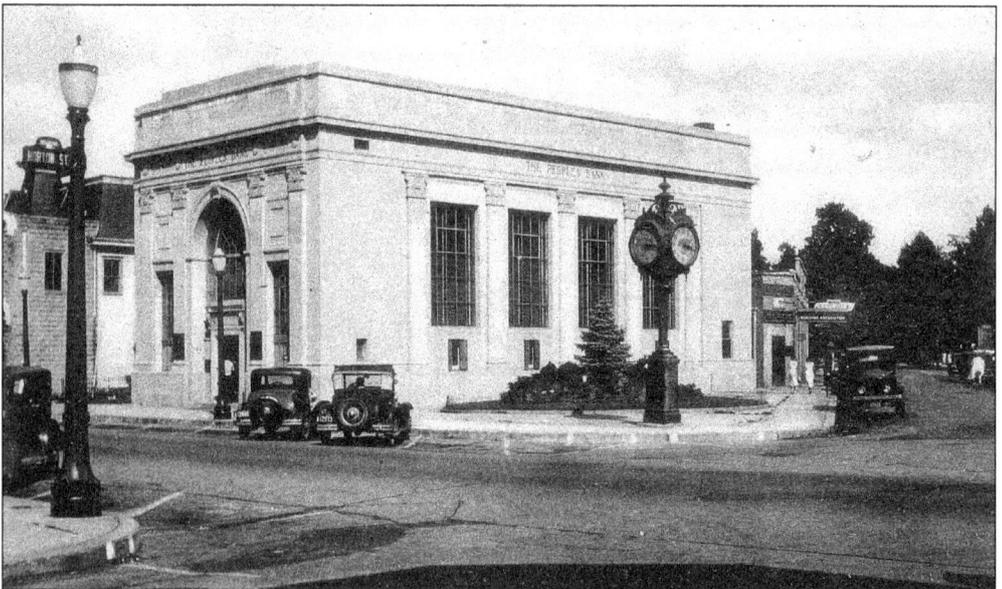

The People's Bank building still stands on the corner of Bellevue and Central Avenues. This postcard was produced in the 1920s. The bank has become one of the town's local landmarks. So has the four-sided town clock, which was later moved to another location on Central and Vine Streets after being struck by a car. (Courtesy of Dorothy Orlandini.)

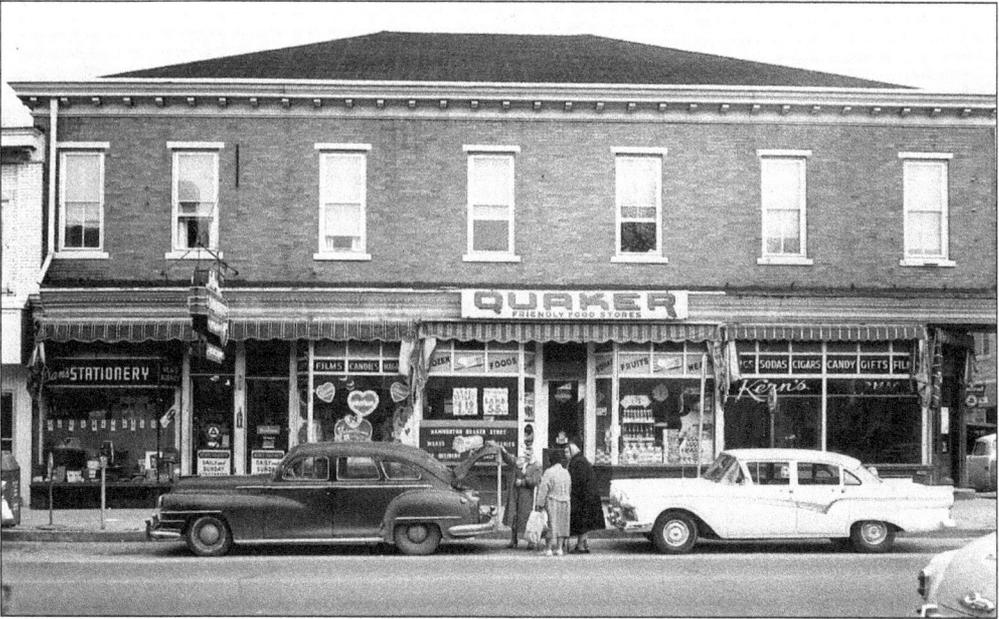

Three stores once occupied the large building at the corner of Bellevue Avenue and Second Street. From left to right, they are Dan's Stationery, Quaker Friendly Food Store, and Kern's Drug Store. The building became the home of Tapper Stationery in the 1980s and still stands on Bellevue Avenue. (Courtesy of Sue Reese.)

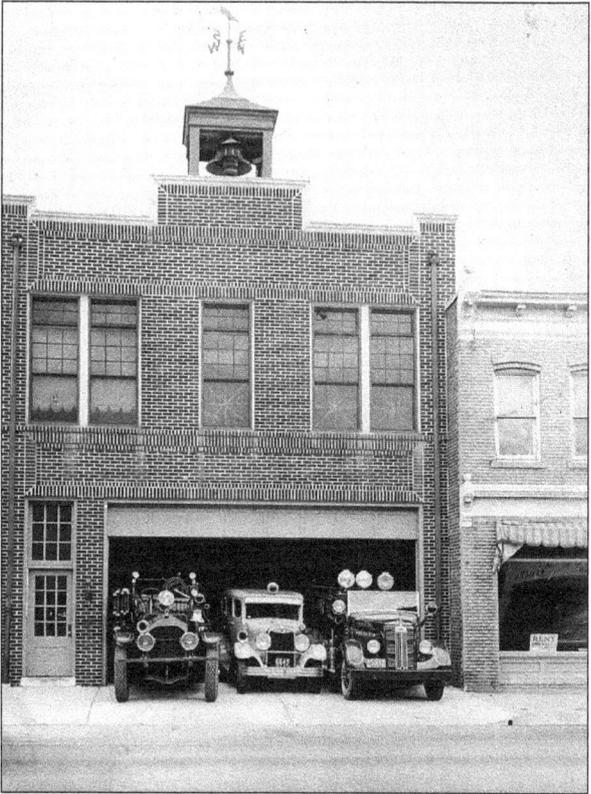

Hammonton Volunteer Fire Company No. 1 was located on Bellevue Avenue. Eventually, there would be two volunteer fire companies making up the Hammonton Volunteer Fire Department. Hammonton Volunteer Fire Company No. 2 is located on the White Horse Pike. Baskets by Inferreras took over the building in the 1990s. (Courtesy of Augie Sorrentino.)

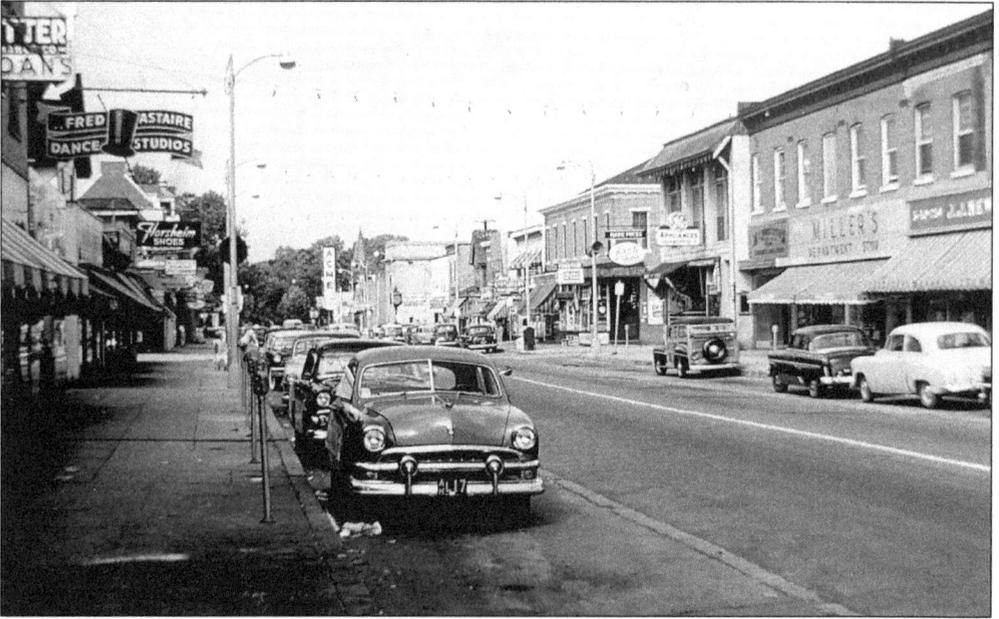

The downtown area is pictured in the early 1950s. Miller's Department Store and J.J. Newberry's are to the left, in the space formerly occupied by Black's store. A woody wagon is parked in front of M.L Ruberton Agency, a real estate brokerage and insurance firm. A "Fred Astaire Dance Studios" sign, complete with top hat, can be seen to the left. (Courtesy of the Hammonton Historical Society.)

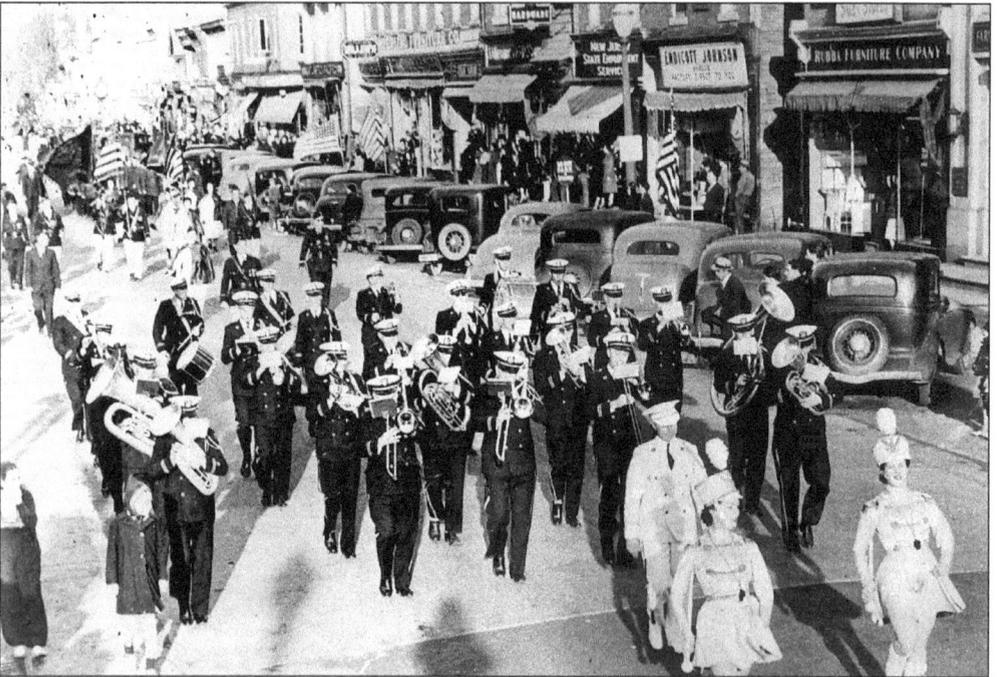

A marching band moves through the downtown in the 1930s. The parade was most likely in honor of Armistice Day. Stores visible include the Rubba Furniture Company, the Endicott Johnson store, and the New Jersey Employment Services office. (Courtesy of Augie Sorrentino.)

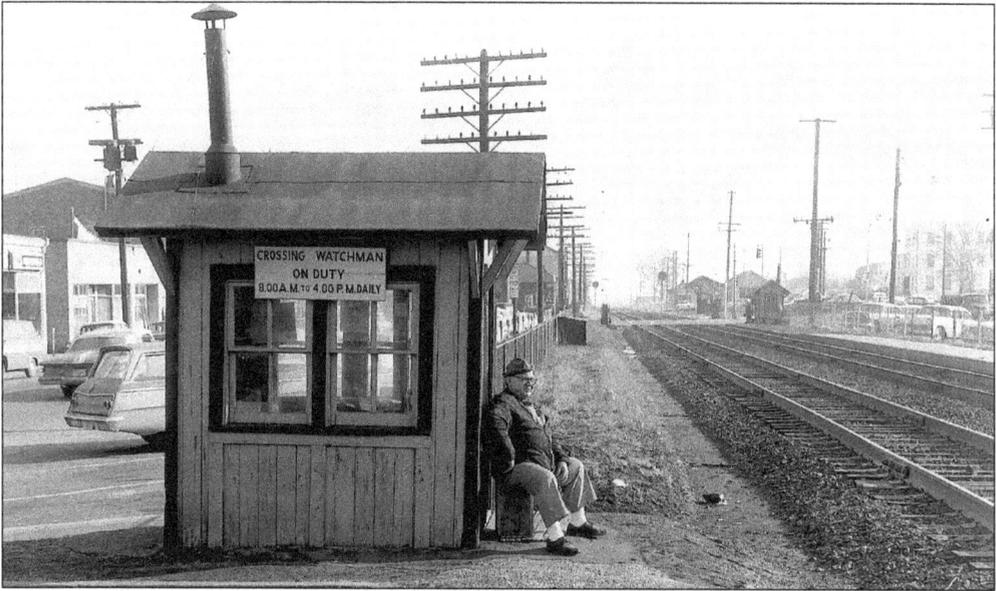

Thank goodness the crossing watchman was on duty. The 1960s marked the end of an era in downtown Hammonton. In a few short years, the crossing watchman and his little shack disappeared, replaced by automated gates, flashing lights, and bells. (Courtesy of Joseph Giralo.)

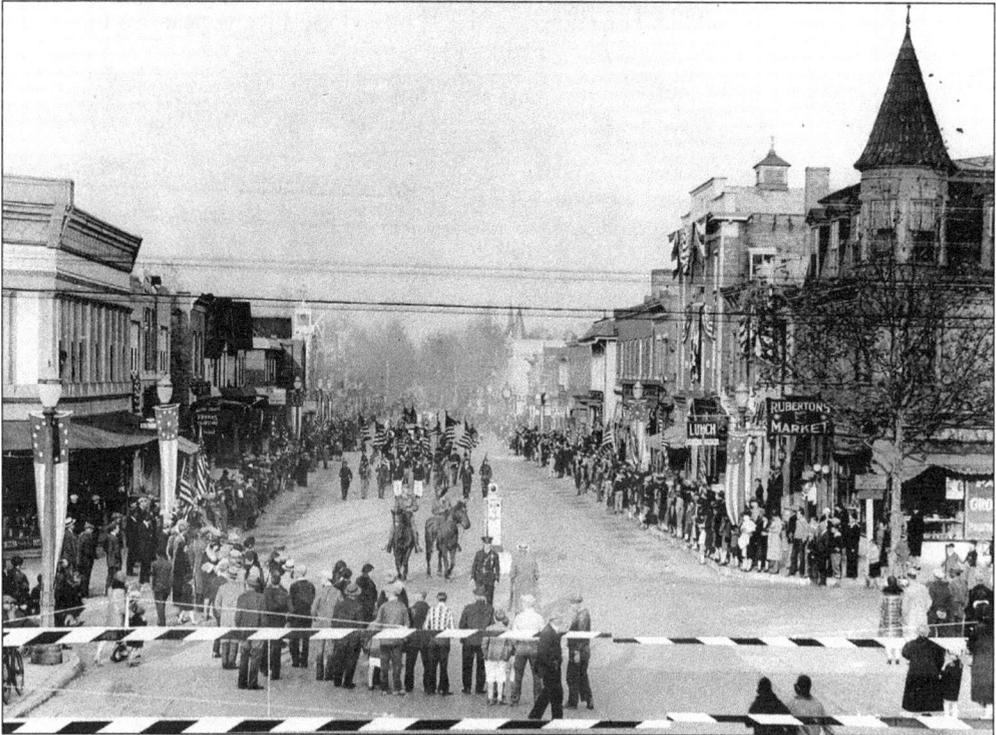

Downtown Hammonton looks extremely patriotic for this parade during the 1920s. The large building with the tower (right), home to Ruberton's Market at the time, burned down in the early 1980s. The building directly across from it was remodeled in the late 1990s to more closely approximate its appearance from the late 1800s. (Courtesy of Augie Sorrentino.)

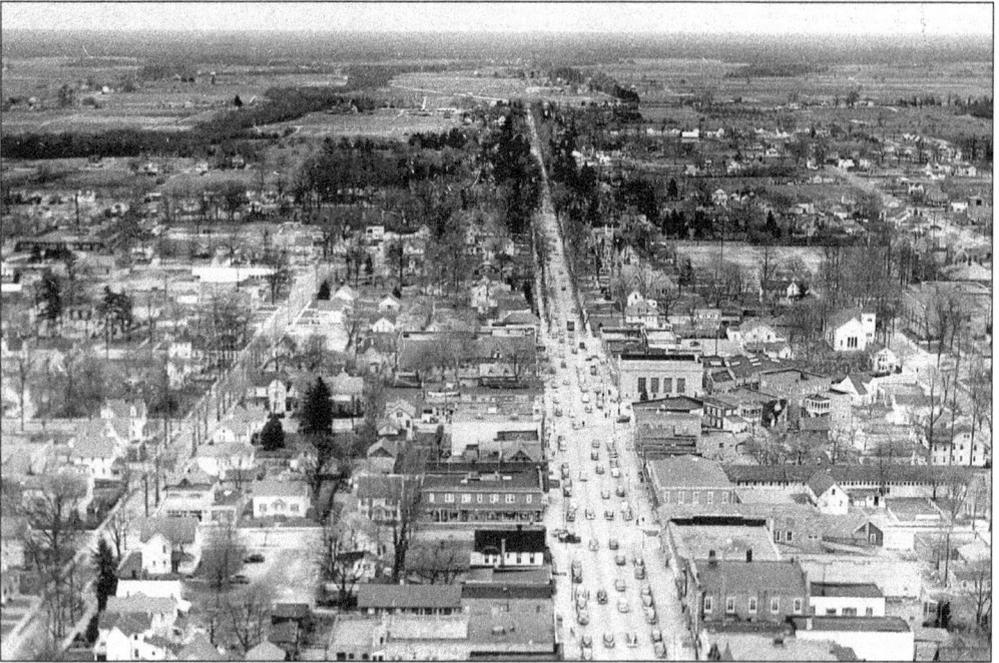

This rare aerial photograph from the late 1940s shows downtown Hammonton with many more buildings and a lot less parking. For reference, the White Horse Pike is near the top of the photograph. (Courtesy of Carol and Reno Farinelli.)

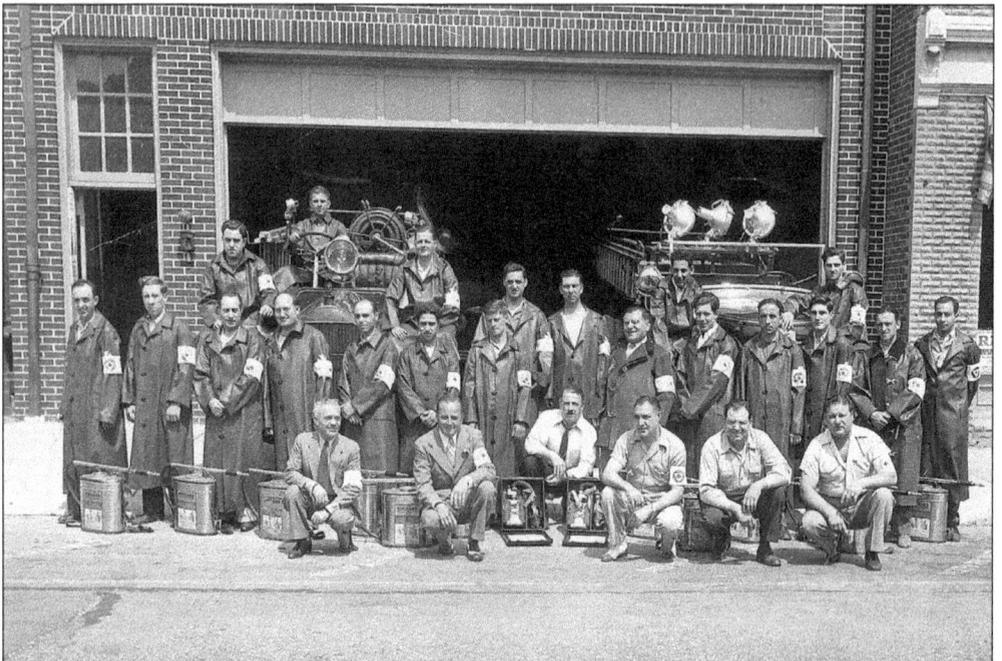

Members of the Hammonton Fire Company No. 1 are pictured in the 1920s at the fire station in the downtown area. Fire jackets were much longer and cumbersome in this era, and the equipment used to fight fires was rudimentary at best, increasing the level of danger for the volunteer members of both companies in the local department. (Courtesy of Grayce Pitera.)

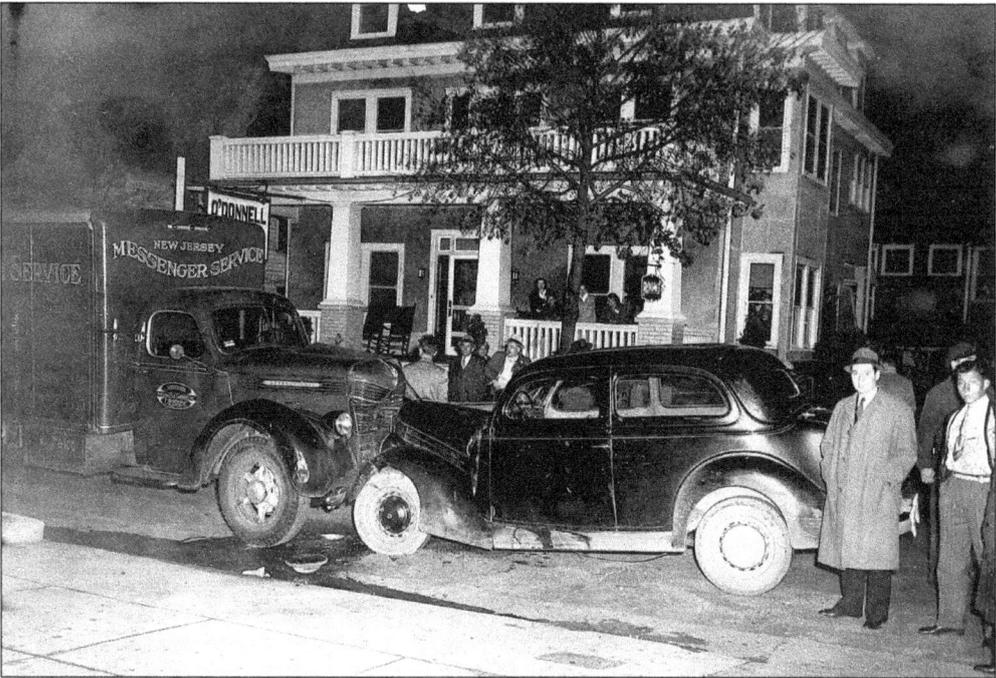

From the looks of things, a lot of the messages in the New Jersey Messenger Service truck did not make it to their destinations on time. The rooming house known as the O'Donnell House is pictured in the background of this view from the 1930s. (Courtesy of Augie Sorrentino.)

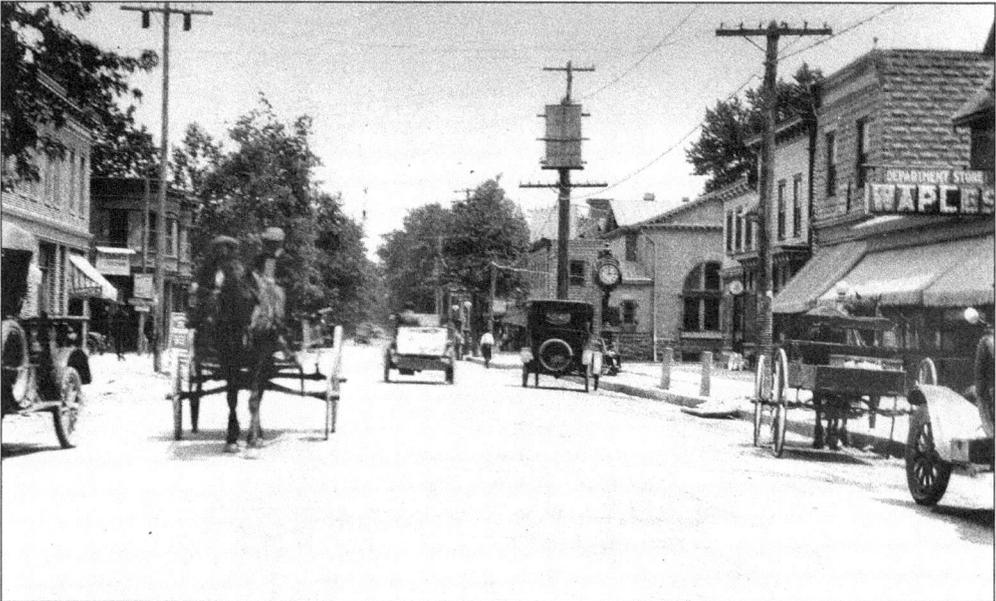

During the 1920s, there was little traffic downtown. It was not surprising to see a horse and wagon parked in front of your car. Waples Department Store (right) was later demolished and replaced with the expanded K & H Auto Stores building. (Courtesy of Angela Donio.)

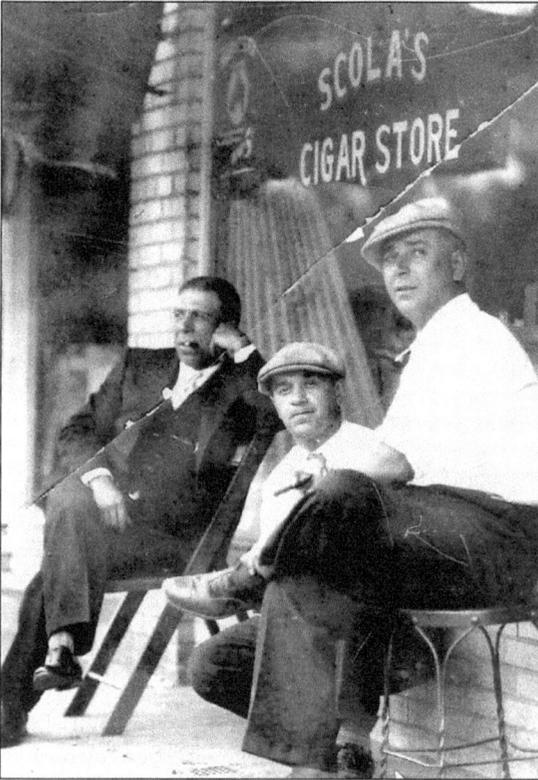

Downtown was known for its hangouts. These establishments served both retail and social functions. Scola's Cigar Store was located on Egg Harbor Road between Bellevue Avenue and Orchard Street. Pictured here are, from left to right, John E. Scola Sr., Anthony "Chielo" Scola, and Peter Marinelli. (Courtesy of John Scola.)

Seen here in the 1920s, the residence and office of Dr. Joseph C. Bitler eventually became the law offices of the Curcio family. The downtown area has a long history as a home to professional offices. (Courtesy of Vincent Giannini.)

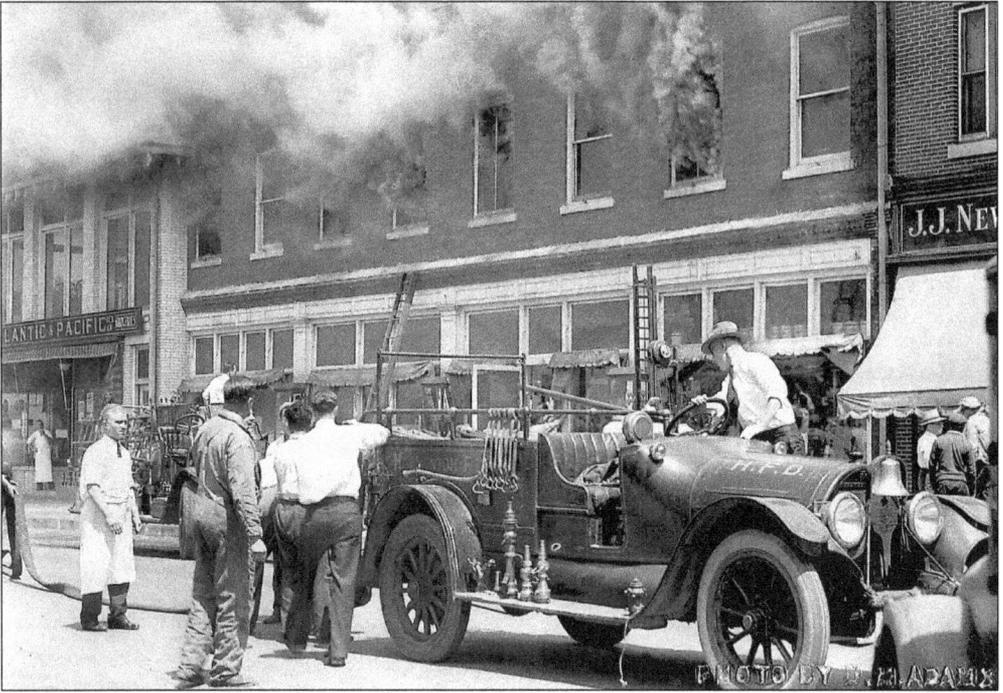

A major fire erupted at Black's store in the 1920s. Members of the Hammonton Volunteer Fire Department worked to control the blaze, which burned out of control on the second floor, above the store. The Great Atlantic & Pacific Tea Company (A & P) had moved next door to Black's by this time. (Courtesy of the Hammonton Gazette.)

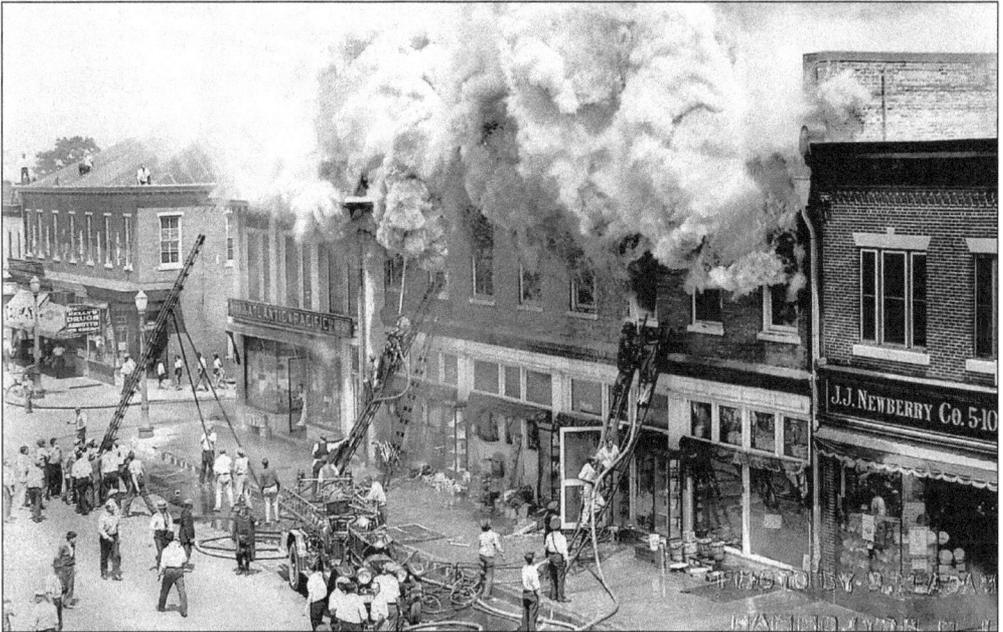

Firefighters scramble up ladders and are met with a raging fire above Black's store. Bellevue Avenue is chaos as traffic is diverted, and the street is filled with townspeople eager to help the volunteers save the building and the store. (Courtesy of the Hammonton Gazette.)

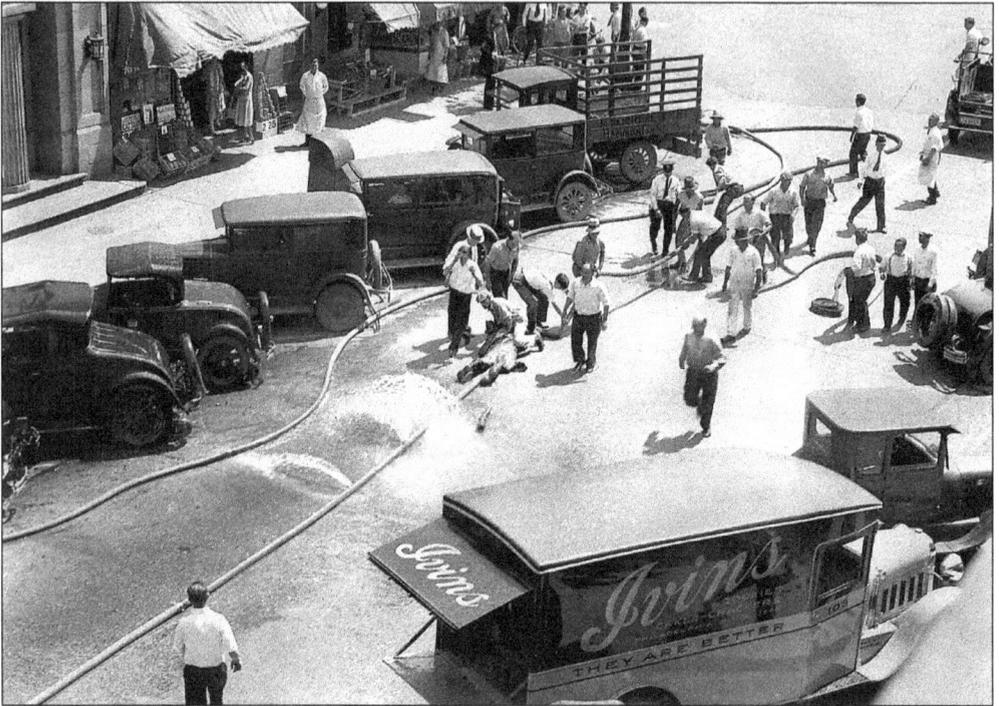

Cars and trucks are covered in soot and ash as the fire burns. A firefighter is seen down in the street, receiving assistance as others rush to help. The fire was controlled, and the building was saved. (Courtesy of the Hammonton Gazette.)

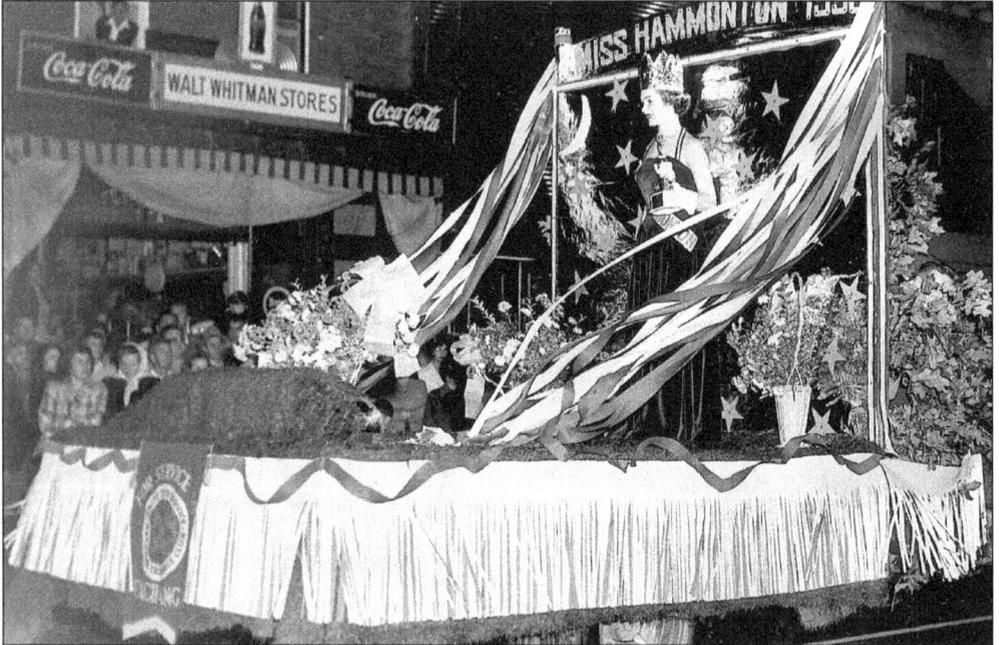

Carol (Kosowski) Farinelli, Miss Hammonton of 1950, rides on a float past the Walt Whitman Store on Bellevue Avenue. The Hammonton Exchange Club sponsored the float. (Courtesy of Carol and Reno Farinelli.)

Three

AN AGRICULTURAL CENTER

Hammonton is unofficially known as the Blueberry Capital of the World. The designation was bestowed by the Greater Hammonton Chamber of Commerce as a means of promoting the town, making it memorable and marketable.

Still, there is basis for the claim. Hammonton has the largest concentration of cultivated highbush blueberries anywhere in the world, and the blueberry has become the signature local crop, with an annual Red, White and Blueberry Festival held in its honor.

It was not always that way.

The town was once known as the Peach City. Its peaches were celebrated for their size, taste, and quality. A peach festival had young ladies vying for the coveted title of Peach Queen. They would be presented with, among other prizes, a bough of pink peach blossoms.

The local agricultural history began auspiciously. New England farmers who were lured to Hammonton by the promise of fertile land could do little, as the heavy equipment brought down from Maine, New Hampshire, and Massachusetts sank into the sandy Pine Barrens soil. Those who decided to stay, particularly those of Italian descent, were eventually rewarded. They made their fortunes on signature crops, such as Jersey tomatoes, peaches, and blueberries. Fruit and vegetables grown in Hammonton gained a reputation for being of the highest quality.

Many scratch their heads and smile with amusement at New Jersey's self-proclaimed status as the Garden State. Stand in Hammonton's fields of fruits and vegetables in the high heat of July, and you will find that the state still has some places where that motto makes sense.

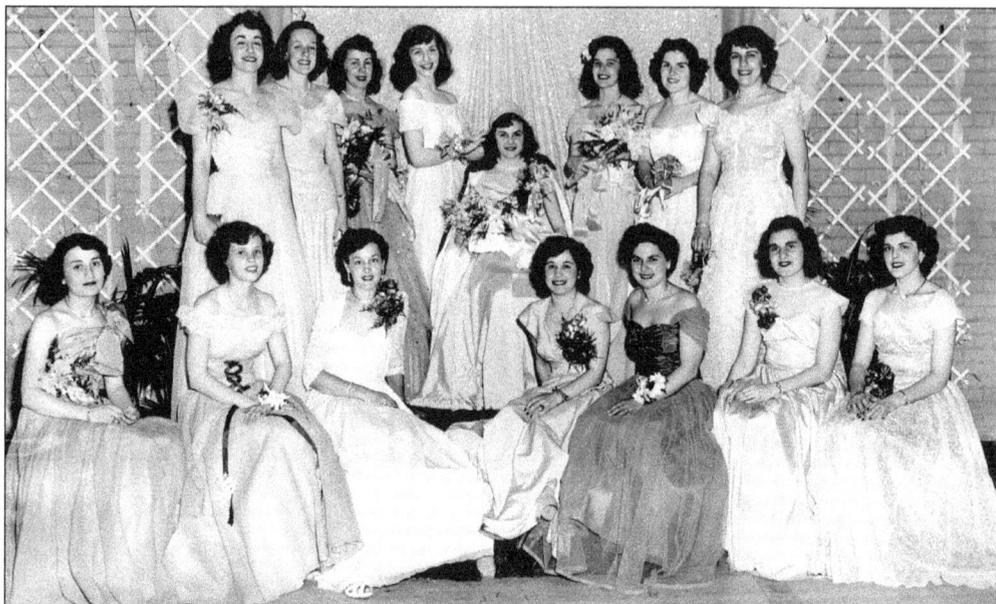

The Peach Queen poses with her court. Being selected as the Peach Queen was considered a coveted honor in the 1940s and 1950s. Peaches were an incredibly successful crop in Hammonton at the time. From left to right are the following: (front row) Gloria Donio, Marilyn Glazert, unidentified, Ann Maimone, Deletta Perna, Helen Grasso, and Bernice Christopher; (back row) Adeline Tomasello, Gail Adams, Geraldine Hawkins, Harriet Peters, Carol (Kosowski) Farinelli (seated), Anita Esposito, Joy Mottola, and Mildred Figaro. (Courtesy of Carol and Reno Farinelli.)

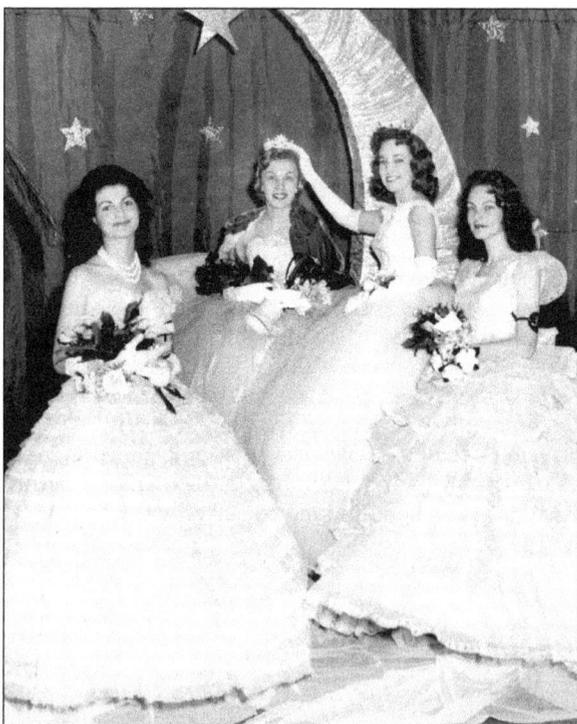

Peach Queen Judy Wiedemer relinquishes her crown to Betty Ann Sooy as two other members of the court, Rosalie Curreri (left) and Kathleen Campanella, hold bouquets. Formal dresses of the era were required of young women who aspired to the title of Peach Queen. (Courtesy of Judy Jiampetti.)

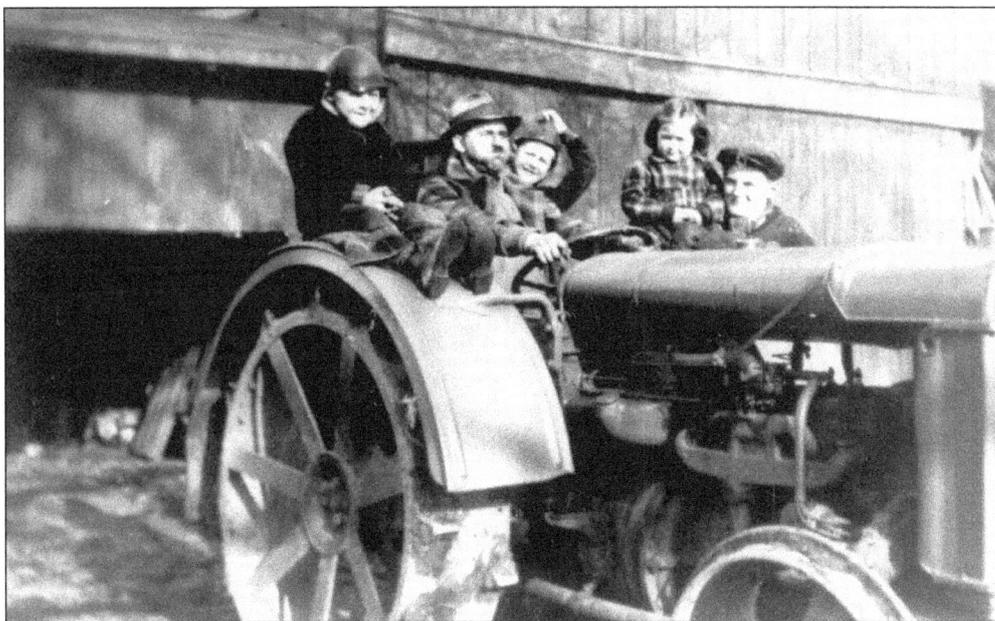

Zeitler's Poultry Farm was located at 281 Middle Road. Tractor rides were one of the side benefits to living on the farm. From left to right are Frank Zeitler, Joseph Zeitler, Randolph Zeitler, Josephine Zeitler, and Richard Tanzer. (Courtesy of Josephine and Vincent Giannini.)

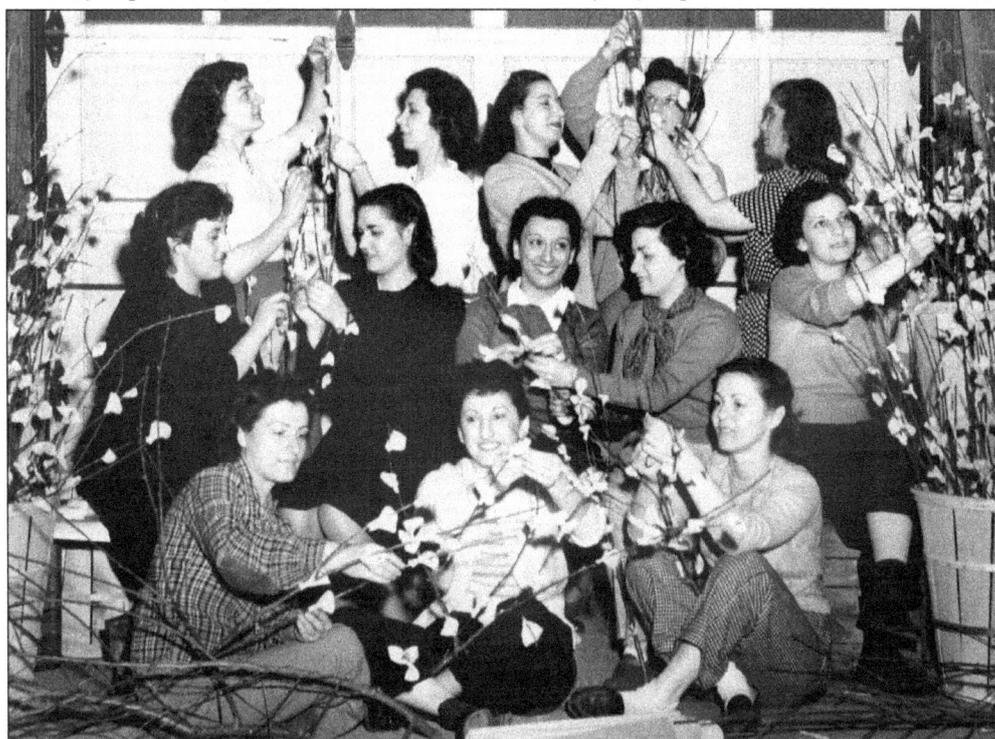

Members of the Stella Maris Club prepare decorations for the May Hop, an annual dance that was part of the celebration of the local Peach Blossom Festival. Faux blossoms were made by twisting pink crepe paper onto tree branches. (Courtesy of Dorothy Orlandini.)

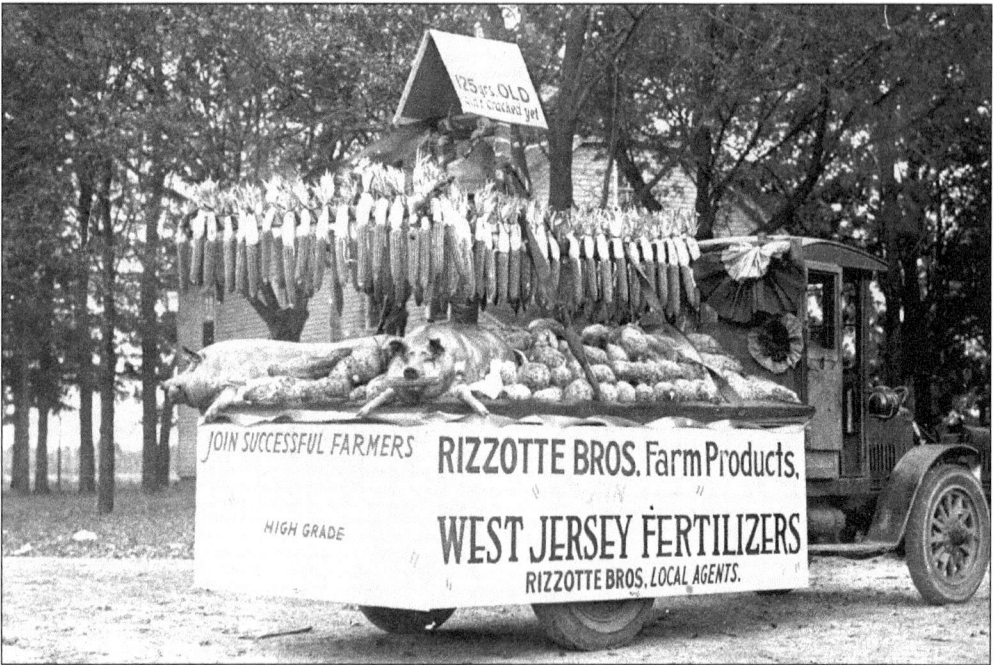

This float, laden with the fruits of a harvest, appeared in parades in the 1930s. The roast pigs on the back of the float are indicative of the Rizzotte Brothers Italian heritage. A pig roast was often a cause for celebration for local Italians. The sign on top of the bell reads, "LIBERTY BELL'S FIRST COUSIN 125 YRS. OLD ain't cracked yet." (Courtesy of Evelyn Penza.)

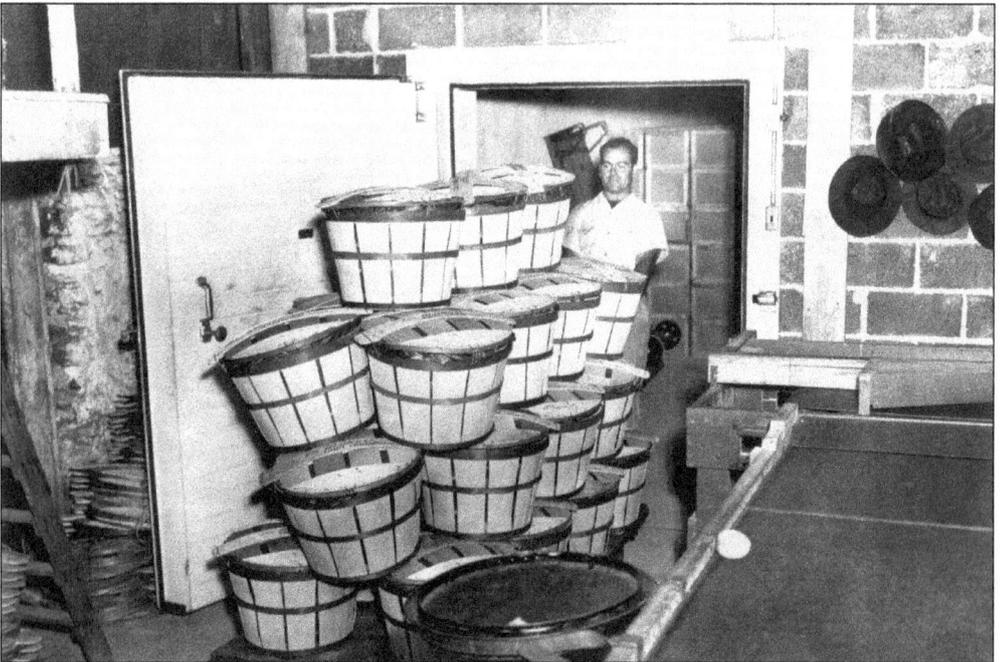

Dave Rizzotte pushes bushels of peaches out of a cooler at Glossy Fruit Farms. The farm observed its 115th year of operation in 2002. The hats on the wall were used by people working in the fields as protection from the heat and sunburn. (Courtesy of David Rizzotte.)

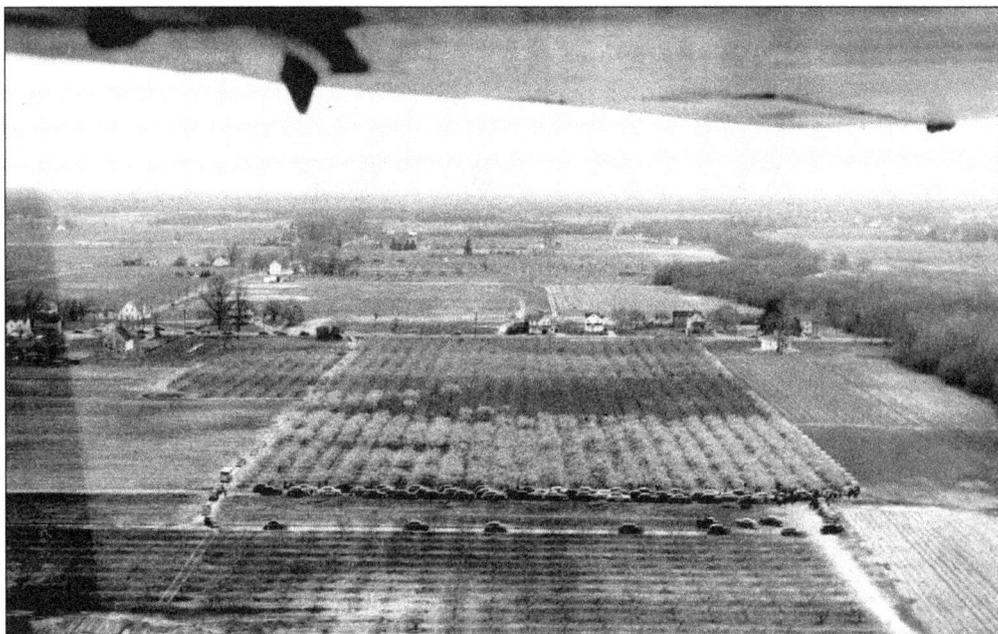
The Peach Blossom Festival is pictured in this late-1940s aerial view. The light area in the center of the photograph is completely pink with blossoms. This farm was located off the White Horse Pike. (Courtesy of Reno and Carol Farinelli.)

In this 1940s view, John "Shoes" DeMarco stands in front of bushels of peach baskets at his packing house, which was located on the White Horse Pike. The others are unidentified. (Courtesy of Sharon Franchetti.)

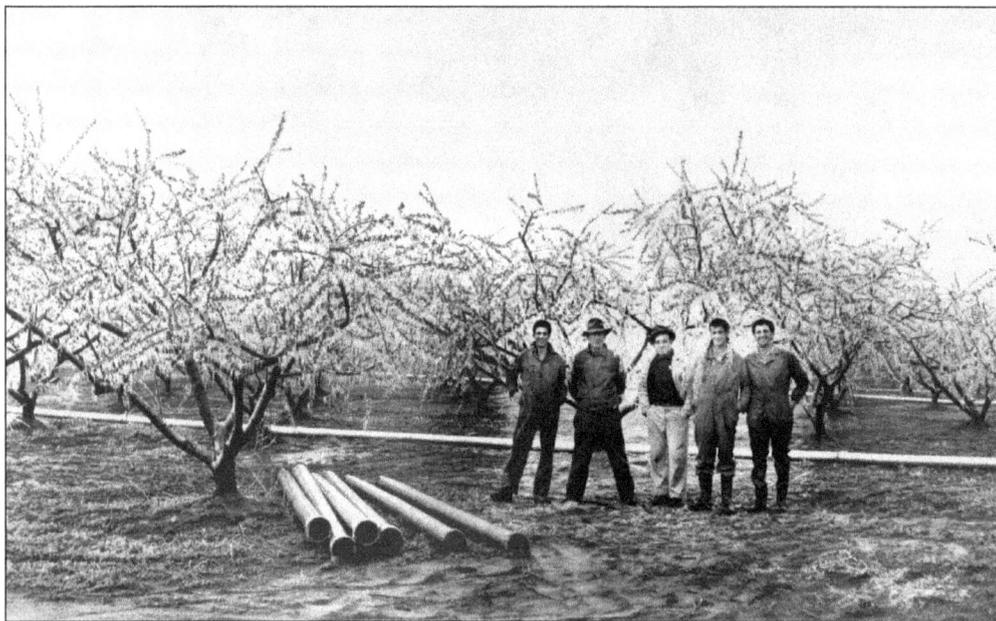

Members of the DeMarco family survey the installation of the first irrigation lines used with local peaches. (Courtesy of Phil DeMarco.)

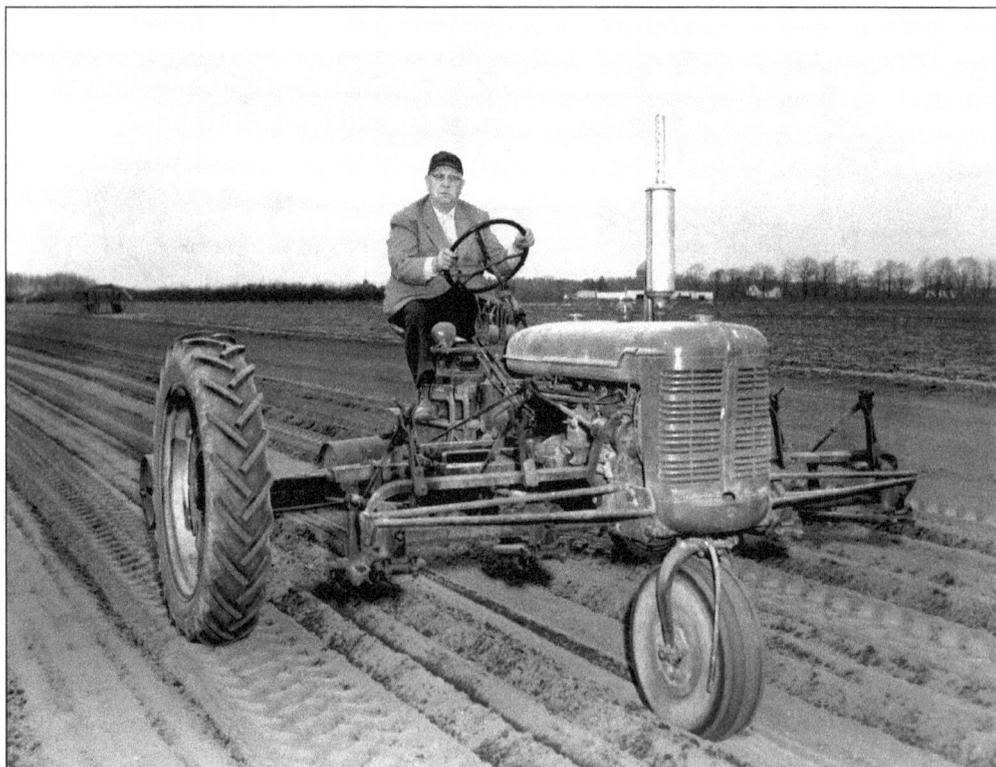

Anthony Rizzotte operates a tractor at Glossy Fruit Farms. The Rizzottes grew a variety of vegetables during the early 20th century, but their primary fruit crop was peaches. (Courtesy of Evelyn Penza.)

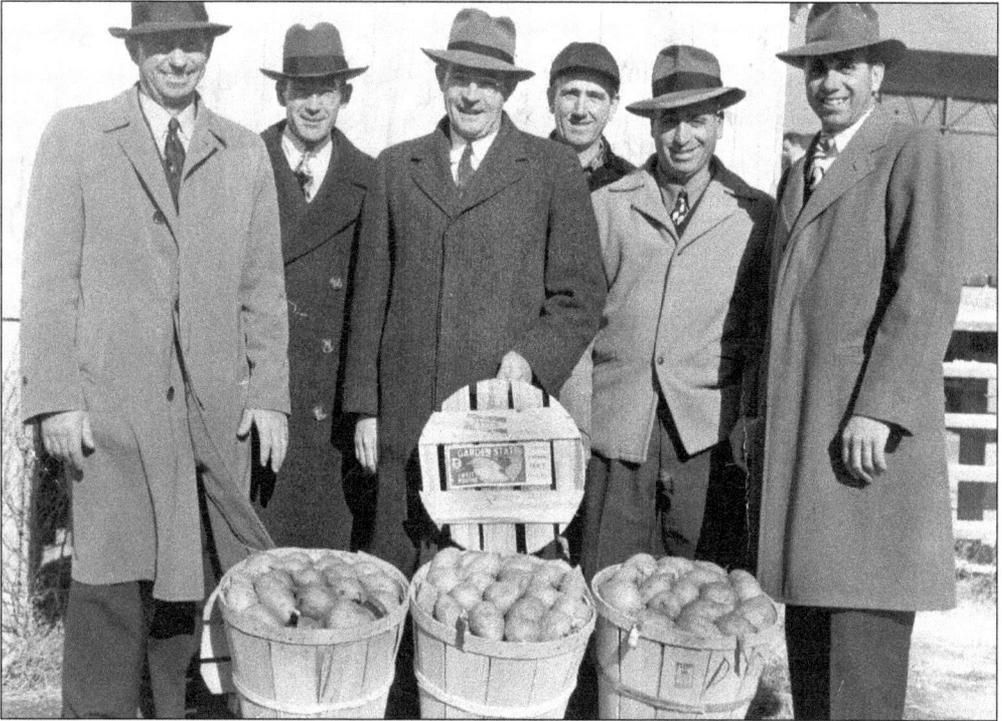

A proud group of men surveys the latest sweet potato harvest in the 1940s. The only men identified are Atlantic County Agricultural Agent John Brockett (third from left) and Joseph Battaglia (sixth from left). (Courtesy of John Wiessner.)

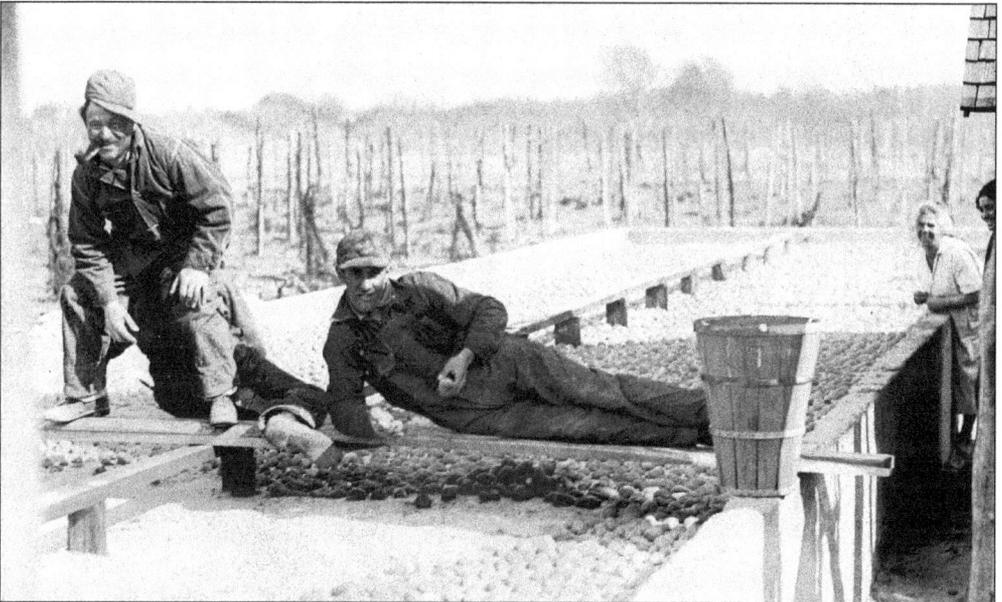

Glossy Fruit Farm employees lay sweet potatoes in a hotbed. Laid by hand, the potatoes were warmed from underneath by hot water, by metal barrels filled with burning wood, or by an electrical current. This accelerated their growth, creating new seedlings that were planted and produced next year's sweet potato crop. (Courtesy of Evelyn Penza.)

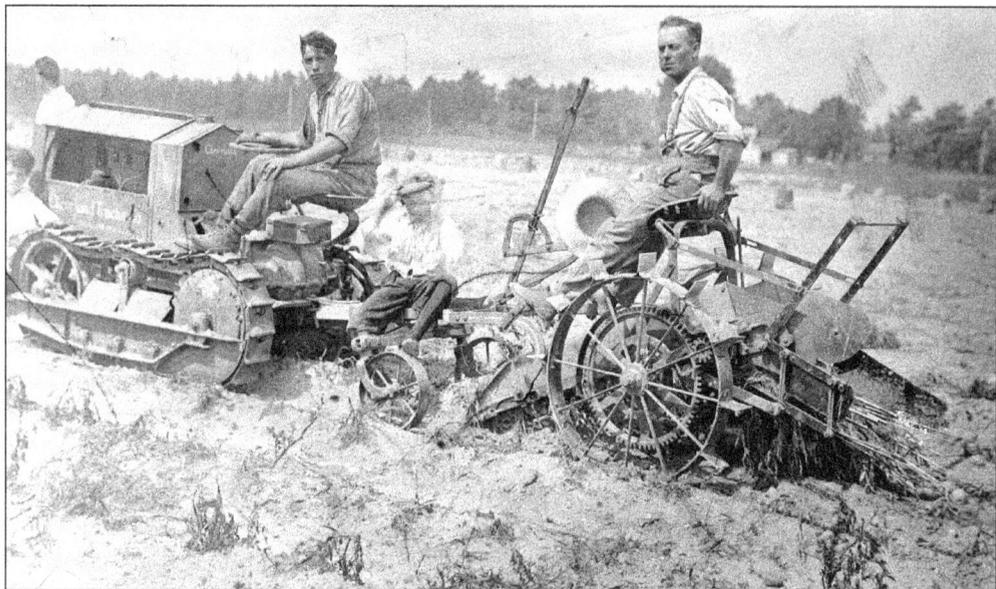

Working the land in Hammonton required patience and the right equipment. In this 1920s photograph, Tony Rizzotte (far right) and Glossy Fruit Farm employees dig a local sweet potato field. (Courtesy of Evelyn Penza.)

Blueberries eventually replaced peaches as the primary cash crop in Hammonton. From left to right are Antonia Totoro, Jessie Sorrentino, and Domenica Sorrentino in a blueberry field. (Courtesy of Augie Sorrentino.)

John Wiessner stands in front of the Square Deal Farm Market in 1943. Annie and Antonio Giacobbe founded the market, located on the White Horse Pike, in 1928. The bushel baskets contain apples. (Courtesy of John Wiessner.)

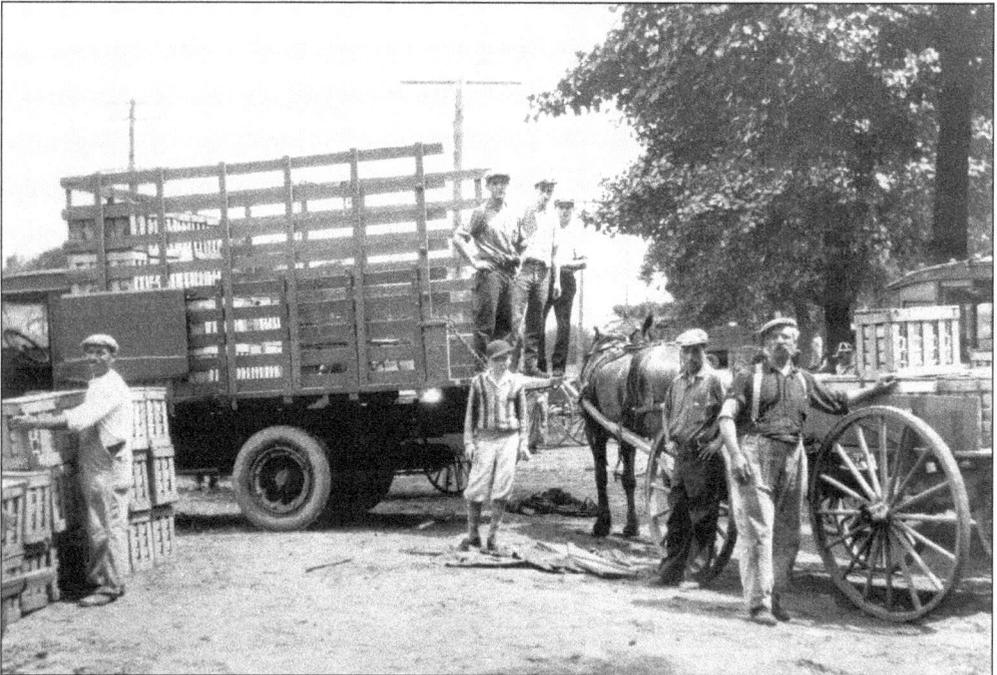

In the 1920s, horse-drawn carriages and large trucks unloaded fruits and vegetables all day long at the cooperative then known as the Hammonton Municipal Market. (Courtesy of John DeLucca.)

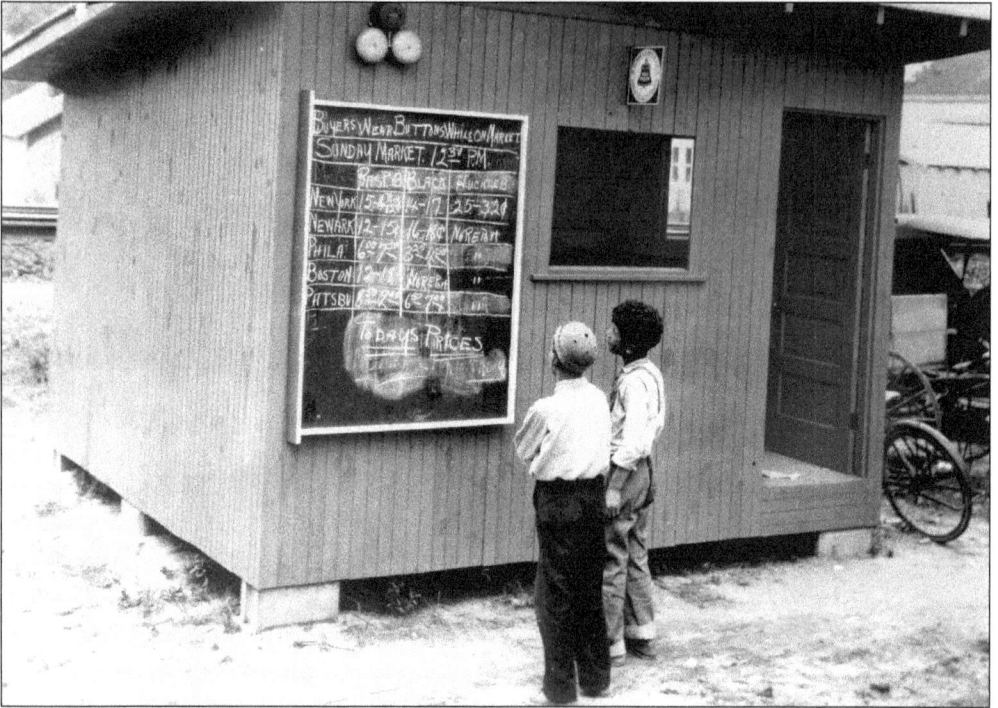

The chalkboard on the office at the Hammonton Municipal Market showed the day's prices for raspberries, blackberries, and huckleberries in New York City, Newark, Philadelphia, Boston, and Pittsburgh. A reminder posted at the top of the board said, "Buyers wear buttons while on market." (Courtesy of John DeLucca.)

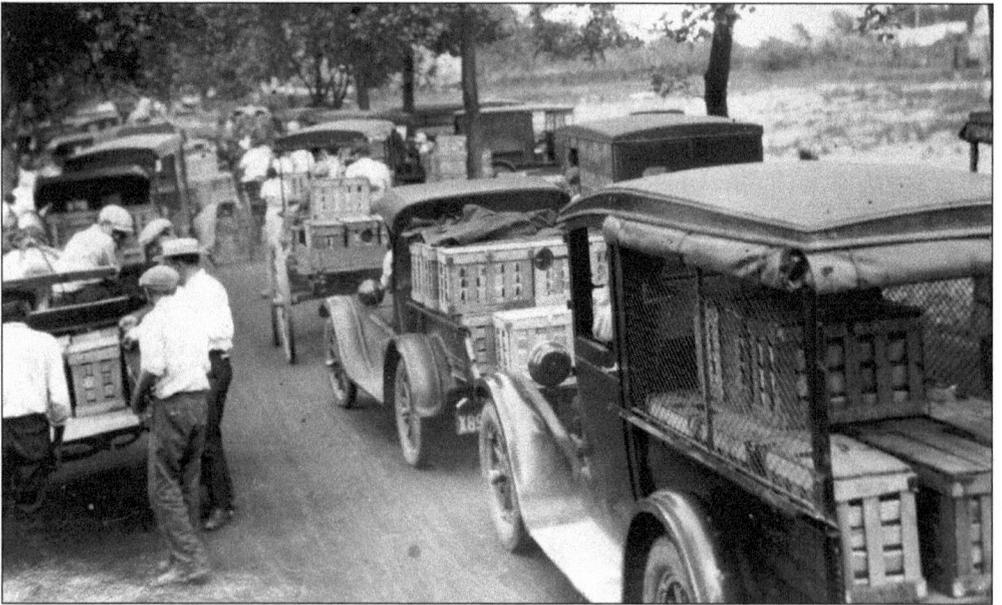

Trucks filled with produce line West End Avenue and wait for their turn at auction. The trees planted along both sides of the street provided shade for farmers, who spent the time catching up with each other about the events of the day. (Courtesy of John DeLucca.)

The Hammonton Grain Company was part of the agricultural scene of the 1930s. Local sign painter Domenic Pitera created this sign for the company, which specialized in the sale of Beacon Feeds, a particular brand of grain. (Courtesy of Grayce Pitera.)

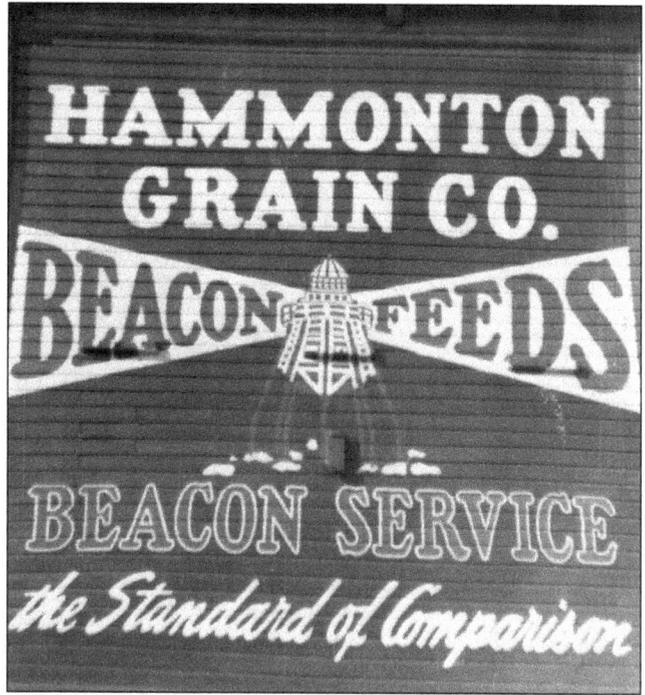

HAMMONTON GRAIN CO.

BEACON FEEDS

BEACON SERVICE

the Standard of Comparison

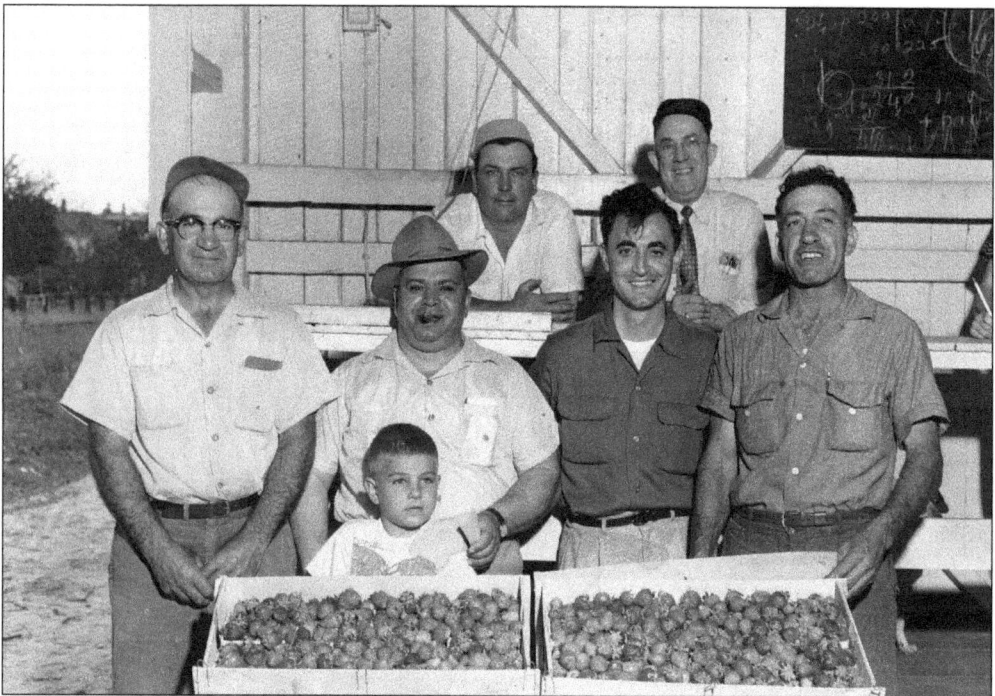

Each year at the fruit cooperative on West End Avenue, the first two crates of strawberries were auctioned off for charity. Pictured behind those two crates are, from left to right, the following: (front row) Anthony "Spitz" Tomasello, John "Shoes" DeMarco (standing behind an unidentified boy), Sam Cappuccio, and Angelo "Skipper" LaManna; (back row) Melvin Sickler and Harold Yehl. (Courtesy of Sharon Franchetti.)

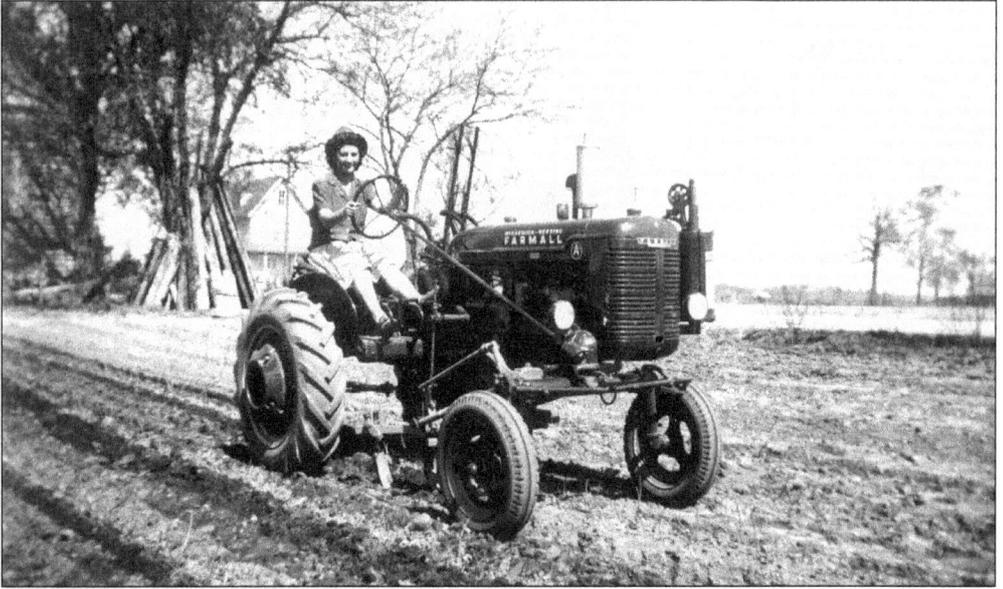

Kathryn Presti sits on a Farmall tractor in 1956. Equipment like this was indispensable on the Hammonton farms of the early 20th century. (Courtesy of Joseph Presti.)

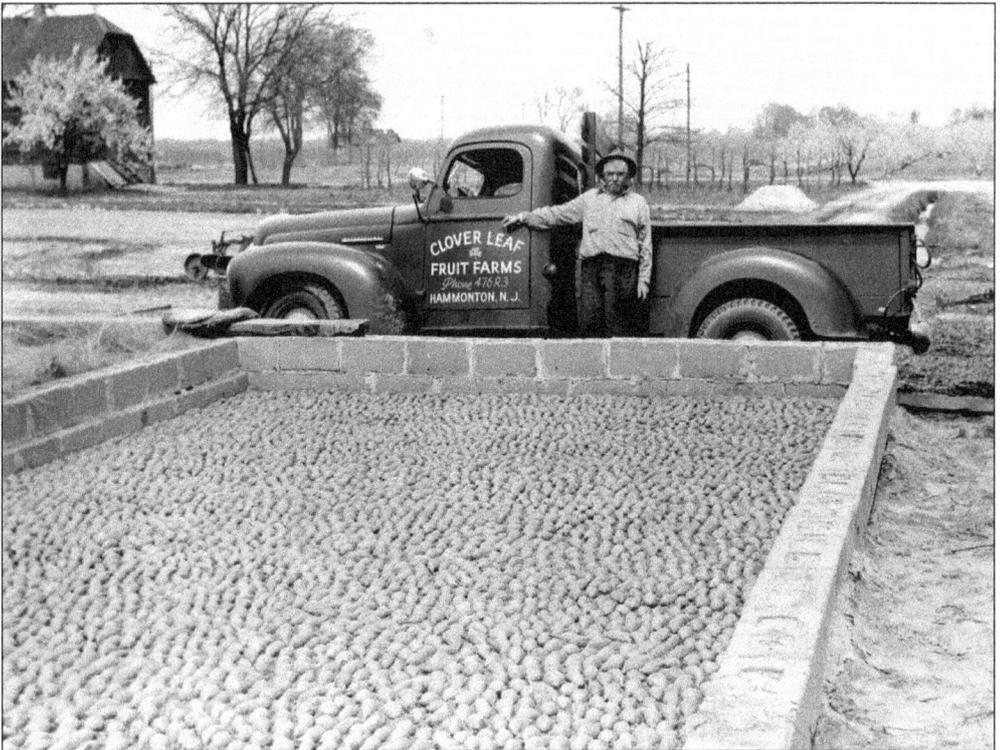

Gaetano Presti owned Clover Leaf Fruit Farms. He is surveying a sweet potato hotbed. Sweet potatoes have long been an excellent local crop and have been one of the most consistent parts of local agriculture for decades. (Courtesy of Joseph Presti.)

Four

BUSINESS AND INDUSTRY

The garment industry that once dominated the local landscape has all but vanished. By the early years of the 21st century, three local tailor shops downtown were all that remained of more than a dozen clothing factories that had employed thousands of workers.

Their names were well known once. Hammonton Park Clothes, owned by William B. Kessler, was the largest. Others—such as the Crown Pants Company, the Aggressive Coat Company, or the Modern Clothing Company—were thriving by the mid-20th century and had completely vanished 50 years later.

The Osgood Shoe Company predated the other clothing factories. It was founded by Charles Osgood, who learned the trade in New England.

Although it has vanished, the local clothing industry left an indelible mark on the community and its character. So many of the immigrants to Hammonton, predominantly Italian and Hispanic, sought refuge from the hot work in the fields and became seamstresses and tailors in the factories.

Hammonton's main business pulse did not lie solely in the larger industries, such as clothing and pharmaceuticals. Residents felt the personal touch of hundreds of locally owned businesses that became longstanding institutions.

The town's main street was home to many of these businesses, places where the owner was behind the counter and had plenty of time to converse and interact with the customers and catch up on local news, on every level. That sense of dedication to the community has remained with many local businesses to the present day, retaining and reinforcing Hammonton's strong sense of character and place.

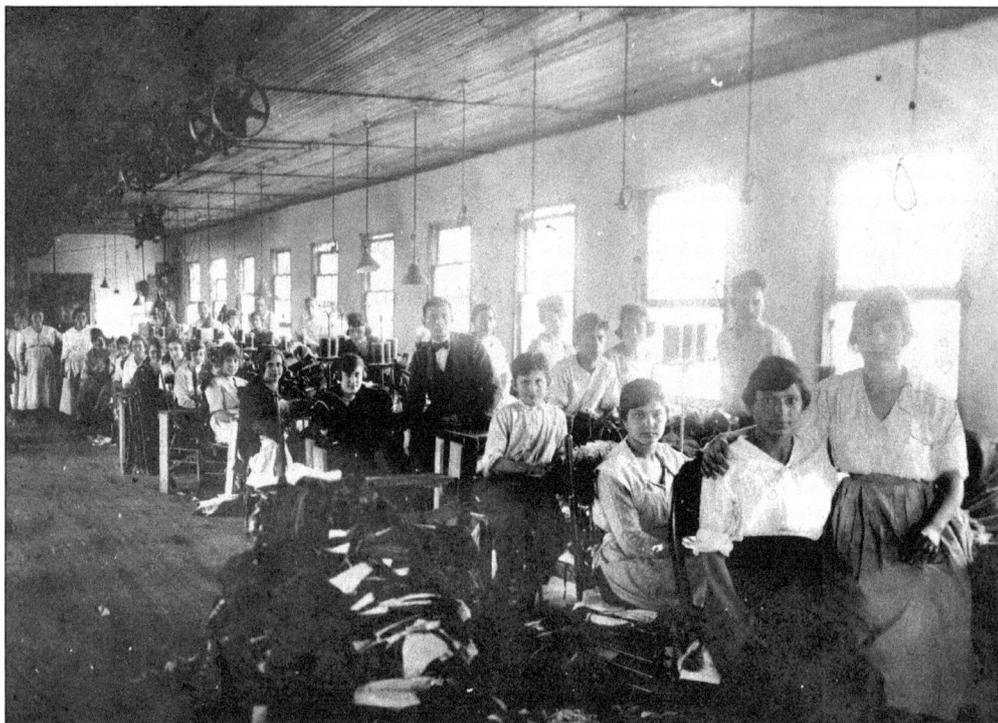

Workers at the Hammonton Shoe Company stop for a brief break in the early 1900s. Osgood's factory was notable for its three-story brick building, one of the largest in town, and its large windows, which provided ample sunlight and ventilation for factory workers. (Courtesy of George Cappuccio.)

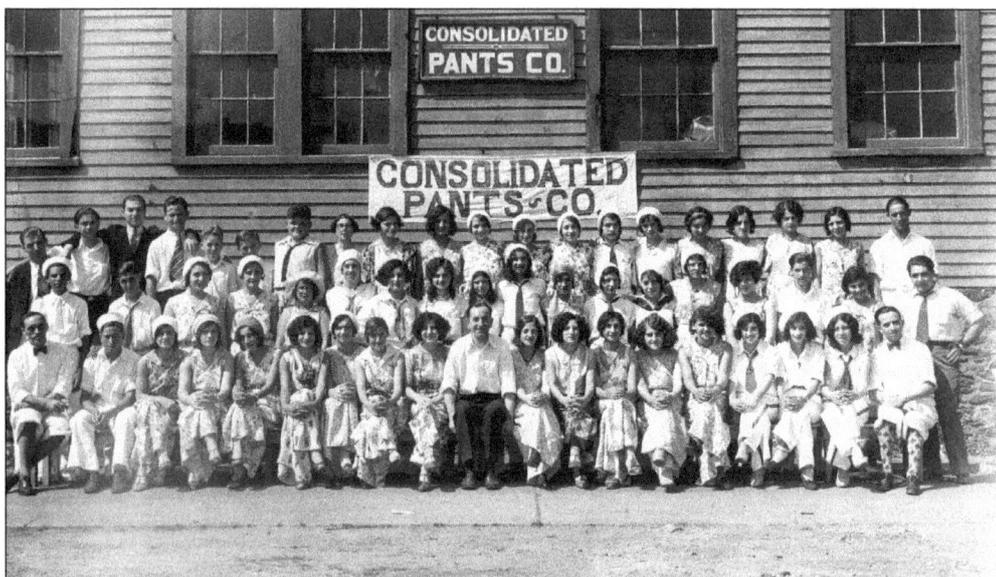

Without women, there would not be any clothing industry in Hammonton, as this picture of Consolidated Pants Company workers shows. Seamstresses expertly created some of the finest garments, many of which were shipped to New York and other cities and sold in the best stores. (Courtesy of Joseph Giralo.)

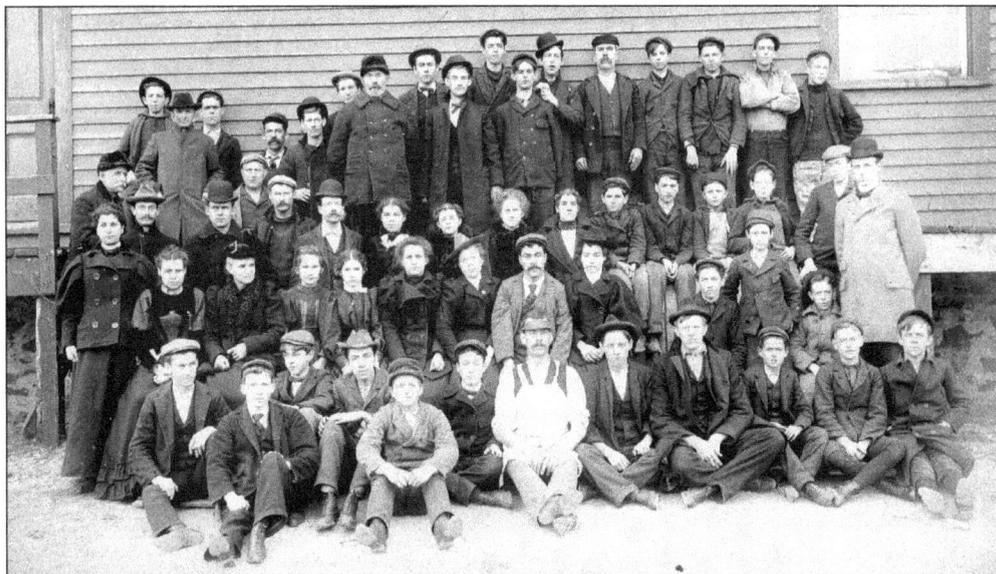

Employees of the Osgood-Smith Shoe Factory are pictured *c.* 1898. From left to right are the following: (first row) Cal Mathis, Tom Twomey, Hal Harley, Charles Link, Harry Wills, James Gerstenfeld, Charlie Coombs, Harry Thomas, Bert Beverage, Nick Currey, Frank Wetherbee, and Bert Warner; (second row) Elizabeth Coast, Lizzie Seeley, ? Bradbury, ? Roller, ? Finberg, ? Roller, Sarah Henshaw, Sam Gerstenfeld, Maggie Greford, Will Carson, Alex Wetherbee, and unidentified; (third row) Frank Thomas, Len Davis, John Galigor, Howard Sooy, John "Roddy" Naylor, Bob Goff, ? Warner, Emma Henshaw, Mamie Hetzer Ruderow, Lana Spyes, ? Roller, unidentified, Arty Werner, Ed Reeves, George Link, and Hulbert Tomlin; (fourth row) Fritz Eiker, Nick Mick, George Rehmann, Louie Spyes, Raymond Wild, unidentified, ? Poyer, Julius Rehmann, George Spyes, Chris Rehmann, John Jenison, unidentified, Harry Carson, Fred Warner, unidentified, Bill Mick, and Dewitt Morris. (Courtesy of the Hammonton Historical Society.)

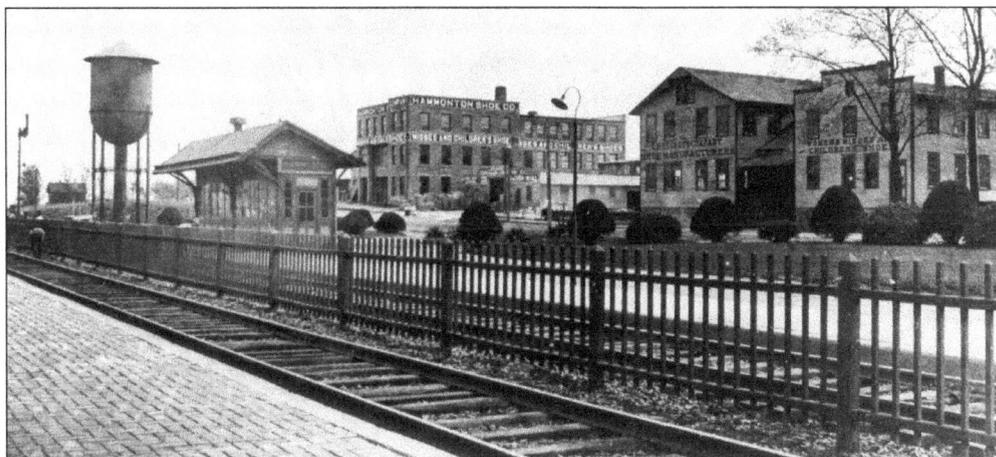

Front Street in Hammonton had a much different look in the first half of the 20th century. Shoe manufacturing was a major industry locally. The large building on the left was the Hammonton Shoe Company. C.F. Osgood Shoe Manufacturers occupied the two buildings on the right. According to the sign on the front of the building on the far right, "Womens Misses and Childrens Shoes" were made there. (Courtesy of Joseph Giralo.)

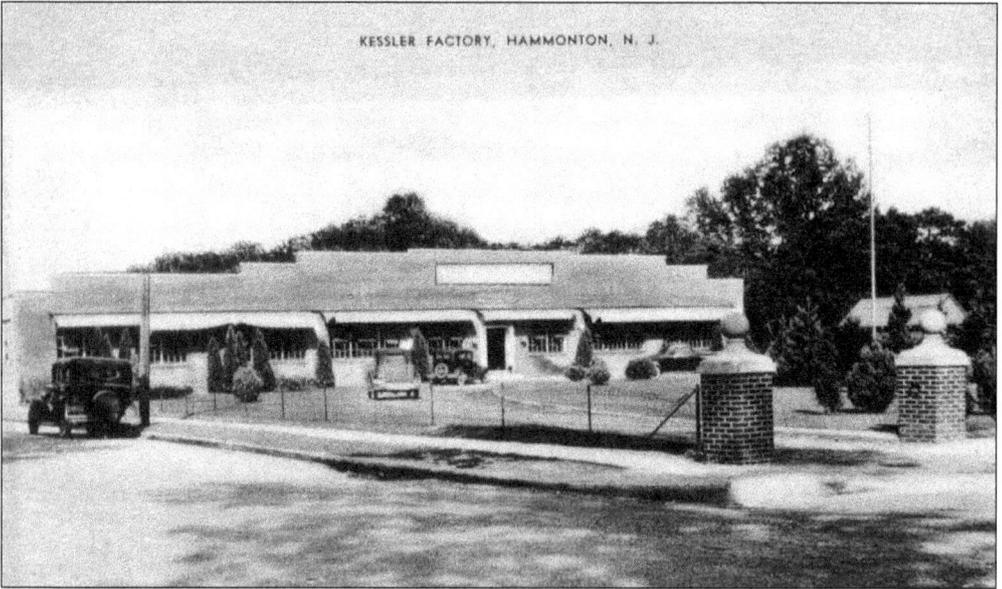

KESSLER FACTORY, HAMMONTON, N. J.

William B. Kessler's Clothing Factory, on the corner of Pleasant and Tilton Streets, is shown in the 1920s. A large addition was later built onto the factory, which eventually became one of the town's largest employers. Botany 500, Calvert, and Hammonton Park Clothes were three of the brands of men's suits manufactured at the location. The suits gained international fame because of their quality. (Courtesy of Dorothy Orlandini.)

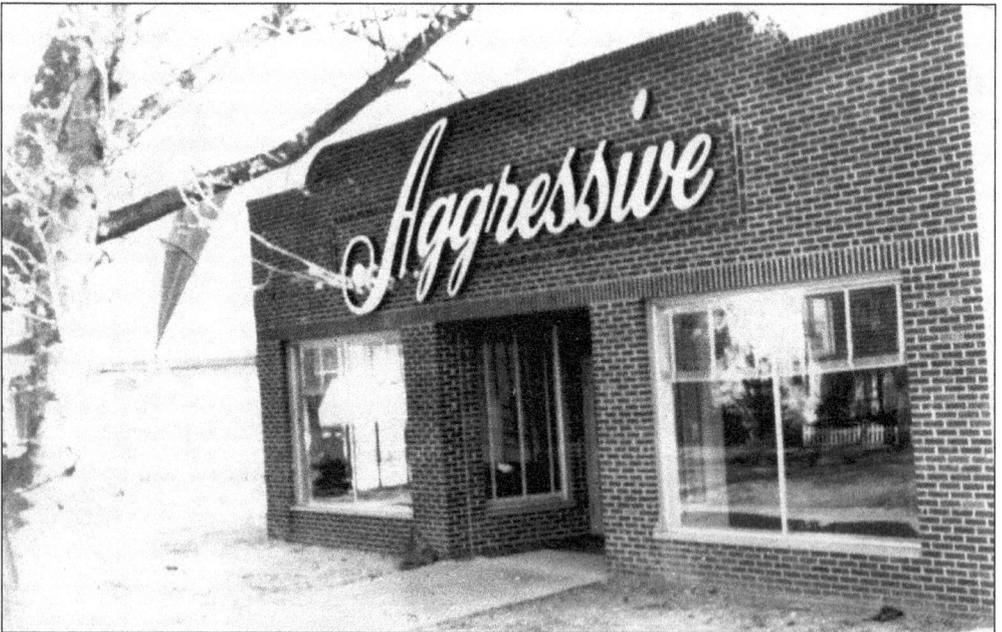

The Aggressive Clothing Factory was located on Washington Street. Aggressive was known for its well-made line of coats. (Courtesy of Grayce Pitera.)

Machise's Express Company was located on Egg Harbor Road. The company specialized in the transportation of fuel oil. (Courtesy of Grayce Pitera.)

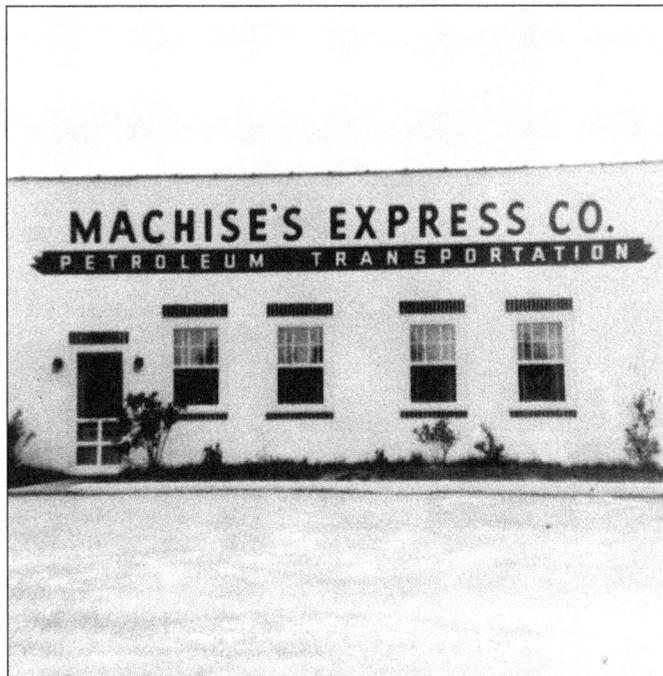

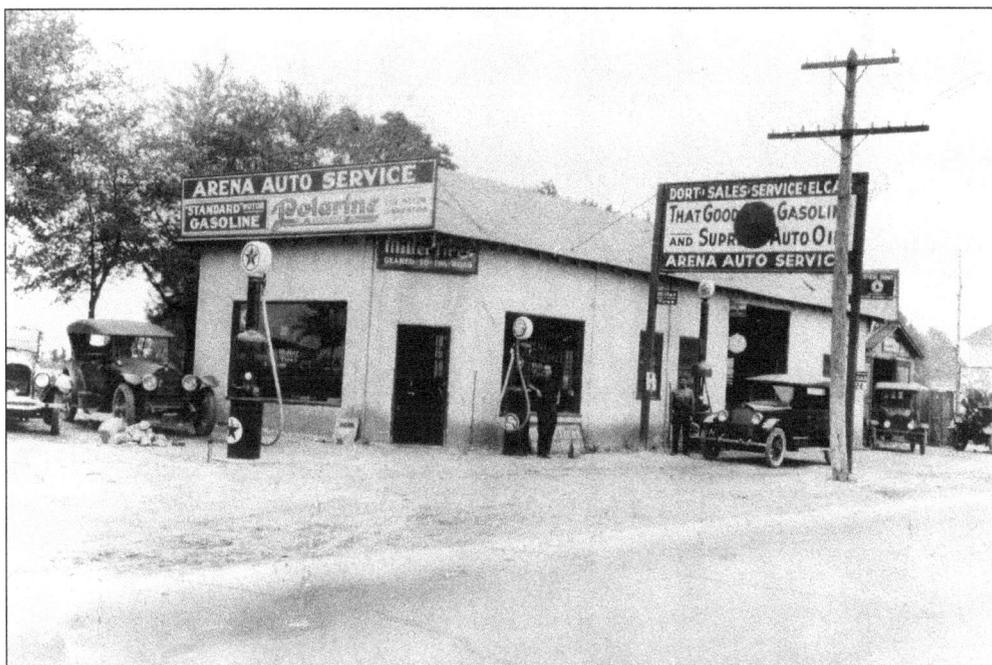

Arena Auto Service was established c. 1920. This photograph was taken c. 1925. Edwin Kingenberg (left) and Salvatore "Bill" Arena are pictured in front of the original home of Arena Automobiles on the White Horse Pike. (Courtesy of Arena Automobiles.)

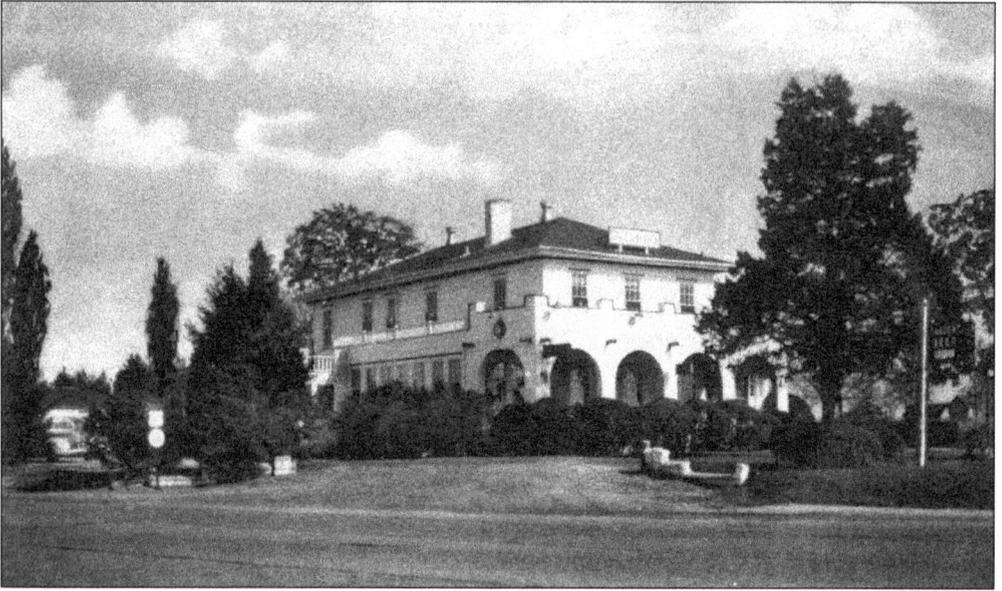

A Spanish Mission–styled restaurant known as the Cedars once stood at the intersection of the White Horse Pike and Route 206, then known as Trenton–New York Road. (Courtesy of Dorothy Orlandini.)

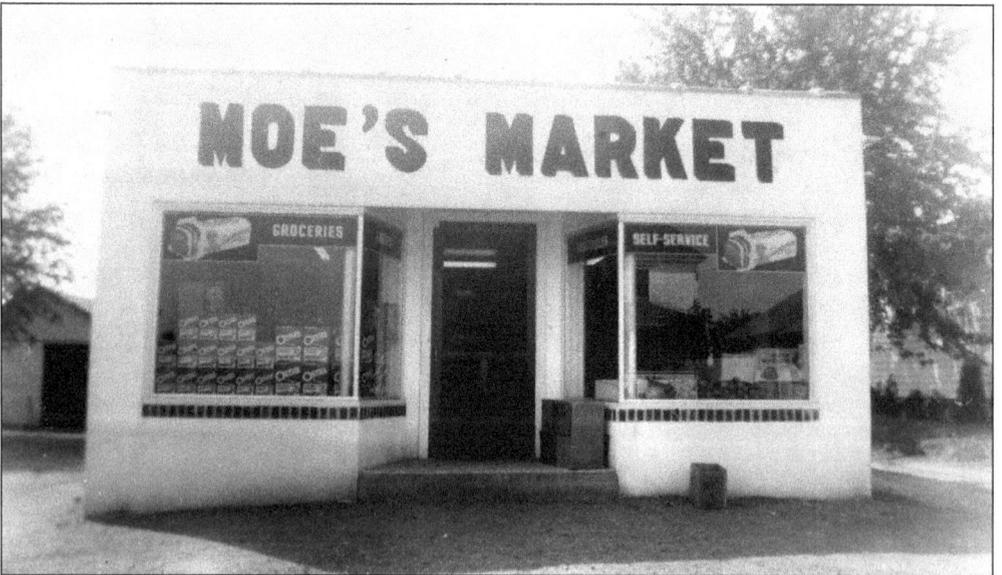

Moe and Louise Giambatista owned and operated Moe's Market on the White Horse Pike. The store, established in the 1950s, was a small, family-owned food market specializing in fresh-cut meats. The building still stands on the White Horse Pike. (Courtesy of Ginger Perri.)

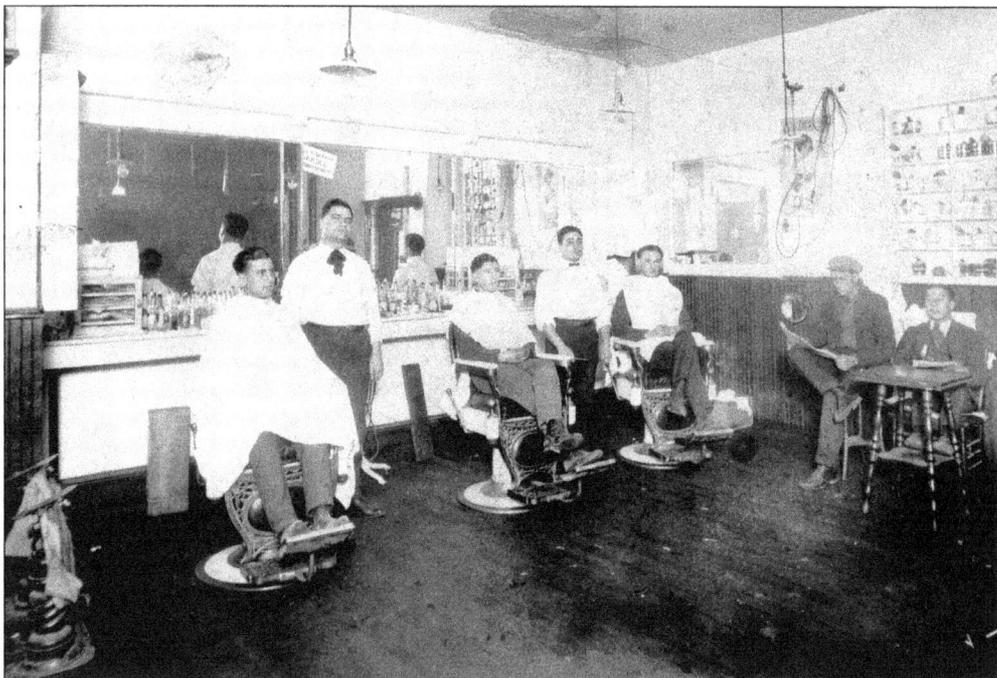

The interior of the Santomas Barber Shop is pictured in the early 1900s. There were three chairs, and people still waited for the expert Santomas cut. (Courtesy of Rita Benedetto.)

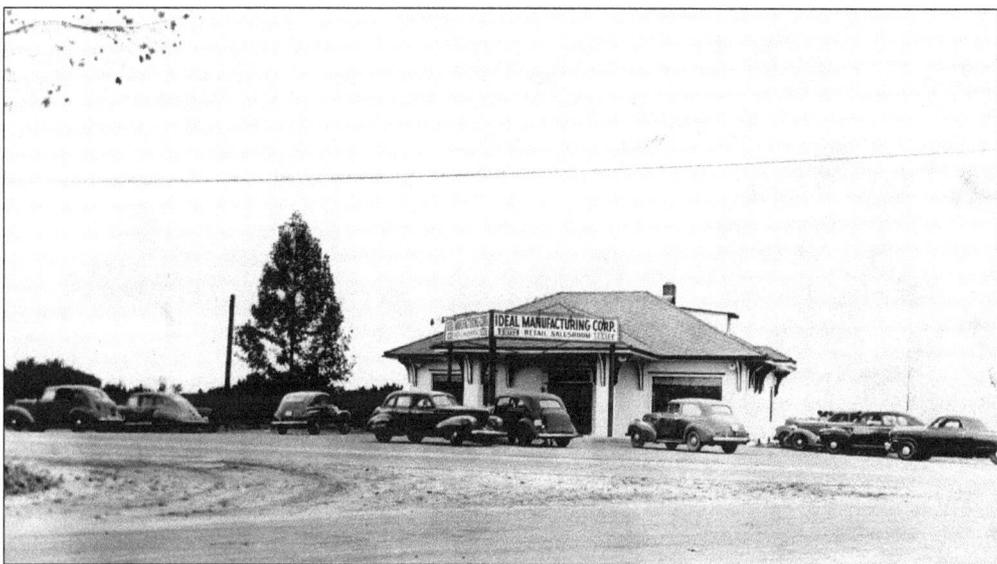

The Ideal Manufacturing Company was a smaller enterprise in the 1930s. Two large Quonset huts were later added to the original building, which began as a bus station on the White Horse Pike. (Courtesy of Augie Sorrentino.)

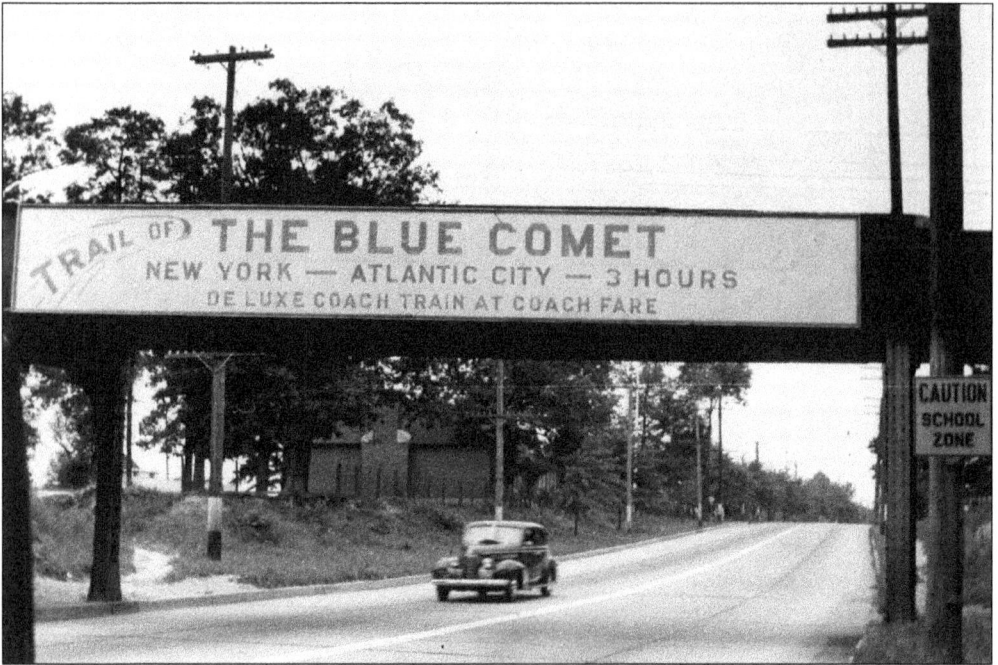

On the way into Hammonton, travelers on the White Horse Pike were reminded that the famed passenger train known as the *Blue Comet* traveled across this bridge and through downtown Hammonton. (Courtesy of Augie Sorrentino.)

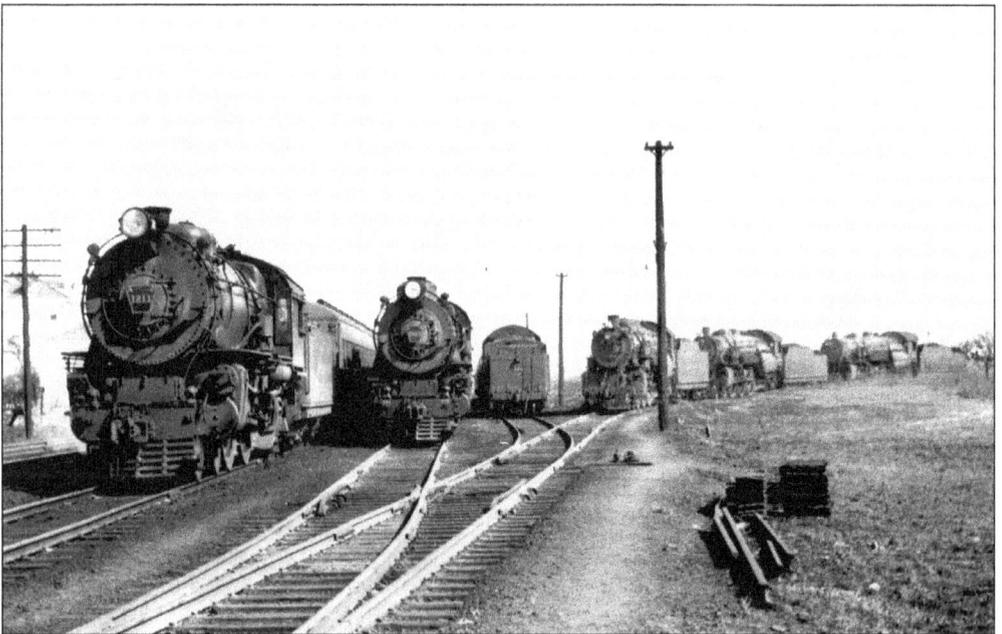

The rail yard of the Pennsylvania Railroad was located one block up from Egg Harbor Road. Large steam engines wait their turn in the yard, which saw heavy use in the early part of the 20th century. (Courtesy of Joseph Giralo.)

Hammonton Savings and Loan, the precursor to Empire Savings, was located on Bellevue Avenue in downtown Hammonton. It was one of two locally owned savings-and-loan institutions. The other, First Federal Savings, was located down the street. (Courtesy of Grayce Pitera.)

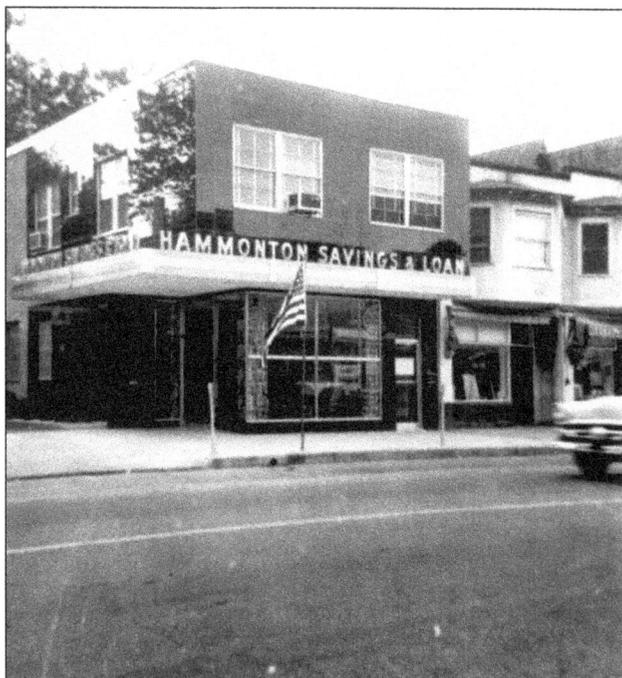

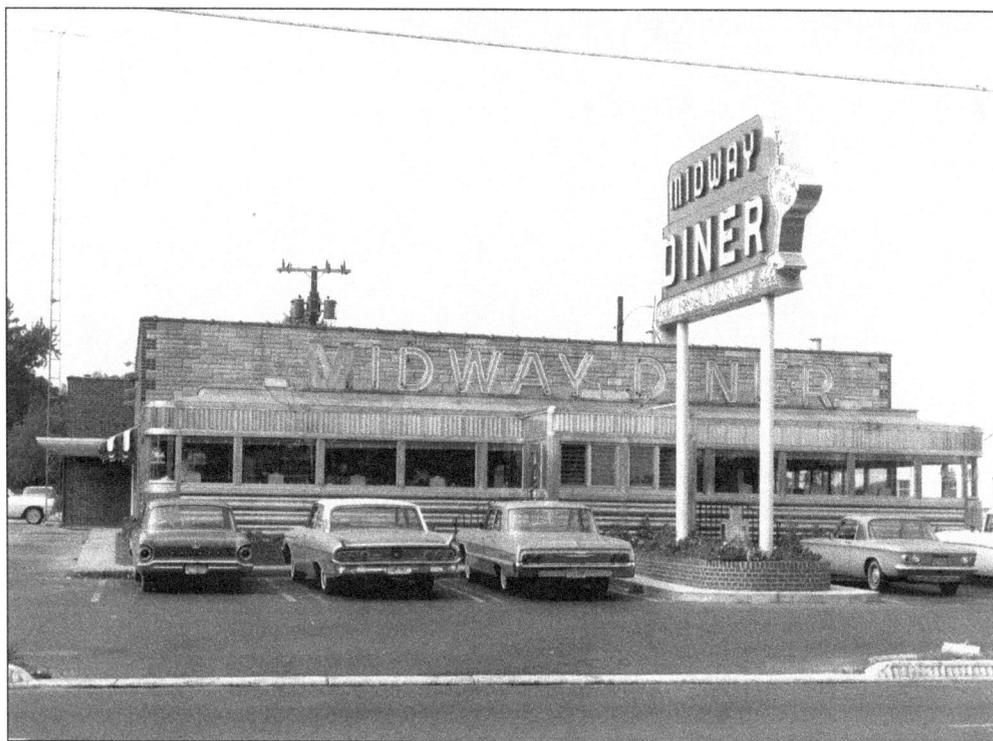

Midway Diner—aptly named because of Hammonton's location on the White Horse Pike, nearly halfway between Philadelphia and Atlantic City—was the archetypal American diner of the 1950s and 1960s. Its neon sign, with the champagne glass advertising the diner's cocktail lounge, was a classic. (Courtesy of Sharon Franchetti.)

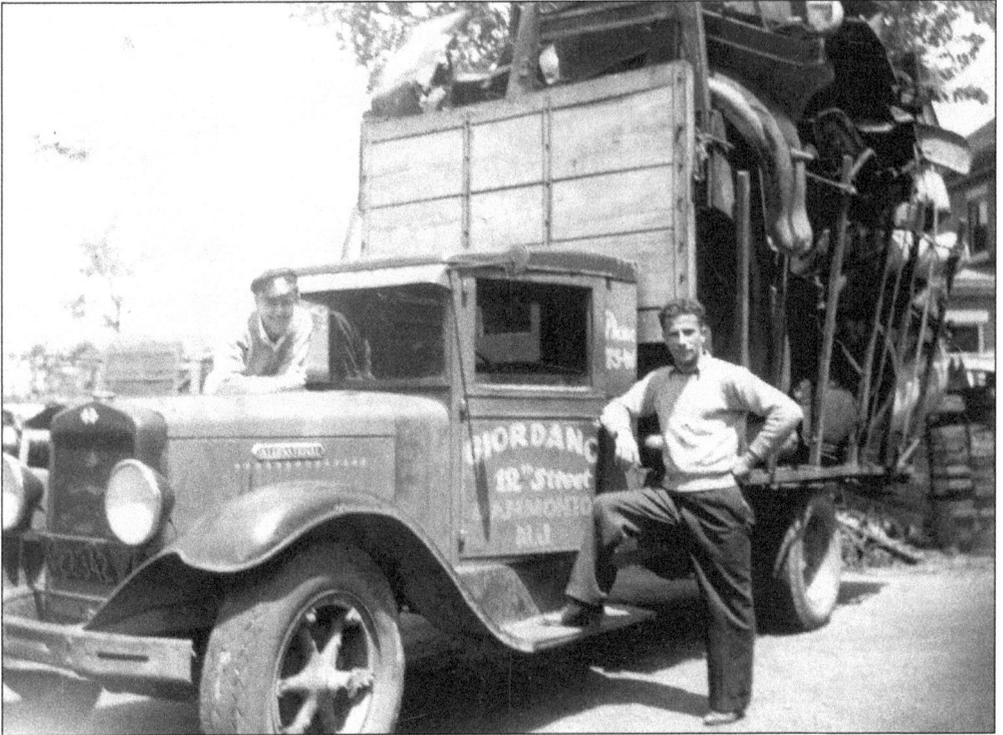

The Giordano family collected scrap and stored it on their 12th Street property. Pictured are Jack Giordano (right) and a worker. (Courtesy of Jack Donio.)

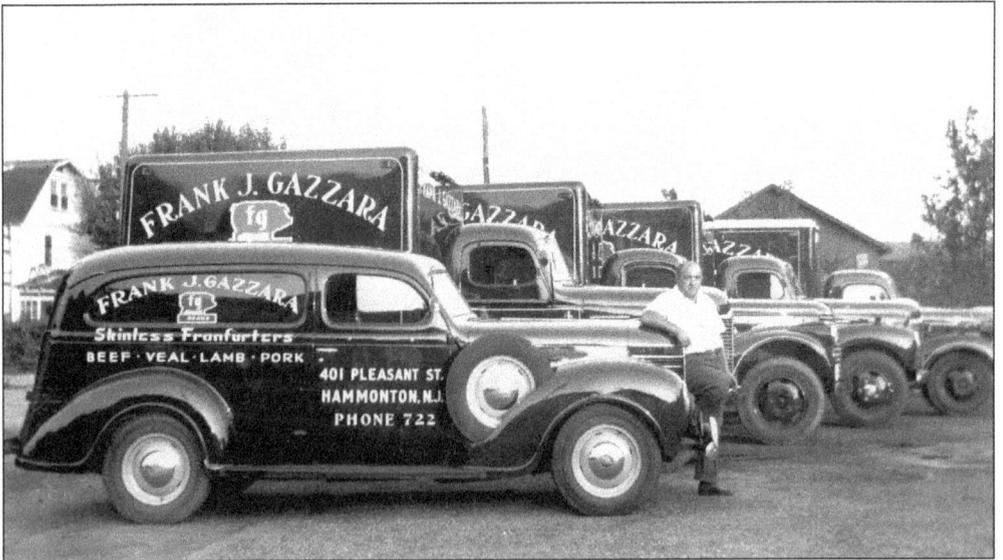

Frank Gazzara ran one of the most successful slaughterhouses in southern New Jersey. He was also well known for portraying Santa Claus each year in the town's Christmas parade. He is shown here with his fleet of trucks in the 1940s. (Courtesy of Frank Gazzara.)

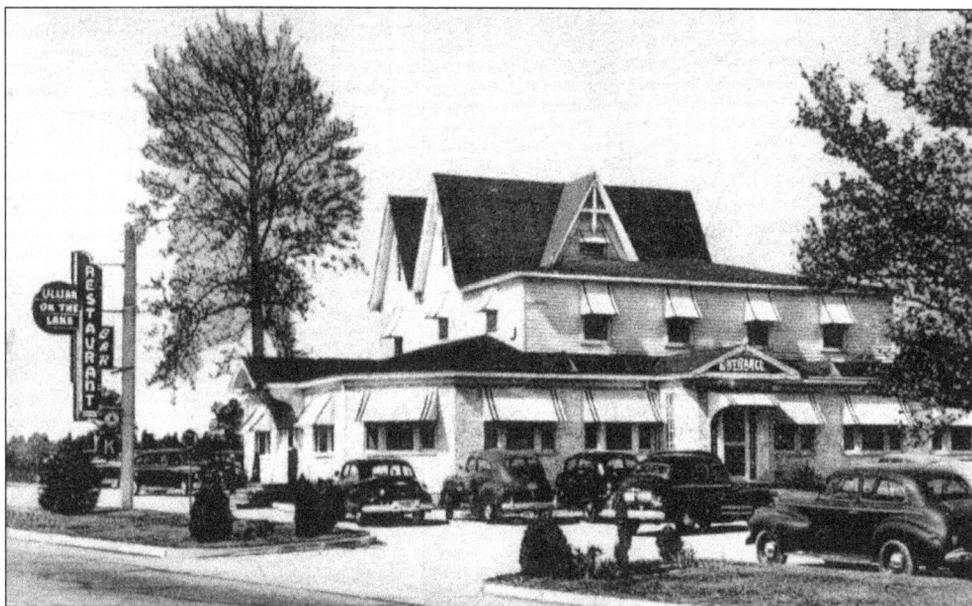

Many local gatherings, family dinners, and social evenings were spent at the Lillian on the Lake, a bar and restaurant that stood on the shores of the Hammonton Lake, across from the site of William B. Kessler Memorial Hospital. (Courtesy of Gina Rullo.)

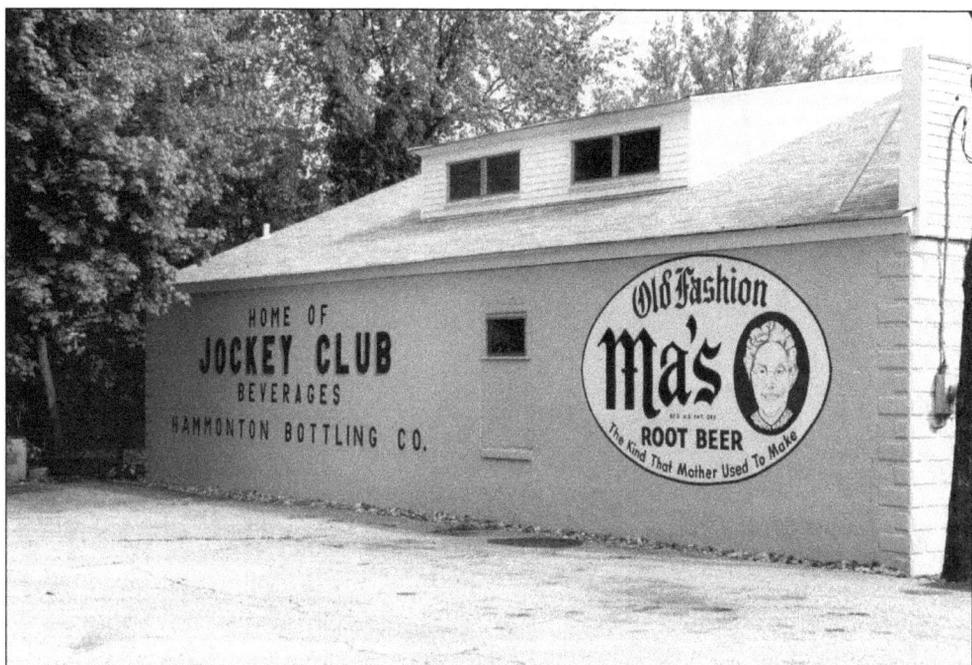

The painted advertising on the wall of the Hammonton Bottling Company has been a local landmark for decades. The bottling company, located on Orchard Street and owned and operated by the Farinelli family, sold Jockey Club Beverages and Old Fashion Ma's Root Beer, along with other favorites like black cherry soda, Dixie Cola, and Wake Up. (Courtesy of Carol and Reno Farinelli.)

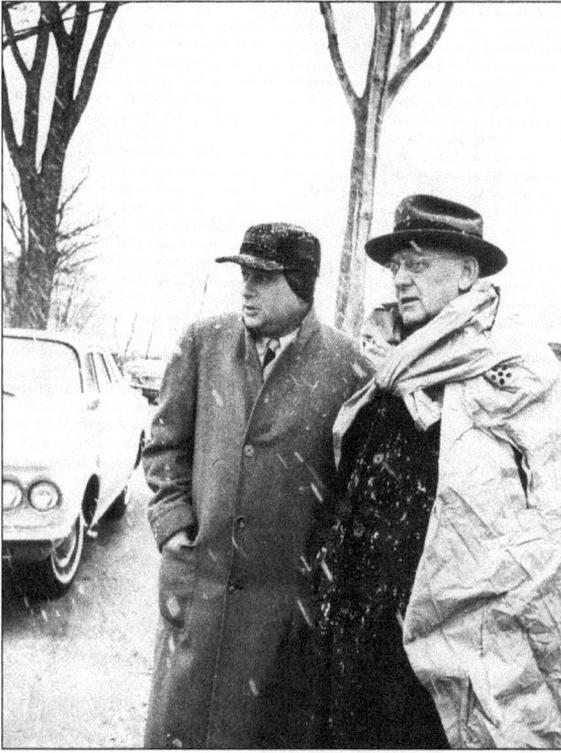

Richard Newman (left) and Michael L. Ruberton are pictured on the snowy groundbreaking day in 1962 for William B. Kessler Memorial Hospital, located on Central Avenue and the White Horse Pike (Route 30). The hospital opened in 1964. (Courtesy of William B. Kessler Memorial Hospital.)

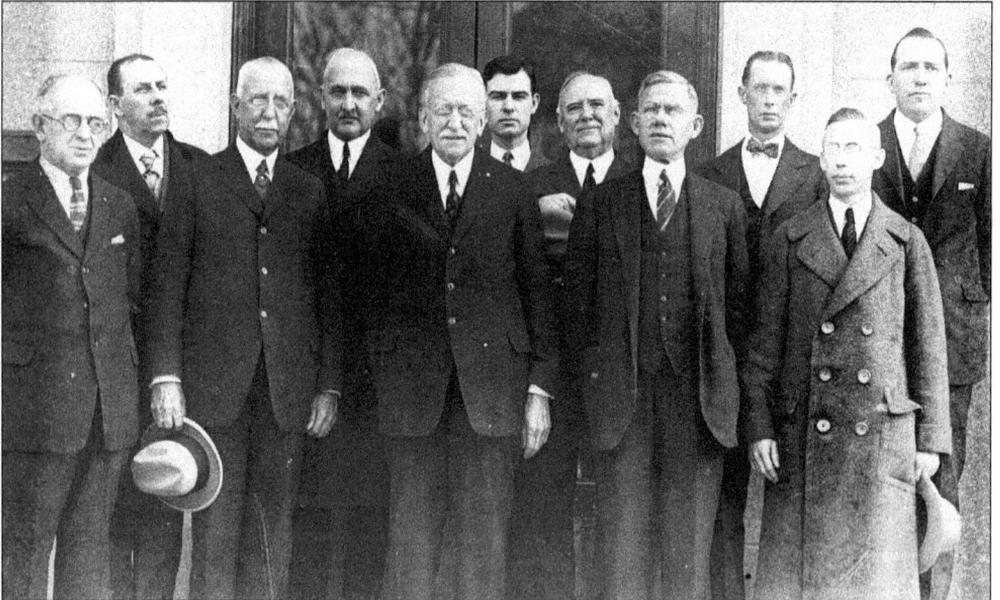

Members of the board of directors of the People's Bank and Trust Company pose in front of the bank building on Bellevue Avenue. This building was later donated to the town for use as a town hall when the bank built a new building. The photograph was taken between 1926 and 1930. From left to right are Laton M. Parkhurst, J.A. Waas, William J. Smith, Charles Fitting, Wilbur R. Tilton (cashier), George Collins (assistant cashier), William L. Black, John G. Galigne, W.E. Crane, William Doerfel, and George H. Eckhardt.

Five

EDUCATION AND GOVERNMENT

Local schools and government have a longstanding prominence in the social strata of Hammonton. As local institutions, they were the home of the ideas, dreams, aspirations, and goals of the entire community. The people who worked for the schools and town or ran for public office were held to a higher standard and expected to meet it.

The town council form of government and its public-friendly meetings were a holdover from the New England concept of direct democracy.

In the mid-1800s, when the original public schools were built in Hammonton, long before the days of the automobile, they were placed in the various sections of the town, closest to the rural populations that they served.

The rural schools had names that befit the one-room schoolhouses—for example, Oakdale, Rosedale, and Parkdale.

By the late 1800s, a more centralized location for the school district was sought. An eight-acre parcel of land bordered by Peach Street, Central Avenue, and Vine Street in the downtown area was selected. By 1925, there were three landmark structures on the site.

The original buildings of the St. Joseph's Roman Catholic schools were located on Third Street in Hammonton. The high school, originally founded as a seminary for members of the Pallottine Order, began admitting non-seminarians in 1939. In time, the school expanded, building a larger building in 1953.

In Hammonton, the schools, both public and Catholic, have always been seen as a center of community life, a source of civic pride, and the basis for legendary crosstown academic and sporting rivalries.

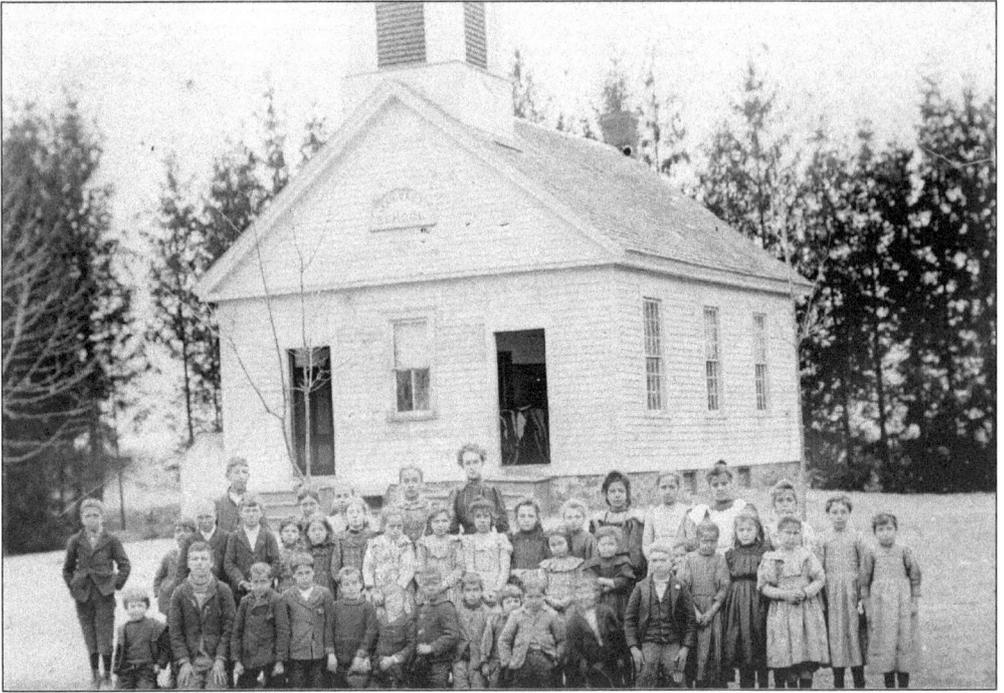

The Oakdale rural school was located on the White Horse Pike near Pine Road. Many local families from that area of town, including the D'Agostino family of Fairview Avenue, attended the school. The building was later razed to make way for the Capelli office building. (Courtesy of Pauline Sindone.)

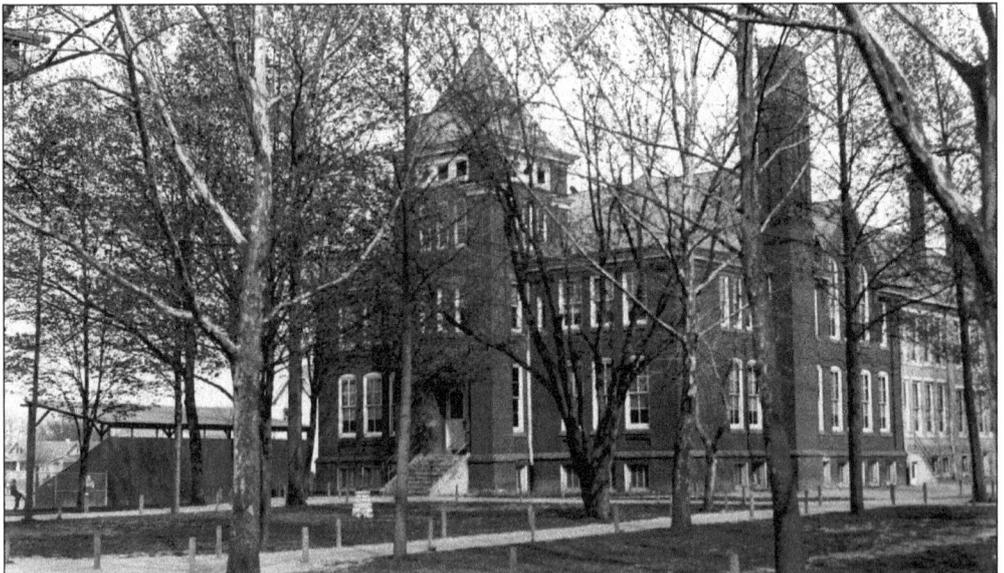

Hammonton Primary School is pictured sometime in the 1920s. The most distinctive feature of this structure is the tower. The building was demolished in the 1960s after years of disrepair, and a significant part of the town's architectural history was lost in the process. Note the covered wooden bleachers overlooking the ball fields next to the school building. (Courtesy of Josephine and Vincent Giannini.)

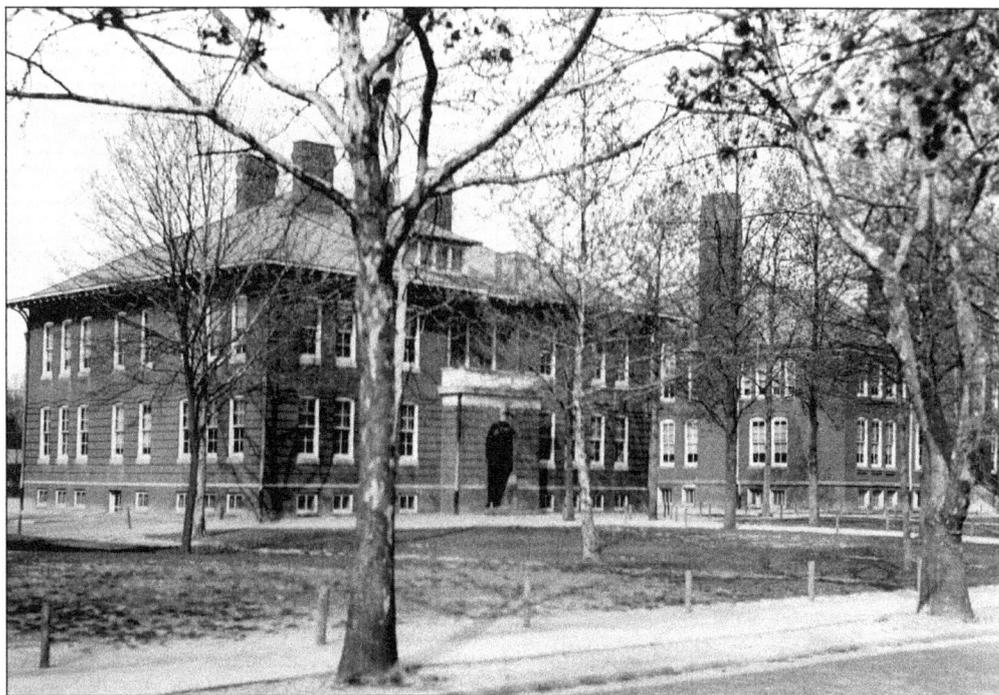

Another school building, echoing the architectural character of the building with the tower, was constructed in 1909. The building still stands between Vine and Peach Streets and was still in use as a public school building in 2002, nearly a century after it was built. (Courtesy of Josephine and Vincent Giannini.)

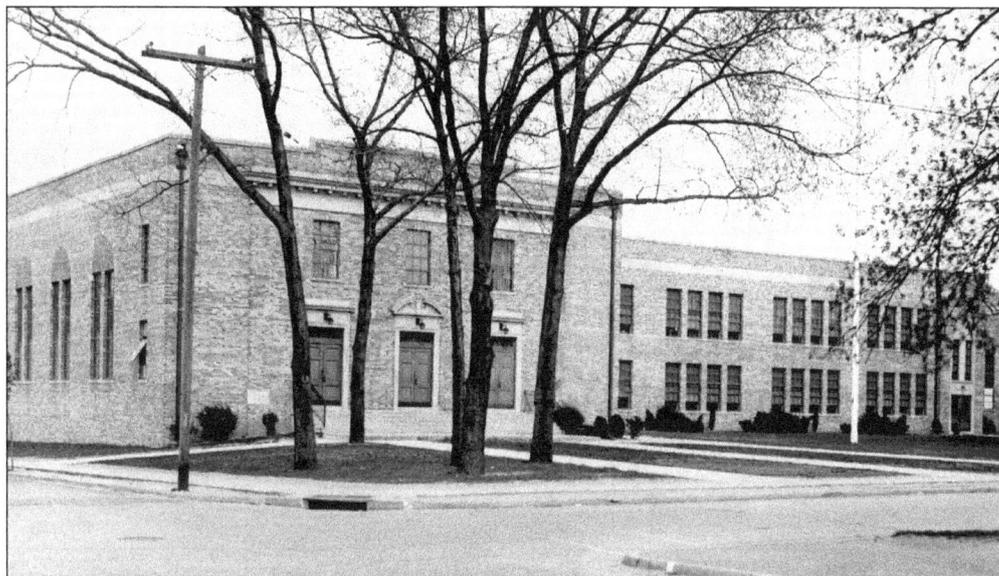

Built in 1925, Hammonton High School was almost brand new when this photograph was taken. High school students attended classes at the corner of Central Avenue and Vine Street for four decades, finally leaving the building for a new facility, built in 1966 on Liberty Street. The 1925 building was then used as a middle school. The high school moved again when a new facility was opened on Old Forks Road in 2002. (Courtesy of Josephine and Vincent Giannini.)

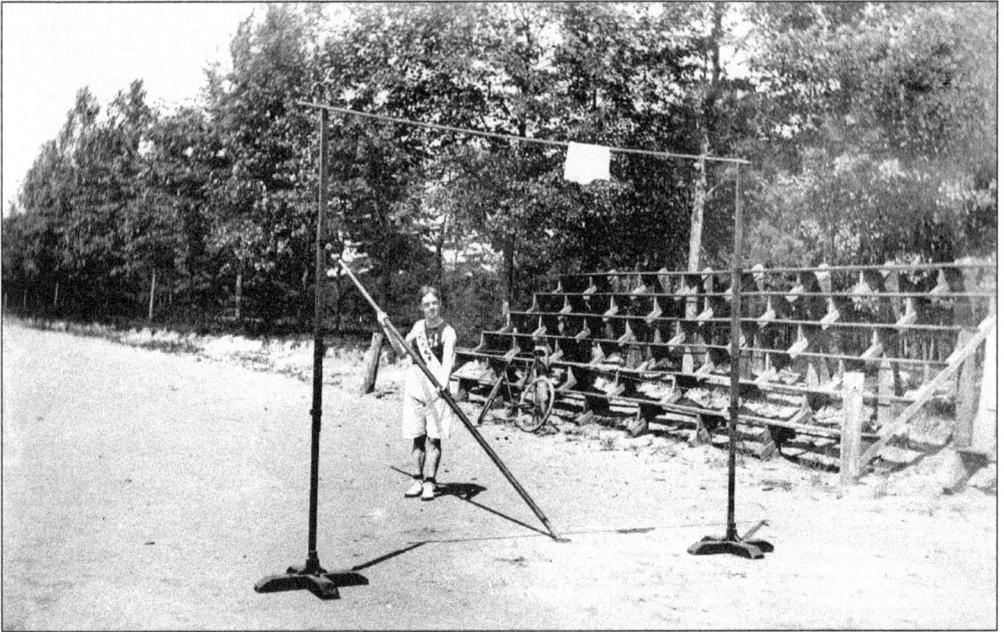

Gene Coggey poses before a pole vault attempt for Hammonton High School in 1907. The high school's athletic fields were located in the downtown, nestled behind the Methodist church on Bellevue Avenue, Vine Street (then known as Schoolhouse Lane), and Peach Street. (Courtesy of the Hammonton Historical Society.)

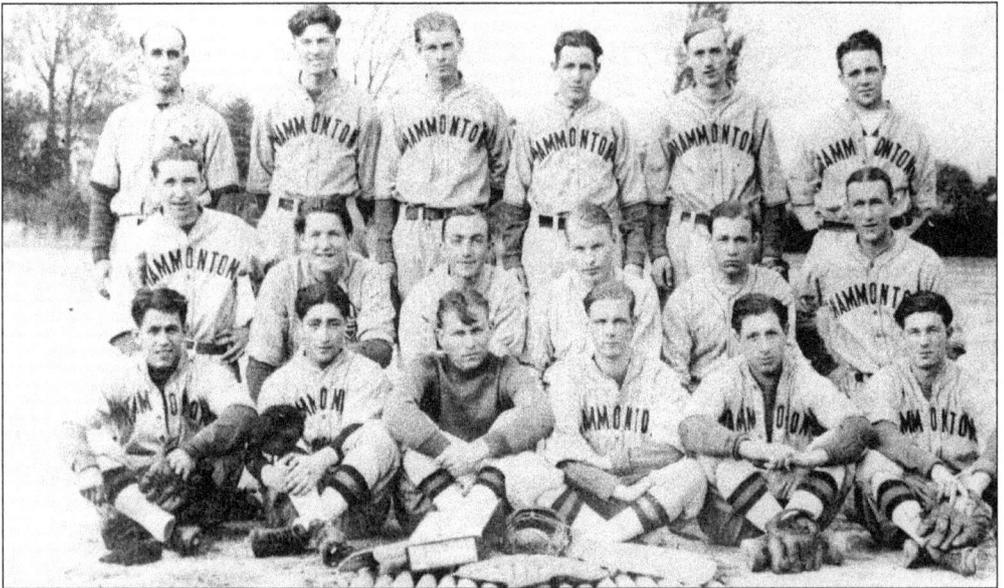

By the end of the 1929 season, the Hammonton High School varsity baseball team had won the South Jersey Championship. Pictured from left to right are the following: (front row) John Barbaccio, Dominic Perna, Charkes Aumack, Bill Wither, "Toots" Errera, and Edward Delessio; (middle row) Oscar Baker, George Rattinger, Walter Daminger, Warren E. "Buck" Sooy, Mike Iulliucci, and Tom Holland; (back row) coach Charles Sipley, Carmen "Mint" Fognano, Dan Wescoat, Dick Morgan, Charles Morgan, and Jack Heggan. (Courtesy of Augie Sorrentino.)

Play productions have been one of the highlights of the educational experience at the local schools. Shown is the cast of a play put on by Hammonton High School's Senior Players on February 9 and 10, 1951. (Courtesy of Joseph Giralo.)

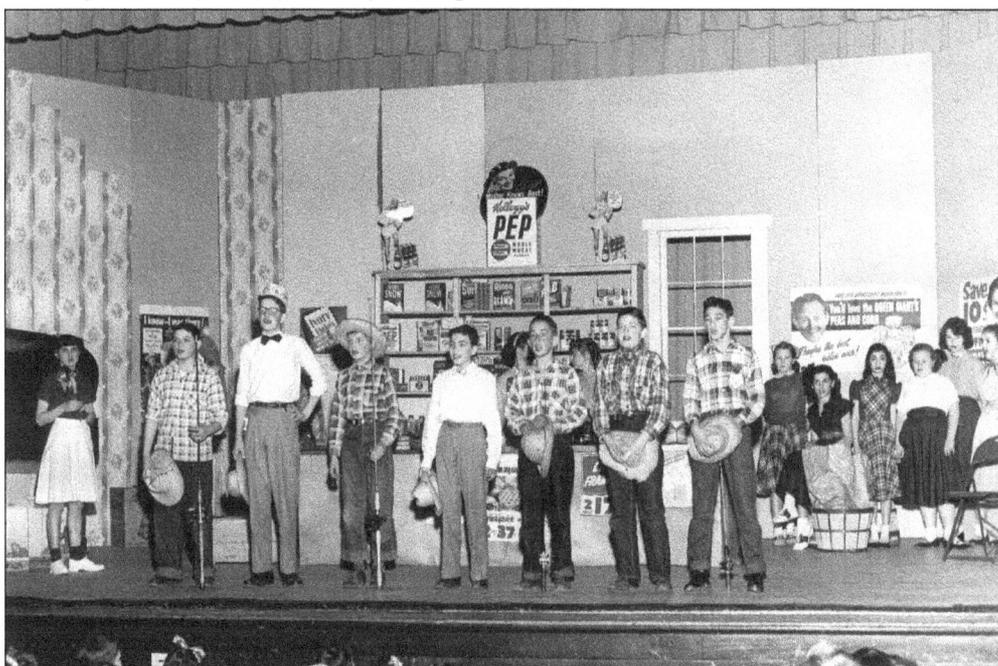

Another school play from the 1950s is pictured here. The stage is set to look like a market of the era. A sign on the back wall features Art Linkletter hawking Green Giant Peas and Corn, and boxes of Kellogg's Pep, Ivory Snow, Campbell's Soup, and Surf detergent are displayed. Now we know what moms were buying back then. (Courtesy of Donna Brown.)

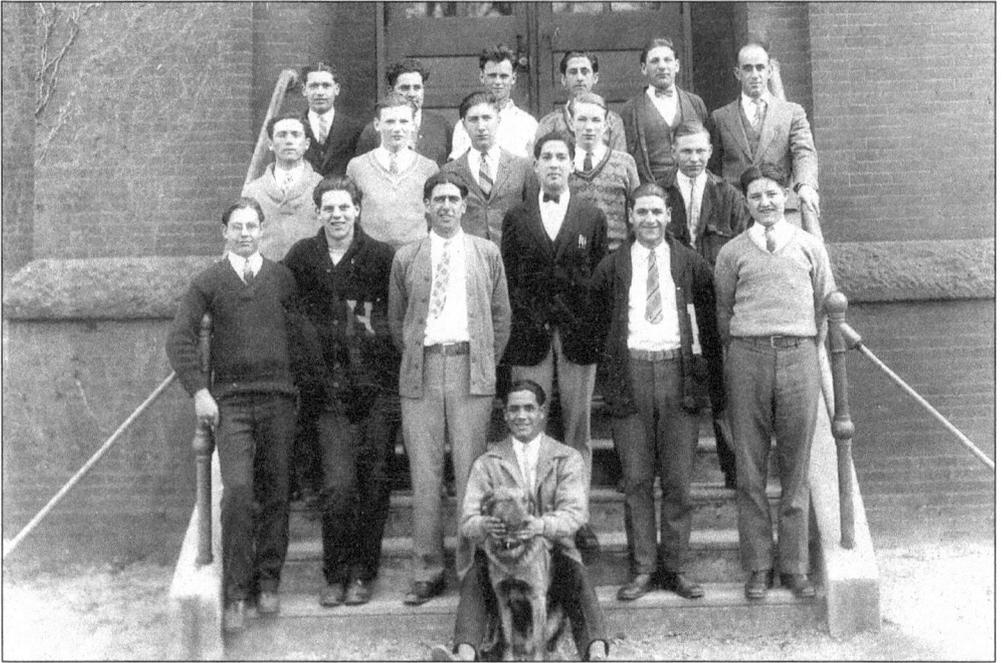

Members of a Hammonton High School class in the 1920s pose in front of the school, located between Vine and Peach Streets. The second boy from the left is wearing a letterman sweater typical of the era. (Courtesy of Augie Sorrentino.)

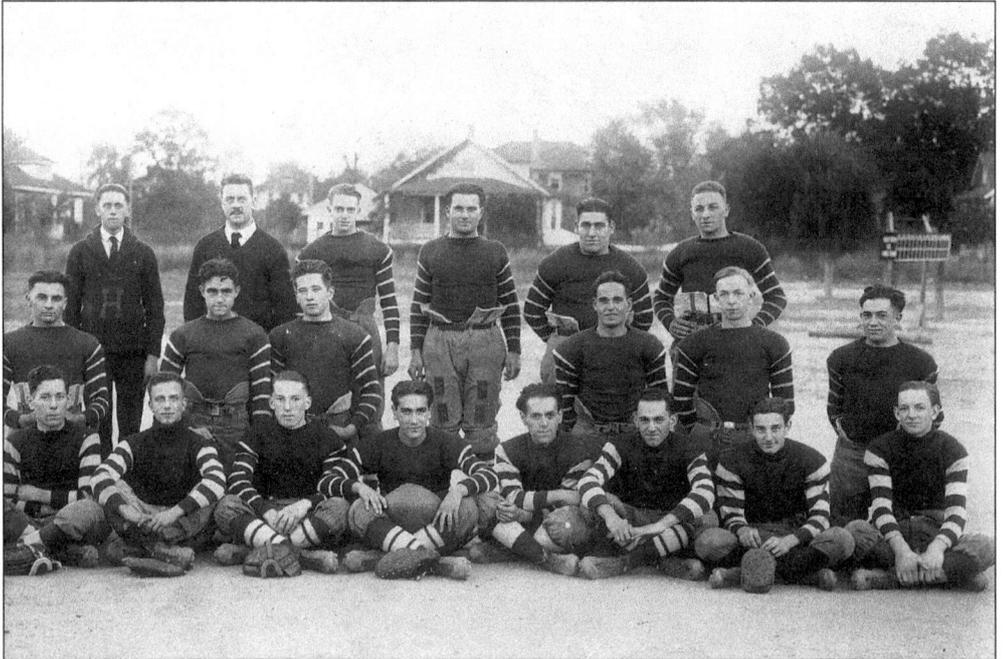

The 1923 Hammonton High School football team did not benefit from the padding and helmets worn by the players of later years. During this era, the ball was much larger, and there was very little passing. The team photograph was taken on the athletic field, located between Vine and Peach Streets. (Courtesy of Augie Sorrentino.)

It may be subtler, but freshman hazing still exists in one form or another. Still, it is nothing compared to what these poor students were put through in the 1950s and early 1960s. Jeanie Valentino (left) and Joseph Ingemi (right) made sure these two freshmen were thoroughly embarrassed. (Courtesy of Jack Donio.)

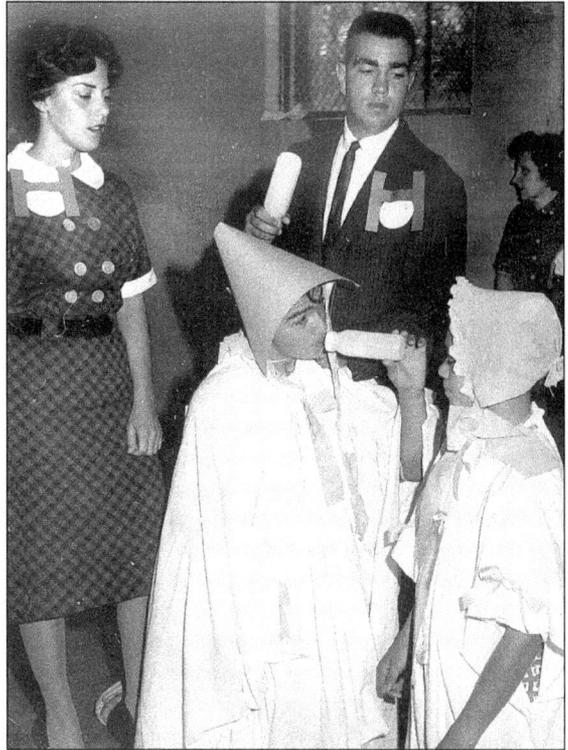

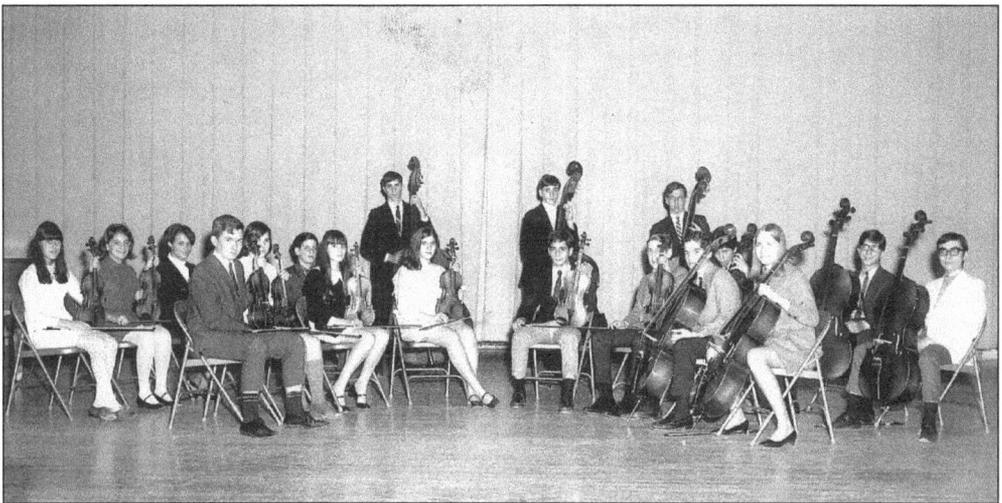

Hammonton's first and only string orchestra holds a performance. The orchestra was cut by the school district due to lack of funding. The instruments, which were rented, were returned. (Courtesy of Rose Rita and Anthony Guerere.)

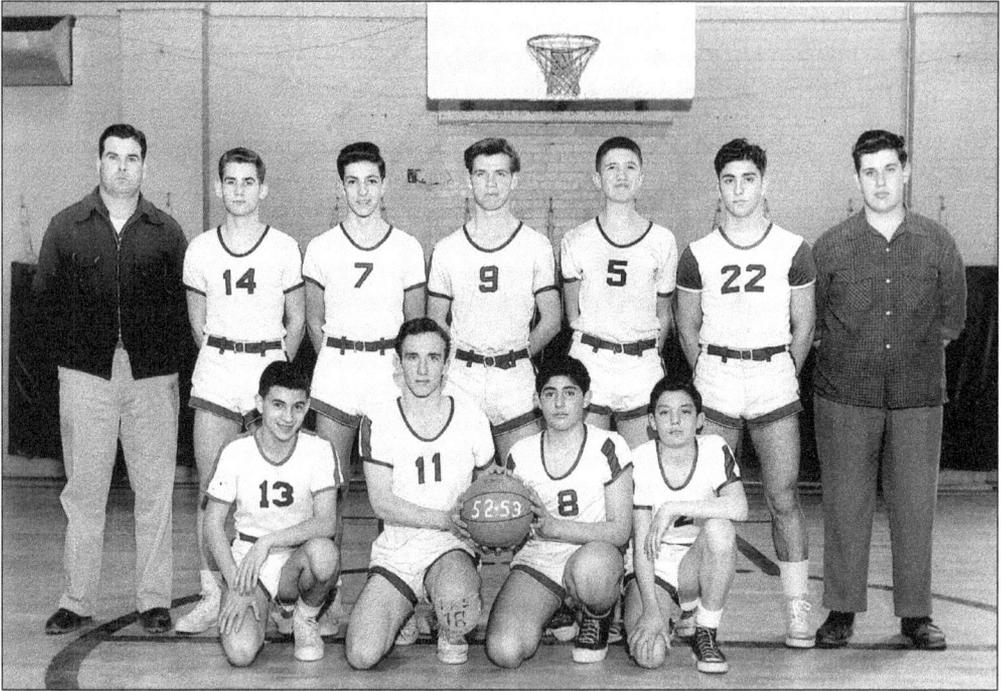

Hammonton High School's junior varsity basketball team was one of many teams that played in the gymnasium on Central Avenue and Vine Street. From left to right are the following: (front row) Anthony Guerere, Carl Lewis, Pat Colasurdo, and Gene Vitale; (back row) unidentified, Ronald Katy, Charles Gazzara, Bob Gregel, Albert DeLaurentis, Anthony "Nuncie" Sacco, and Jack Carino. (Courtesy of Rose Rita and Anthony Guerere.)

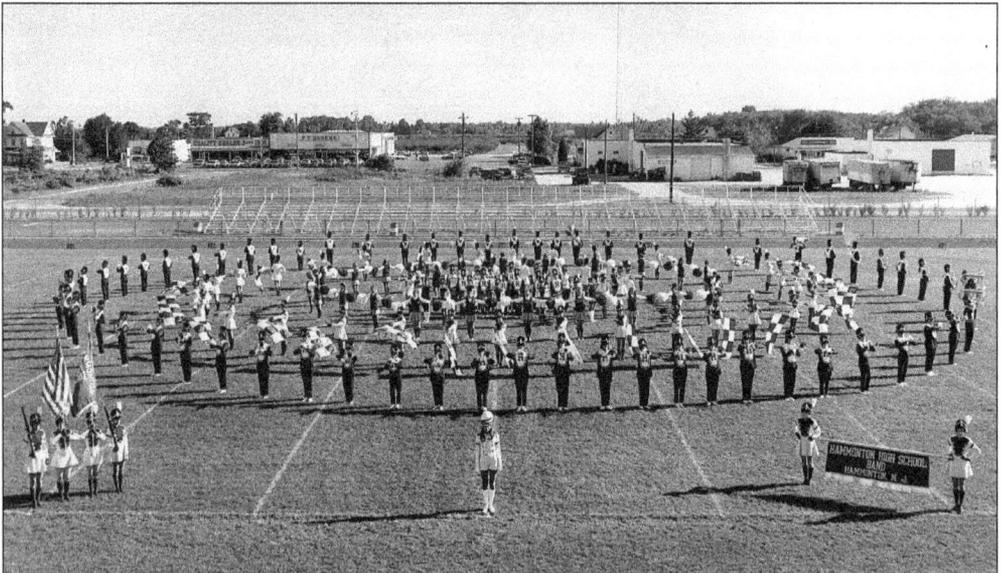

The 1973 Blue Devil Marching Band was typical of its era, with nearly 200 members moving in dramatic formation on the Hammonton football field. Nearly 25 percent of the total school population joined the band in some capacity from the late 1960s until the 1980s. (Courtesy of Rose Rita and Anthony Guerere.)

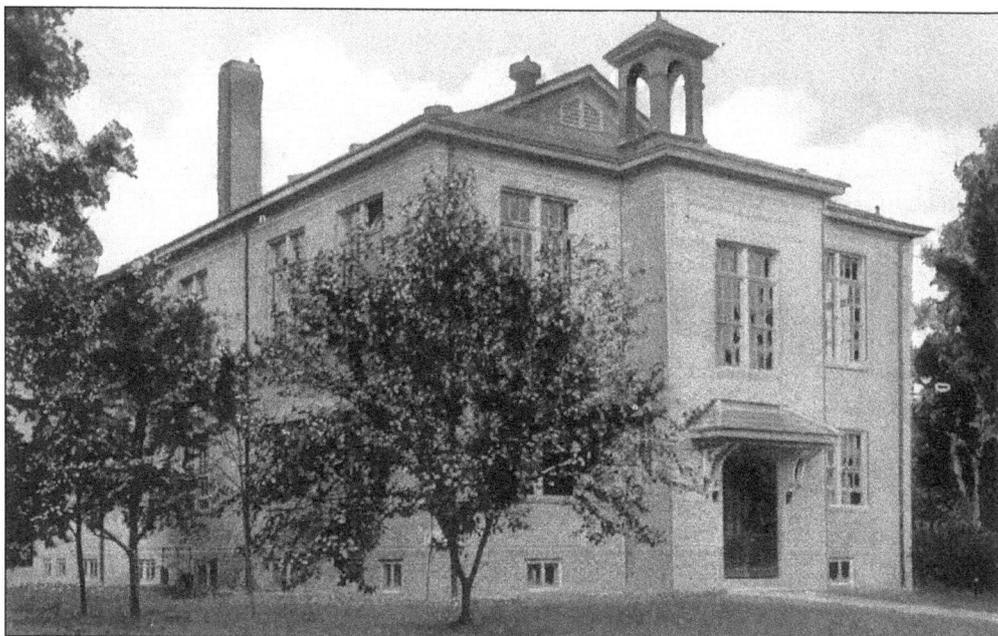

St. Joseph's Roman Catholic School was much smaller in the 1930s and 1940s. This building was incorporated into the design of a larger building that was constructed in 1953. Children were still being taught in its classrooms in the early 21st century. (Courtesy of Dorothy Orlandini.)

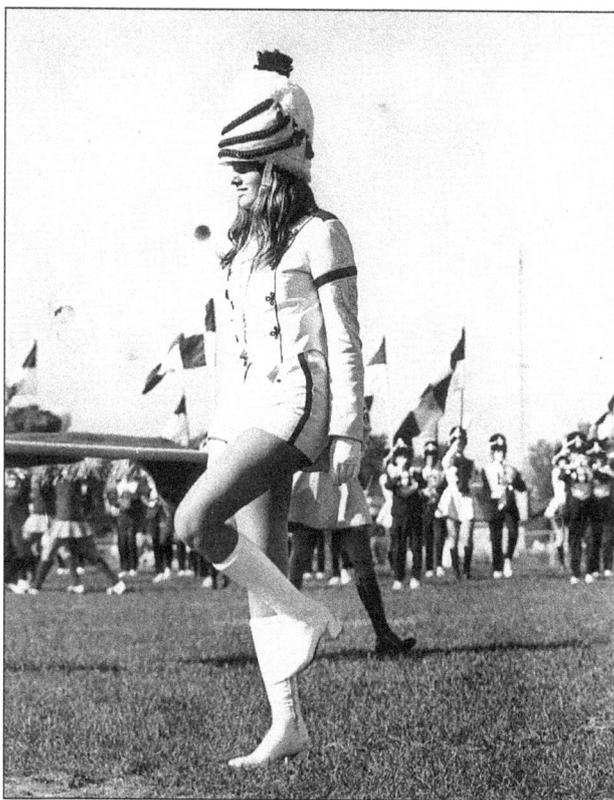

Jean Santora—with go-go boots, hot pants, and beefeater hat—was the drum major for the Hammonton Blue Devils Marching Band during the 1972–1973 school year. (Courtesy of Rose Rita and Anthony Guerere.)

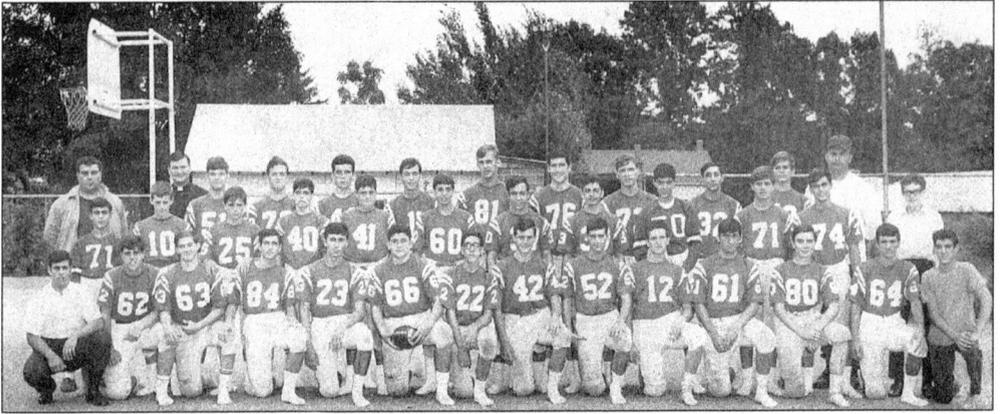

The St. Joseph's Roman Catholic High School 1968 football squad is pictured on the back of a football program from that season. Oddly enough, none of the players appeared to be wearing shoes when the photograph was taken. The team was co-captained by Henry Andrescavage and Dennis Benedetto. (Courtesy of Josephine and Vincent Giannini.)

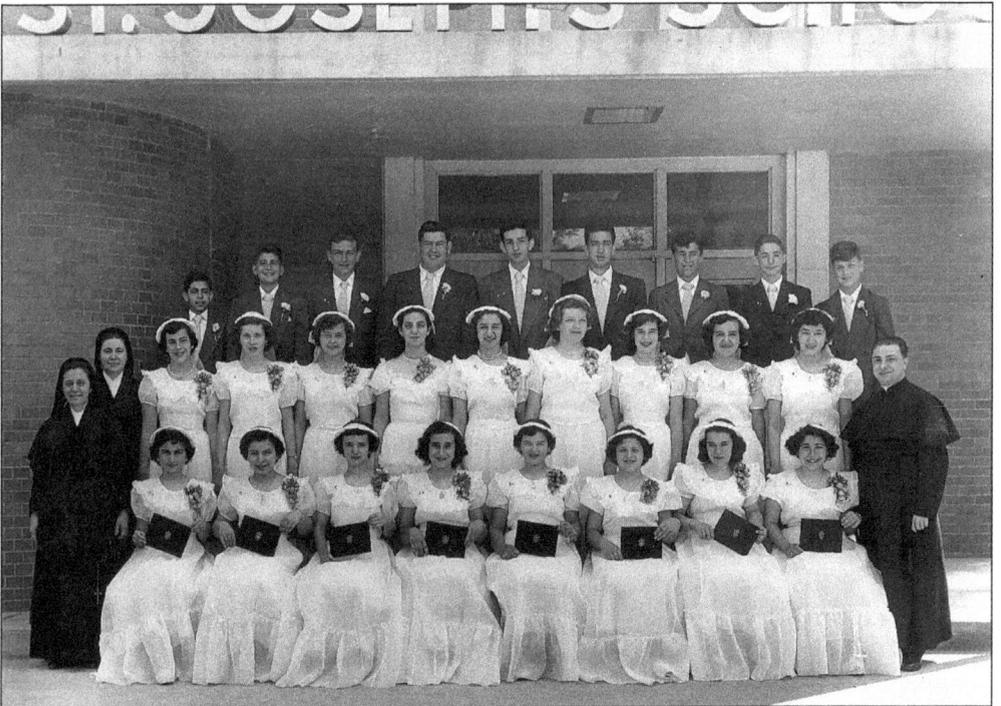

The eighth-grade graduates of St. Joseph's Roman Catholic School pose in front of the school building in 1951. From left to right are the following: (front row) Mother Superior Mary DeCarlo, Geraldine Caputo, Elizabeth Santiano, Patty Macrie, Grace Fiore, Eleanor Rodio, Carol Tomassone, Mary Lemons, Nancy Basile, and Fr. Marco Martorelli; (middle row) Sr. ? Ginetta, Jean Contole, Madeline Van Dyke, Josephine Zeitler, Vema Fichetola Josephine Lucca, Justine Gantner, Kathleen Esposito, Annetta Cappella, and Catherine Cuci; (back row) Salvatore Pietrofitta, Peter Tomasello, Edward Ravelli, John Pulleo, Carmen Andronica, Joseph Sarao, Salvatore Pietrofitta, Thomas Petruzzi, and Michael DeNardo. Not pictured are Ramona Alessandrini, John Tomasello, Catherine Williams, and Joseph Giacobbe. (Courtesy of Josephine and Vincent Giannini.)

Hammonton Town Hall, at the corner of Central Avenue and Vine Street, is shown in the 1920s. Originally the home of the People's Bank, the building was donated to the town and moved to this location from its original site on the corner of Central and Bellevue Avenues. An addition was later built. The 1887 town hall, which later became the home of the Hammonton Historical Society Museum, is visible behind the building. (Courtesy of Josephine and Vincent Giannini.)

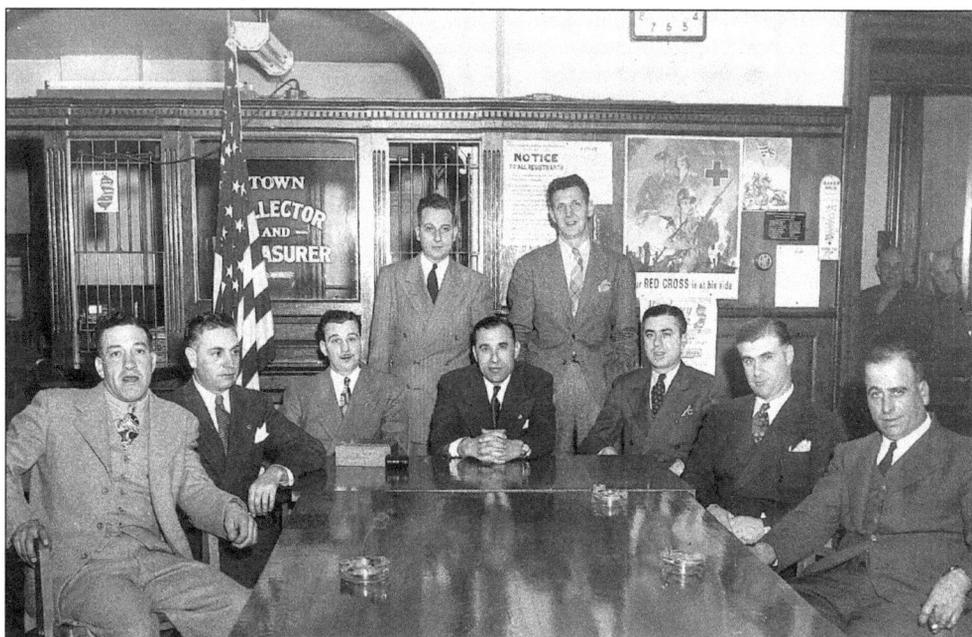

The Hammonton Town Council poses on January 14, 1946. From left to right are the following: (seated) Councilman Angelo "Skipper" LaManna, Charles H. Petrecca, Aurelio Continisio, Mayor John Machise, Councilmen Henry Mortellite, Frank Pitale, and Charles Palmieri; (standing) Town Solicitor Vincent A. DeMarco and Town Clerk John Jacobs. (Courtesy of the Hammonton Historical Society.)

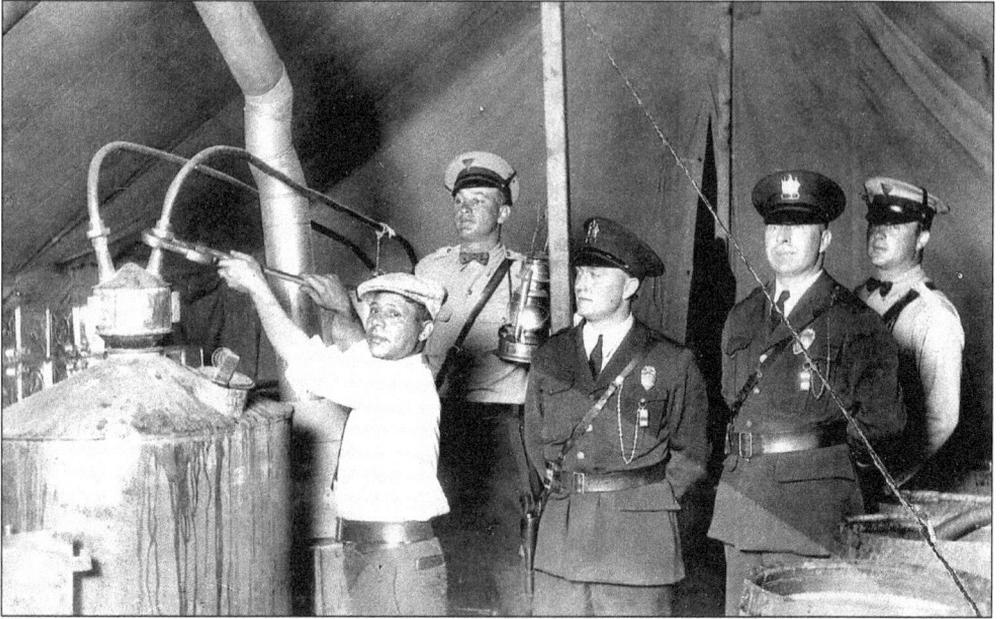

Members of the New Jersey State Police and the Hammonton Police Department raid a still used for the illegal production of alcohol on May 18, 1930. The still was located in a tent in the middle of the Great Swamp Sand Crossway. During the Prohibition era, stills were commonly found in the forests around Hammonton. From left to right are Off. John B. Rubba, Trooper ? Carns, Off. Mike Messina, Off. George Patten, and Trooper ? Beylon. (Courtesy of Augie Sorrentino.)

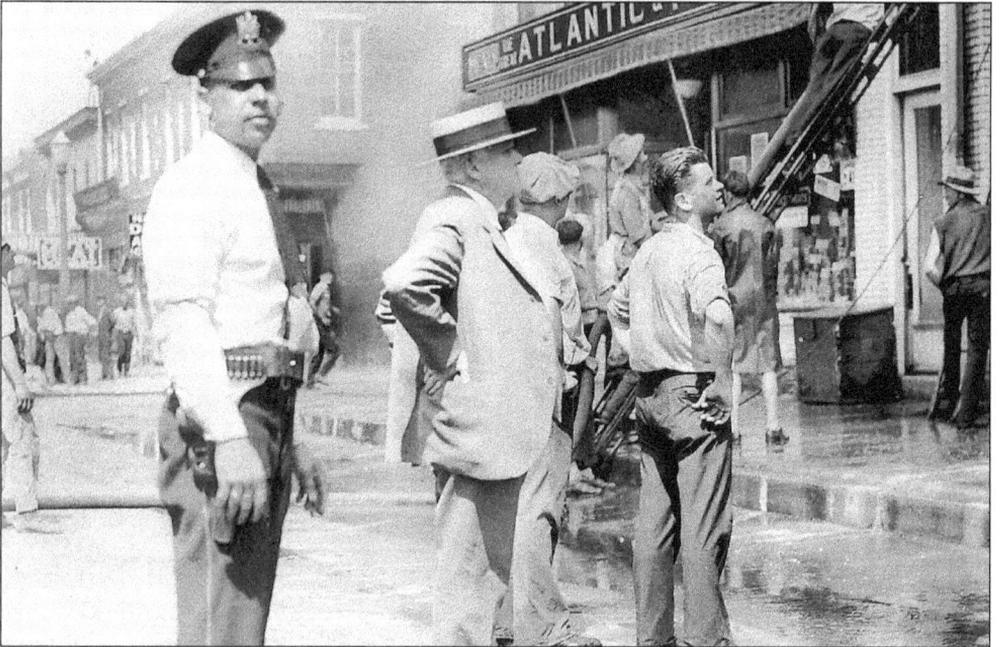

William Black (center) inspects the fire damage to his Bellevue Avenue store while a member of the Hammonton Police Department looks on. Note the bullets clearly visible on the officer's gun belt. (Courtesy of the Hammonton Gazette.)

Postmaster Irma Adams (left) is shown with her daughter Carrie Adams on the day of the dedication of the Hammonton Post Office, July 8, 1939. The dedication was marked with a large ceremony, which included a parade through the downtown area. (Courtesy of the Hammonton Historical Society.)

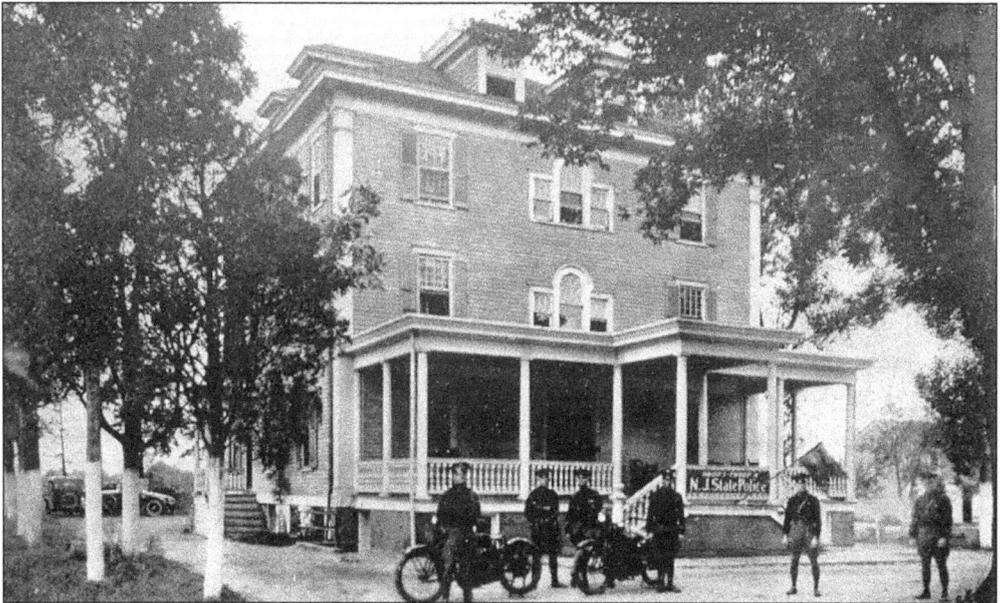

New Jersey State Police Troop A Headquarters, on Egg Harbor Road, is shown here. The building was once the Hotel Royal, which was owned by John Taylor French. The top two floors of the building were later destroyed by fire. The structure later became the home of the local Veterans of Foreign Wars Post. (Courtesy of Dorothy Orlandini.)

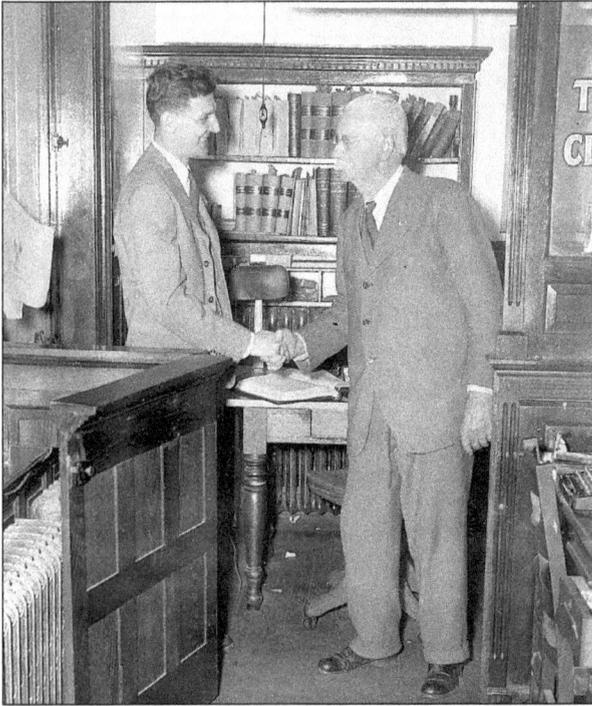

Town Clerk Weeden Richard Seely was one of the oldest municipal employees in the state of New Jersey when he retired on December 1, 1941, at age 88. This photograph, taken on that day, shows Seely shaking hands with John Jacobs, the new town clerk. Seely had been the town clerk since 1908. (Courtesy of the Hammonton Historical Society.)

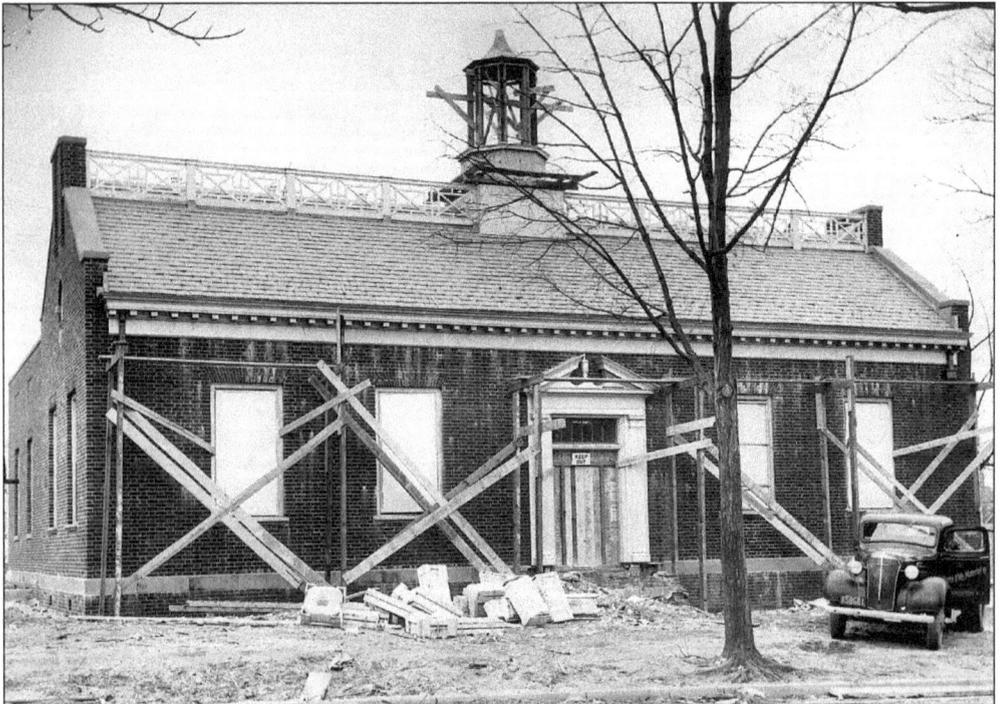

The construction of the Hammonton Post Office was moving toward completion by March 4, 1939, the day this photograph was taken. The post office was a Works Progress Administration (WPA) project, and the design was used in several communities. The post office was built by Hammonton Building Material. (Courtesy of the Hammonton Post Office.)

Six

LEISURE TIME

Hammontonians always knew how to have a good time. Politics and other amusements took prominence in the lives of local residents. There were civic organizations with long histories, church groups, religious societies, and local players staging productions. Townwide civic celebrations, such as the town's Diamond Jubilee in 1941 and its centennial in 1966, drew large crowds of participants and spectators.

The Hammonton Lake Park has been a center of recreational activity in Hammonton since the mid-1800s, when its waters were touted for their "salubrious health effects" in newspaper advertisements promoting the town as a resort.

Whether or not those effects really were salubrious is open for debate, but the lake park became the local spot for swimming, congregating, camps, the arts, youth sports, and many other recreational activities. It was the place people went to relax, cool off on a hot summer day, and be with friends and family.

The park became the home of organized sports, such as the Hammonton Little League. Other sports, such as youth and semiprofessional football, were played on Vine Street in the downtown area. The Hammonton Hawks youth football and semiprofessional teams like the Hammonton Bakers would play under the large light standards set up around the field on Vine Street.

Semiprofessional baseball has been played in Hammonton since the 1800s. Teams of local men named the Brewers, Peaches, and Black Sox played ball in different eras.

Local games, events, pageants, parades, and contests filled the days and nights of locals and provided opportunities to share some time together.

Those opportunities were rarely missed.

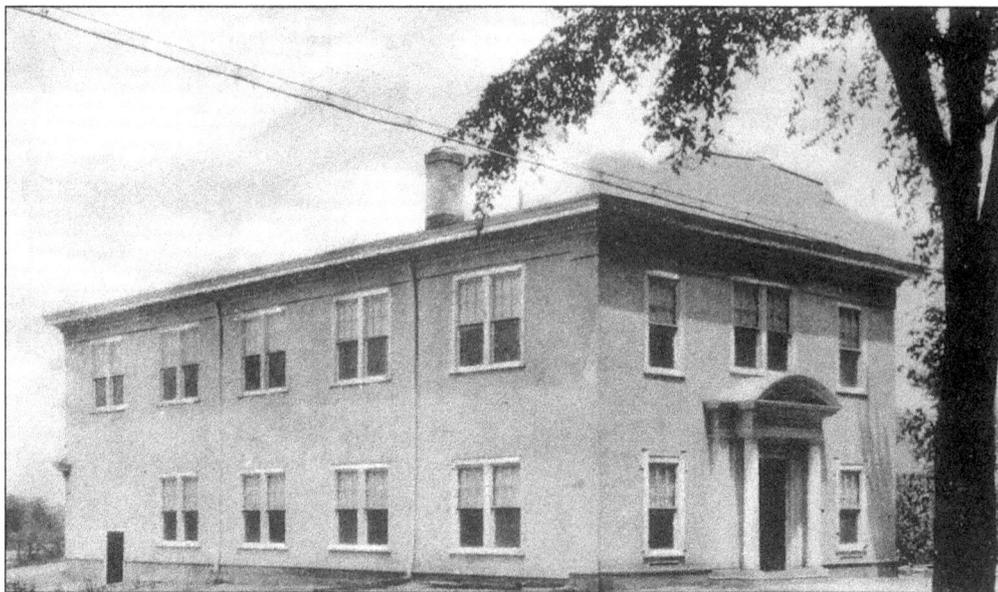

The Masonic Temple has been a fixture of the downtown area for generations. The building is located on the corner of Peach Street and Central Avenue and is still owned and operated by the local Masons. (Courtesy of Dorothy Orlandini.)

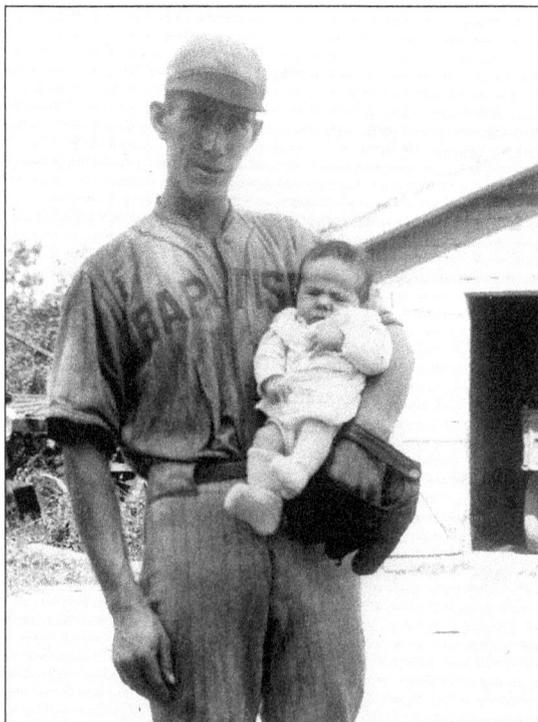

In this 1920s photograph, Gilpin Wescoat Sr. holds Gilpin Wescoat Jr. on the Wescoat family farm. The lettering across the front of the baseball jersey reads, "Baptists." (Courtesy of Dorrine Esposito.)

In the days before global warming, the Hammonton Lake used to freeze solid each winter, providing recreation for local residents. Vincent and Josephine Giannini and their children Ginger (left) and Vincent Jr. (in a bed on a sled, right) were among the many residents who would go sledding and skating near the bar and restaurant known as the Lillian on the Lake. This photograph was taken on January 18, 1959. (Courtesy of Josephine and Vincent Giannini.)

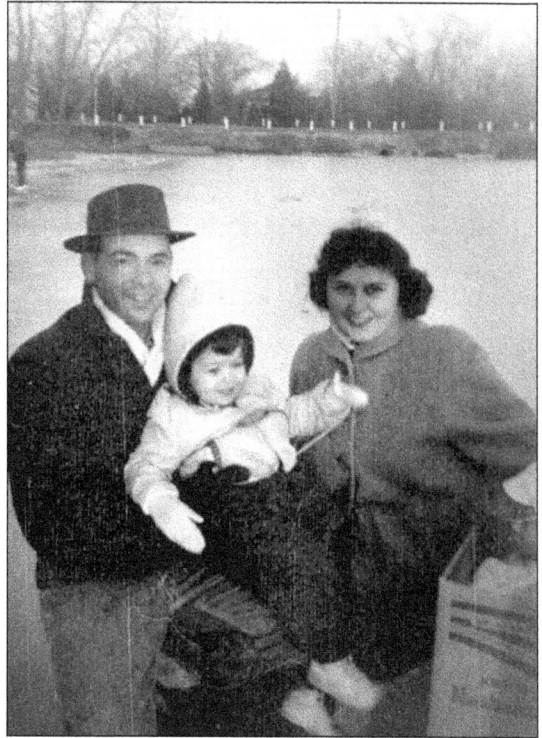

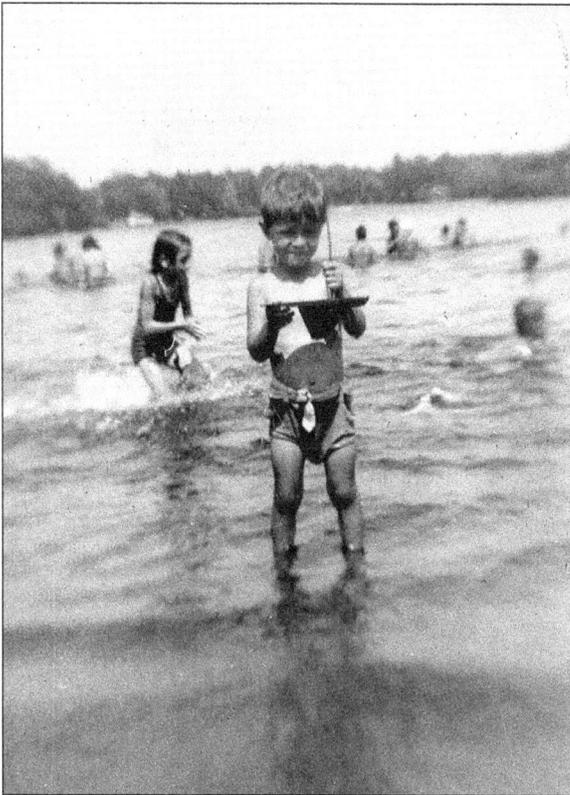

The Hammonton Lake also provided recreation in the summer months. Jack Pagano wades near the shore of the lake in the 1930s. (Photograph courtesy of Jack Pagano.)

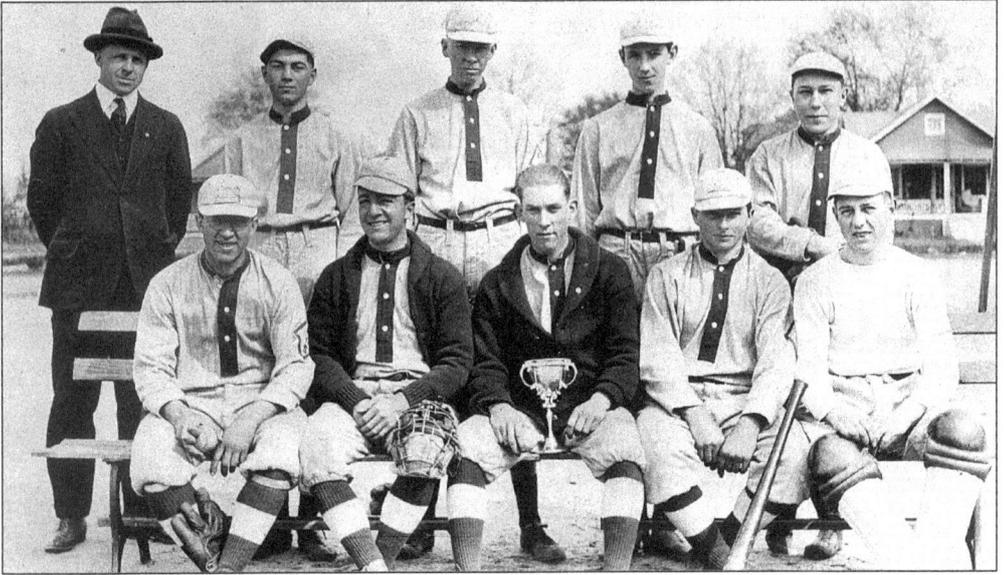

This photograph of a local baseball team was taken in May 1917. Local teams playing for recreation in the Atlantic County Baseball League or against barnstorming teams like the House of David or Negro Leaguers would play on the school athletic fields between Peach and Vine Streets. (Courtesy of Rita and Dan Benedetto.)

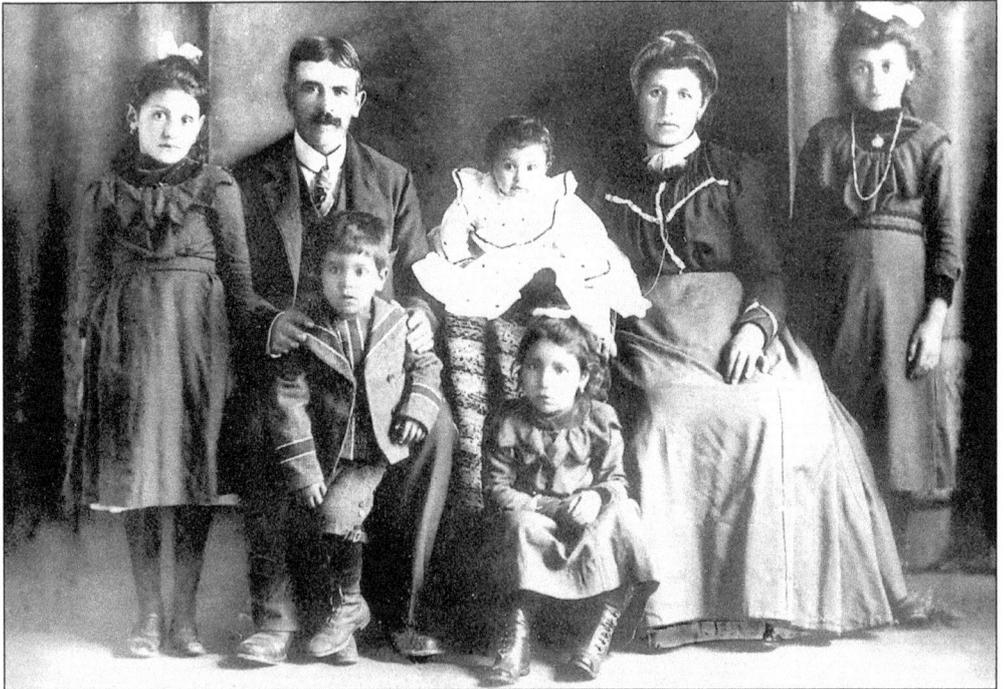

Family ties were very strong in Hammonton, and nearly every Italian family posed for some kind of family photograph. This is the Errera family in 1906. From left to right are Anna Errera (later Santomas), Anthony Errera, Anthony Errera Jr., Jenny Errera (later Blumberg), Frances Errera (later Cappuccio), Rosa Errera, and Mary Errera (later Giacobbe). (Courtesy of Rose Rita and Anthony Guerere.)

Participants in the events for Hammonton's Diamond Jubilee congregate near the town clock, which was then located on the corner of Central and Bellevue Avenues. The Diamond Jubilee was held on June 12–14 in 1941. (Courtesy of Joseph Presti.)

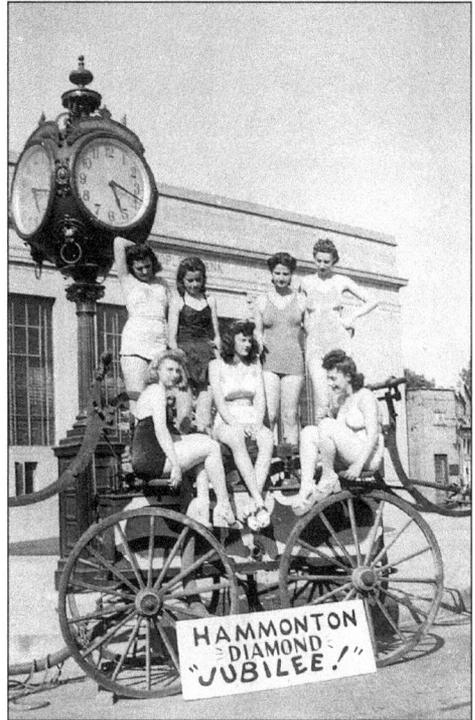

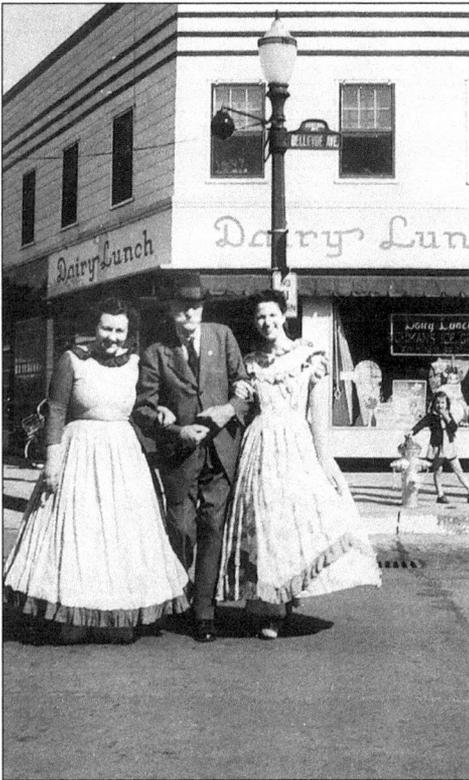

Town Clerk Weeden Richard Seely joins in the fun during Hammonton's Diamond Jubilee in June 1941. This photograph was taken on the corner of Central and Bellevue Avenues, across from the People's Bank building. The Dairy Lunch, a local restaurant, is visible in the background. (Courtesy of Joseph Presti.)

David Rizzotte poses in his Hammonton Hawks uniform in the 1960s. The uniform was completely powder blue, from the helmet to the pants. The Hawks have a tradition as one of the finest organizations in the Atlantic County Junior Football League. (Courtesy of David Rizzotte.)

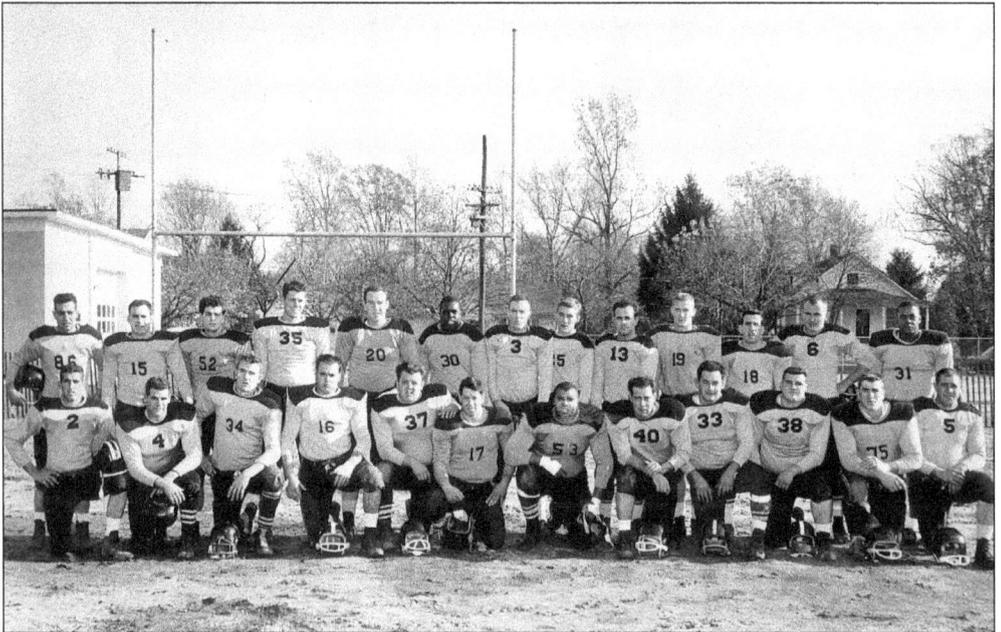

Semiprofessional football was played in the 1940s, 1950s, and 1960s on the school athletic fields between Peach and Vine Streets. The teams had various nicknames. This photograph shows the Hammonton Bakers. Large light standards used to ring the football field during this era, and night games drew hundreds of people. (Courtesy of Jack Donio.)

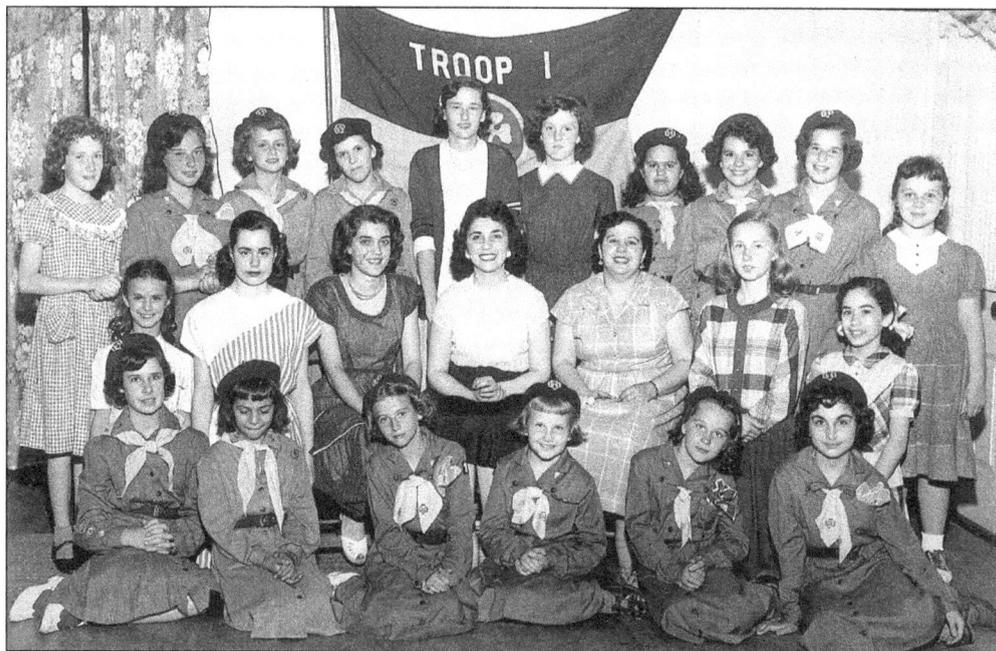

The members of Girl Scouts Troop 1 are all smiles on June 15, 1950. From left to right are the following: (front row) Joan Gallagher, Rita Cappuccio, Doris Ehrke, Ruth-Ellen Walker, Diane Evans, and Geraldine Caputo; (middle row) Geraldine Busser, Rose Mary Perricone, Dot Vitilo (assistant leader), Angelus Weiss (leader), Grace Cappuccio (assistant leader), Joyce Skinner, and Nancy Scafido; (back row) Gail Boyer, Rose Norcross, JoEllen Johnson, Marlene Bruno, Amy McCaughey, Arlene Motolla, Shirley Zirillo, Irene Rubba, Kathleen Esposito, and Bonny Costa. (Courtesy of Angelus and Frank Weiss.)

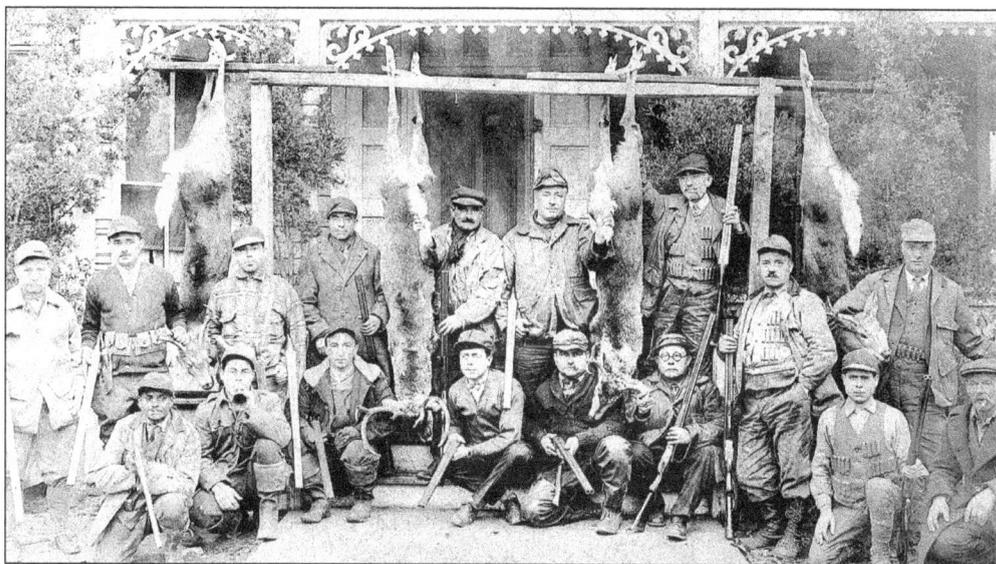

Hunting was a popular local pastime, as shown in this 1926 photograph of the "Giordano Gang." The home on 12th Street near the corner of 12th and Grand Streets still retains its original appearance, including the gingerbread detailing on the wraparound porch. (Courtesy of Jack Donio.)

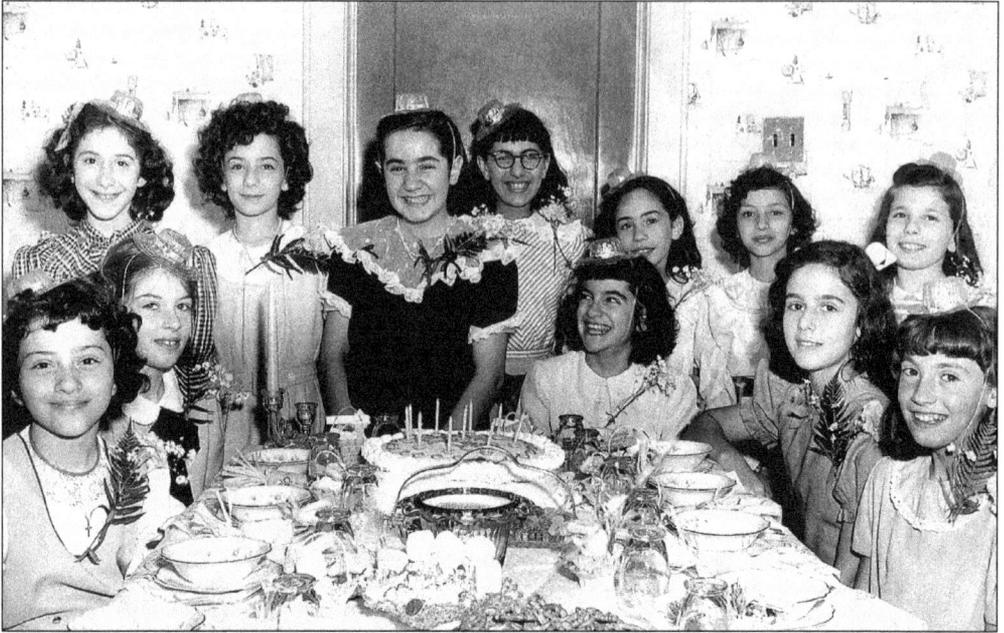

The birthday party of Marie Puleo in 1949 was well attended. From left to right are the following: (front row, sitting) Laurine Costa, Jean Daminger, Kathy Passarella, JoAnn Penza, and Rosetta Ranere; (back row, standing) Connie Macri, Joan Mortellite, Marie Puleo, Marie Cassiani, Nancy Scaffidi, Carmella DeLosso, and Gerry Rodolfi. (Courtesy of Angela Donio.)

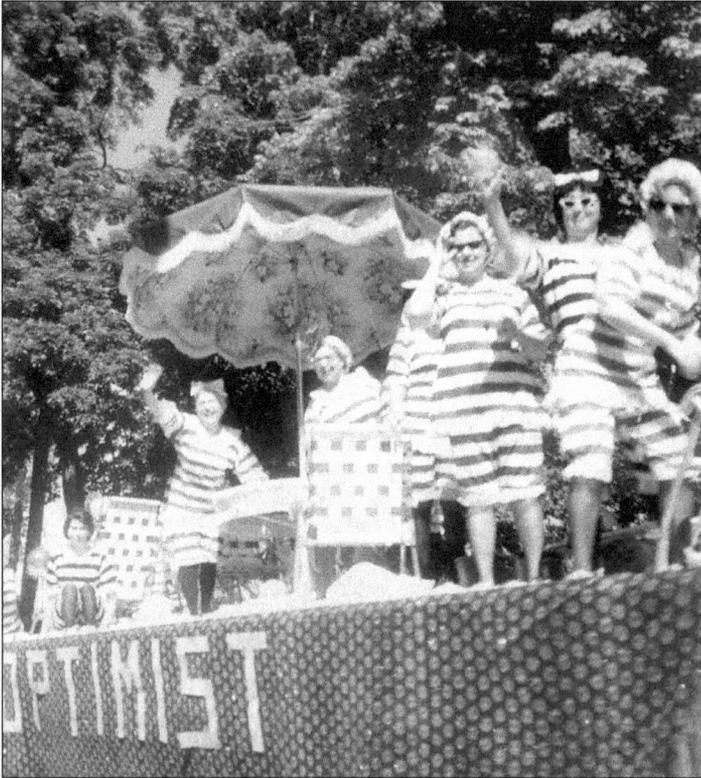

Soroptimist Club members cavort on a float during the Hammonton centennial celebration. The centennial's main events were held from May 21 through May 28, 1966. The parade passed through the downtown area, which was completely decorated in red-white-and-blue bunting. (Courtesy of Rita and Dan Benedetto.)

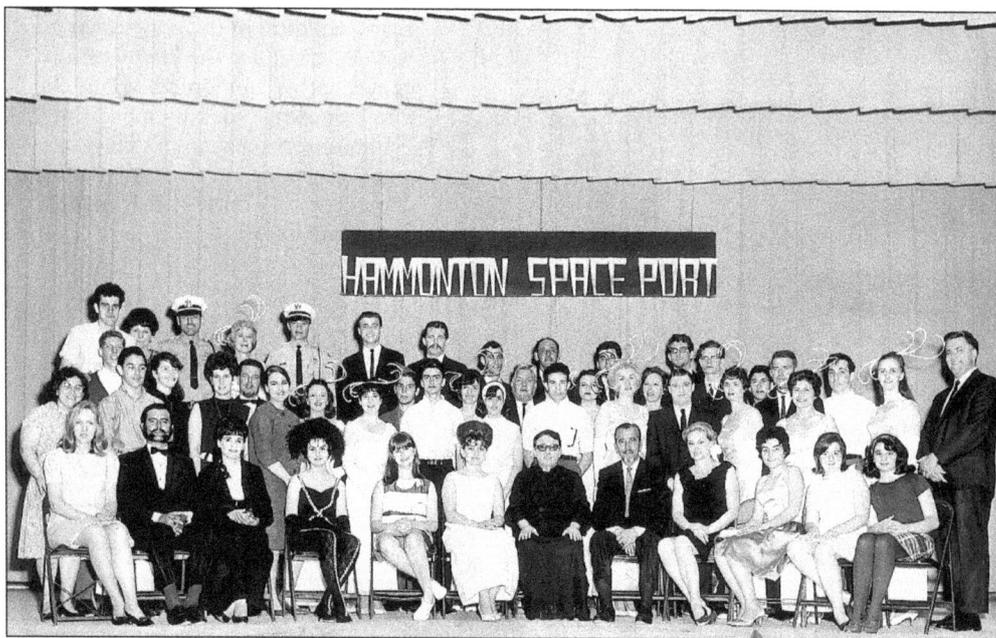

Pictured are cast members of the pageant entitled *100 Years on Parade*, an original production staged at the Hammonton High School on the corner of Central Avenue and Vine Street during Hammonton's centennial in May 1966. The show chronicled key events in the town's history and envisioned the future, including a "Space Port in Hammonton, 2000 A.D." (Courtesy of Joanna Presti.)

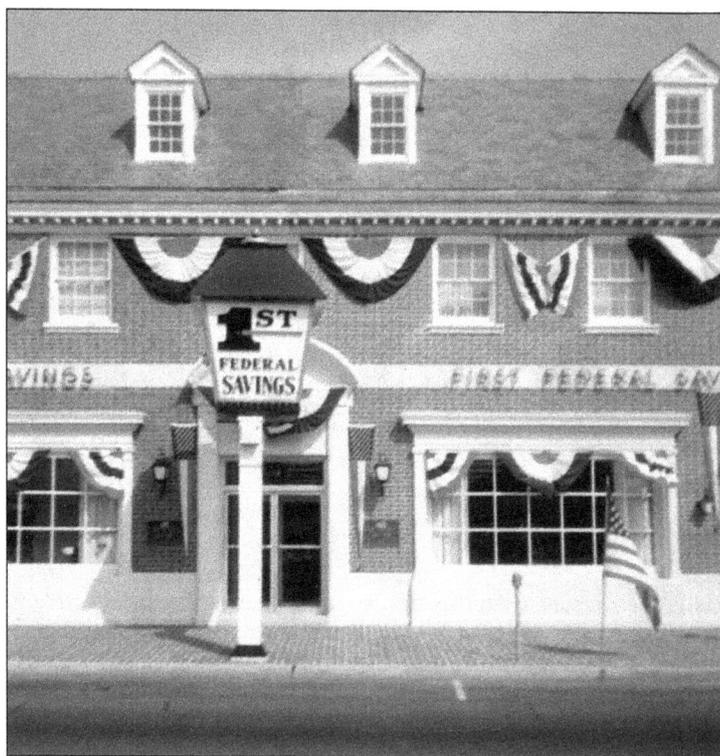

First Federal Savings is festooned with patriotic bunting during Hammonton's centennial. The bank features a large sign shaped like a Colonial lamppost, with clocks on each side. (Courtesy of Rita and Dan Benedetto.)

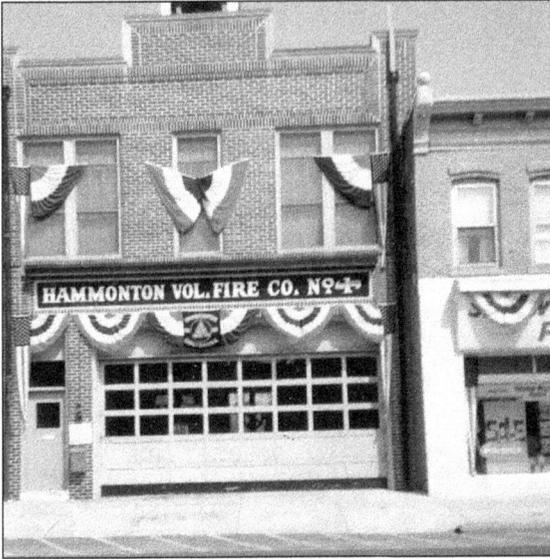

Every building in the downtown area was decorated for the Hammonton centennial. Hammonton Volunteer Fire Company No. 1 included the Hammonton centennial's blue-and-gold banner in the center of its decorations. (Courtesy of Rita and Dan Benedetto.)

Halloween meant costumes and trick-or-treating for local residents. Halloween parties, such as this one from 1948 on Middle Road at the home of Joseph and Katherine Coia, were also common. From left to right are the following: (front row) Theresa Coia, Louis Coia, Marian Capelli, Lennore Grasso, and James Penza; (back row) Roberta Coia, Frances Panarello, Edwin Coia, JoAnn Penza, Josephine Zeitler, Evelyn Penza, and Lawrence Grasso. (Courtesy of Josephine and Vincent Giannini.)

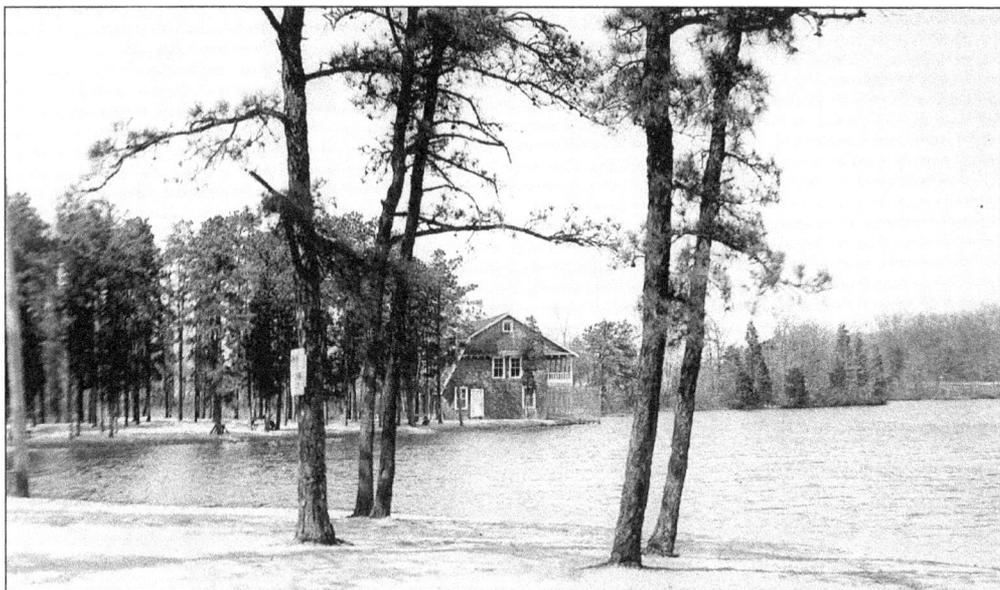

The Hammonton Lake and the caretaker's house are pictured in the 1920s. The house was home to the Hammonton Canoe Club in the late 1800s and early 1900s. It has been converted into the offices of the Hammonton Recreation Department. (Courtesy of Josephine and Vincent Giannini.)

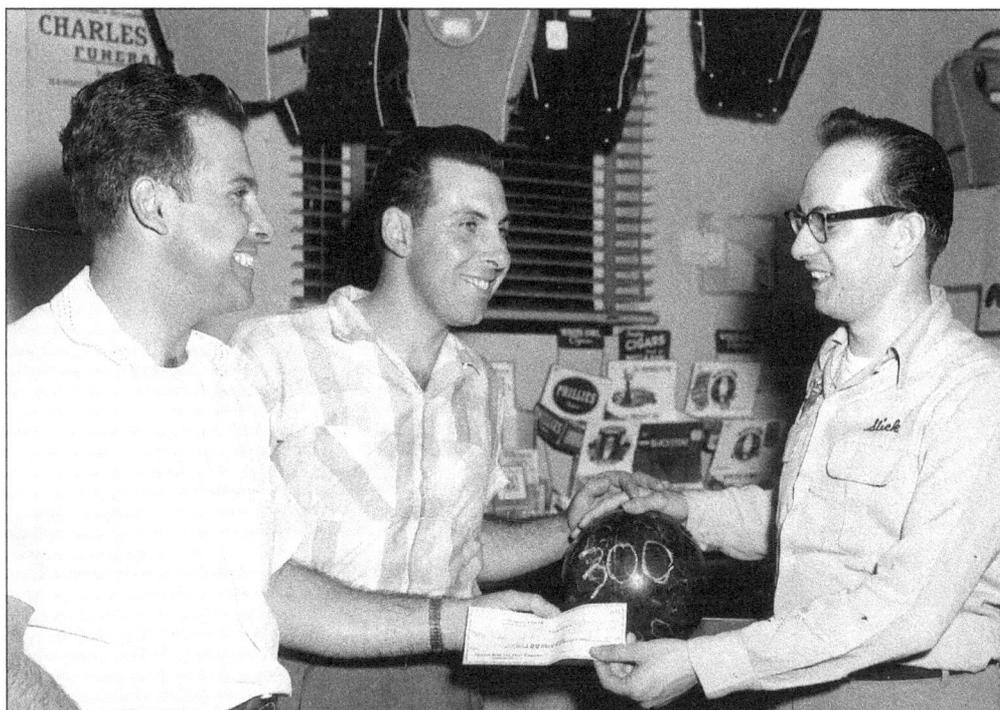

Domenic "Tip" DiDonato (left) and John DiDonato congratulate "Slick" Padulese on his perfect 300 game at DiDonato's Bowling in the 1960s. Hammontonians have bowled at DiDonato's Bowling Center for decades. Prior to that, the local bowling alley was owned by the Entrikin family. (Courtesy of DiDonato's Bowling Center.)

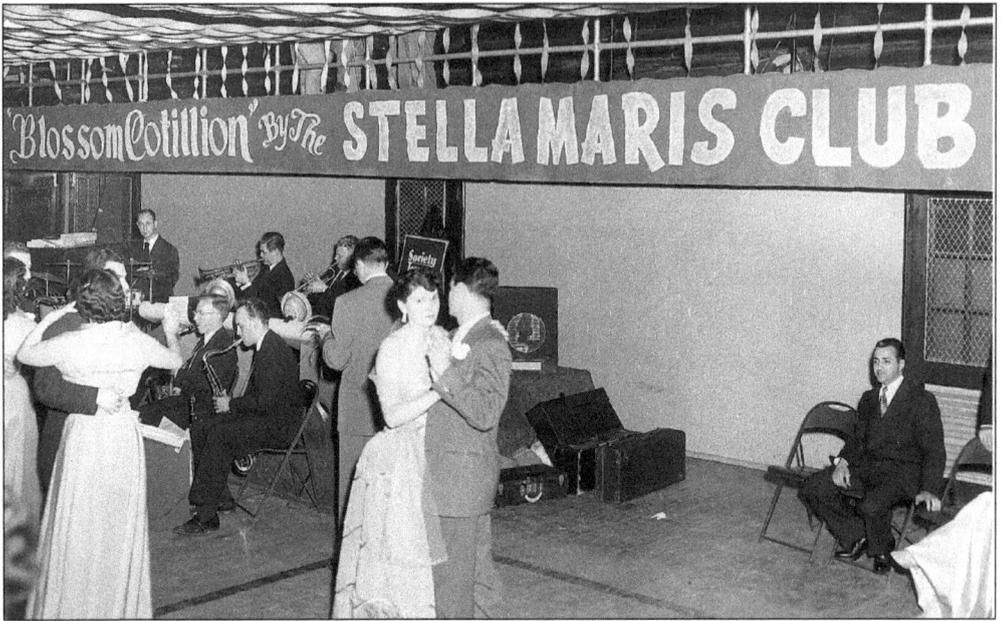

Charles Ranere (right) watches the dancing at the Blossom Cotillion, hosted by the Stella Maris Club during the 1940s. The cotillion, or May Hop, was held in conjunction with the annual Peach Blossom Festival. (Courtesy of Dorothy Orlandini.)

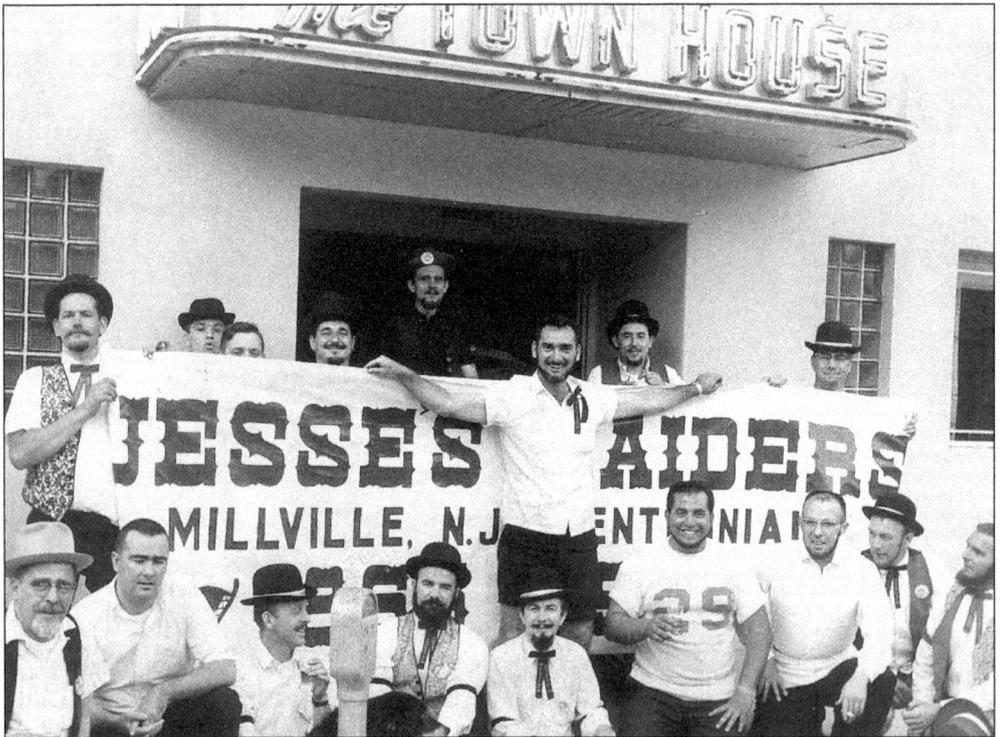

Do not let the banner confuse you—this photograph was taken during Hammonton's centennial, in front of the Town House, on Third Street. The hats and beards were worn by many local men in honor of the local "pioneers" of the 1860s. (Courtesy of Rita and Dan Benedetto.)

Hunting was a pastime that was handed down through the generations. In this 1930s photograph, Paul Sorrentino (right) seems to be catching on fast, judging by the way he is imitating William Sorrentino (left). (Courtesy of Augie Sorrentino.)

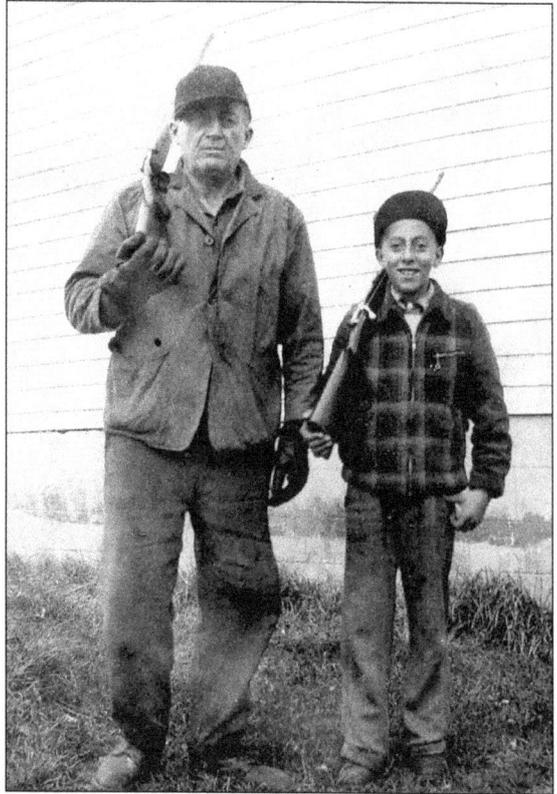

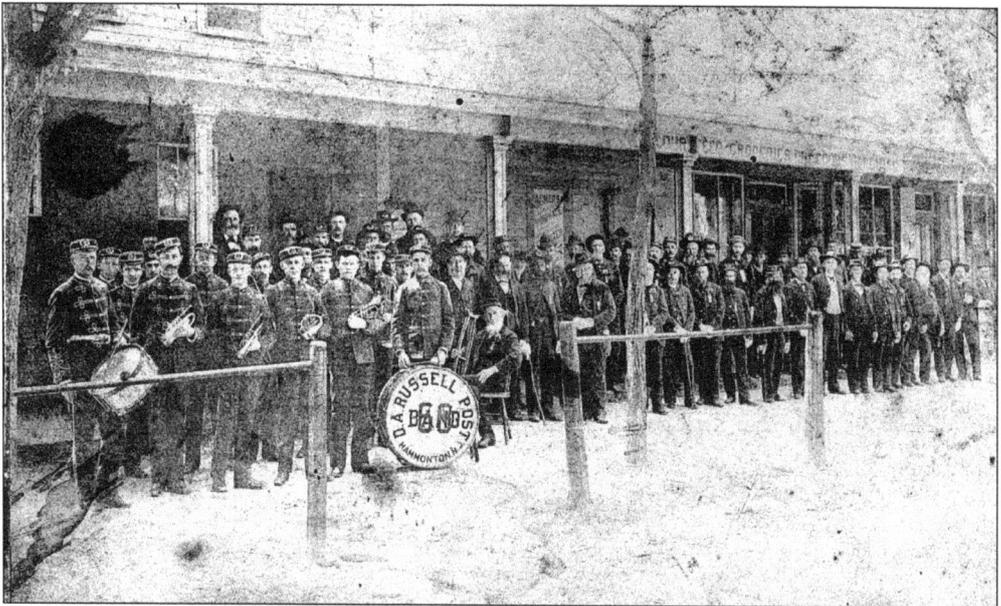

Members of the D.A. Russell Post of the Grand Army of the Republic, an organization made up of Union Civil War veterans, pose on Bellevue Avenue. The post's band is grouped to the left of the photograph. (Courtesy of the Hammonton Historical Society.)

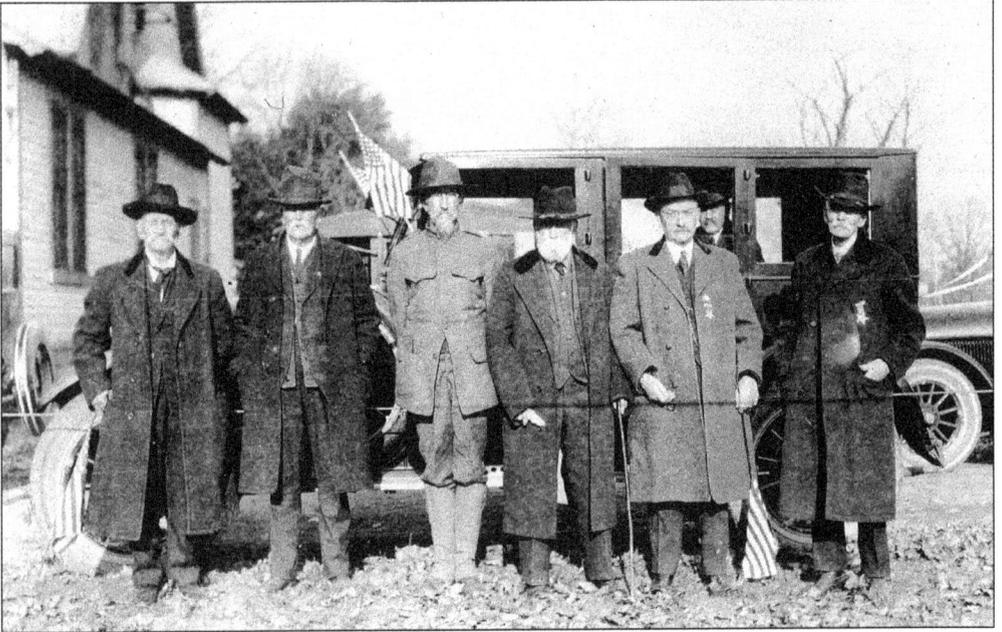

By the 1920s, the members of the local Grand Army of the Republic post had dwindled to only a few. From left to right are Aaron Musick, Casper Craig, unidentified, unidentified, William Collingwood, and Joshua Brown. (Courtesy of the Hammonton Historical Society.)

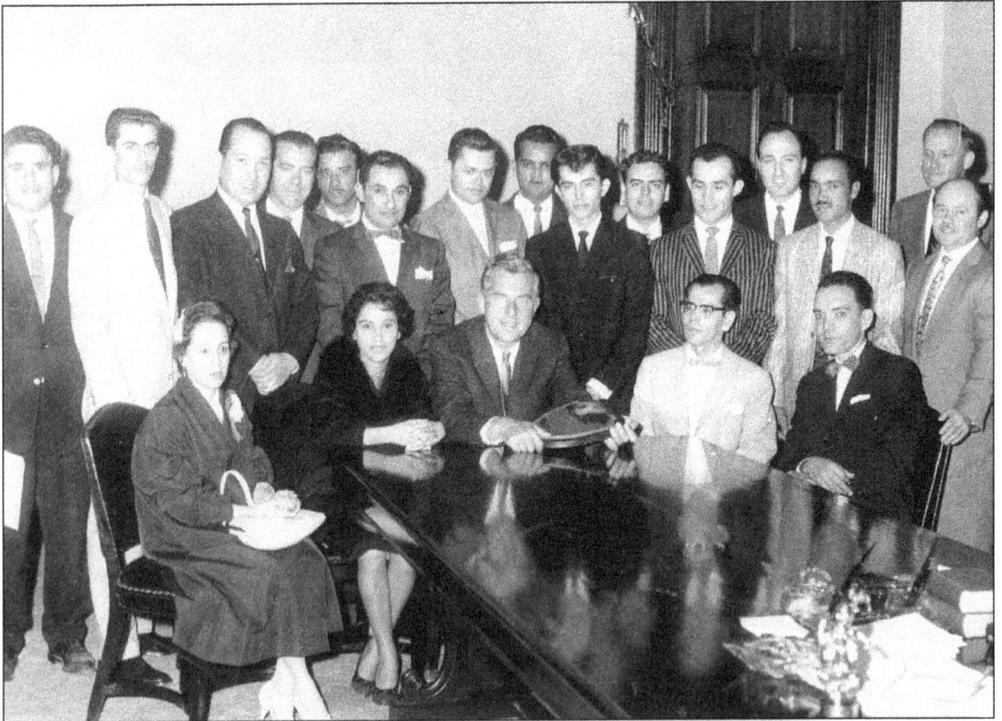

Members of the newly formed Puerto Rican Civic Association (PRCA) meet with Gov. Robert E. Meyner in Trenton. Joe Torres and Fernando Melendez, founder of the PRCA, stand behind Meyner's left shoulder. (Courtesy of the Puerto Rican Civic Association.)

Seven

PRESIDENTIAL VISITS

September 19, 1984, is a boldfaced date on the Hammonton historical calendar. More than 30,000 people packed the downtown area to listen to Pres. Ronald Reagan, at the height of his political career, deliver a campaign speech.

Reagan gazed out at the sea of people cheering wildly for him as he came to the podium on the large platform stretched across Bellevue Avenue. He paused for a moment and turned back toward the members of the town council, state representatives, and Gov. Thomas Kean, who were sitting behind him.

"Wow," he said and then turned back to the crowd to begin his speech.

Images from that day remain burned in the collective memory of Hammontonians who were present, filled with pride that their town had been selected for a visit from Reagan. Residents remember the Secret Service agents atop buildings downtown, the Hammonton Blue Devils Band playing, and the throng of people stretching through the downtown like one collective being.

The talents that are now customarily applied to Reagan—his disarming wit, his ability to command large audiences, his connection with people—were all on display on that perfect September day.

Other visits with and by presidents are included in this chapter. Hammontonians' encounters with Theodore Roosevelt, Richard M. Nixon, and John F. Kennedy are all here.

It was Reagan, however, who made the largest impact with his visit. A large granite rock with a bronze plaque and a street sign that reads "Ronald Reagan Drive" commemorate the historic day downtown.

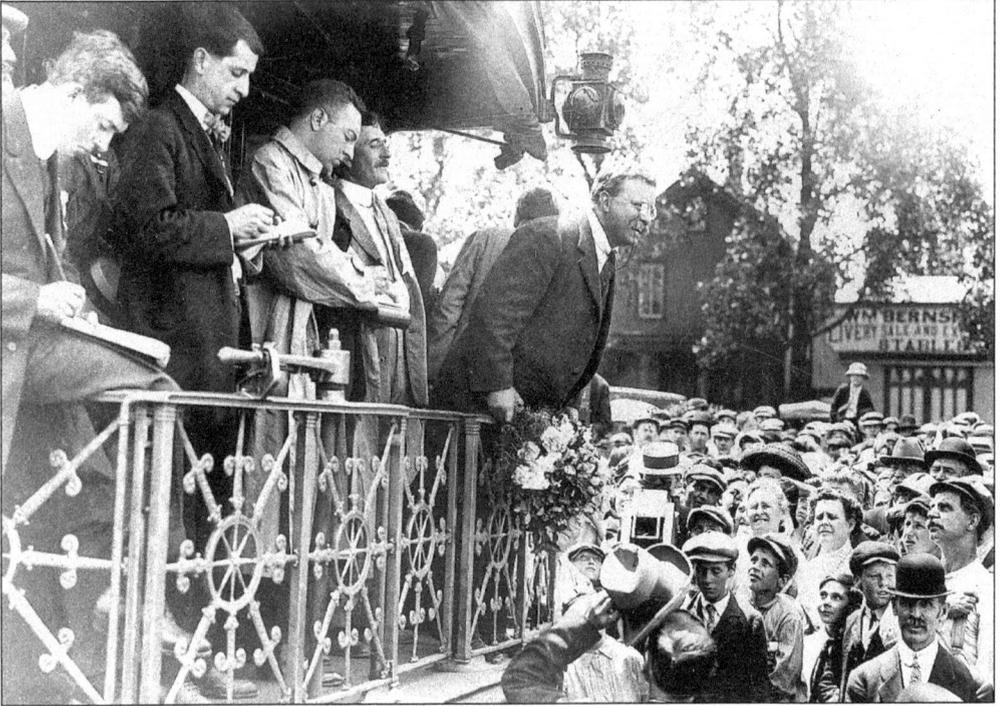

Pres. Theodore Roosevelt makes a whistle stop in downtown Hammonton on May 24, 1912. He was the second commander in chief to do so. Pres. Ulysses S. Grant's train also stopped in Hammonton on his way to the Jersey Shore in 1874. (Courtesy of Rita and Dan Benedetto.)

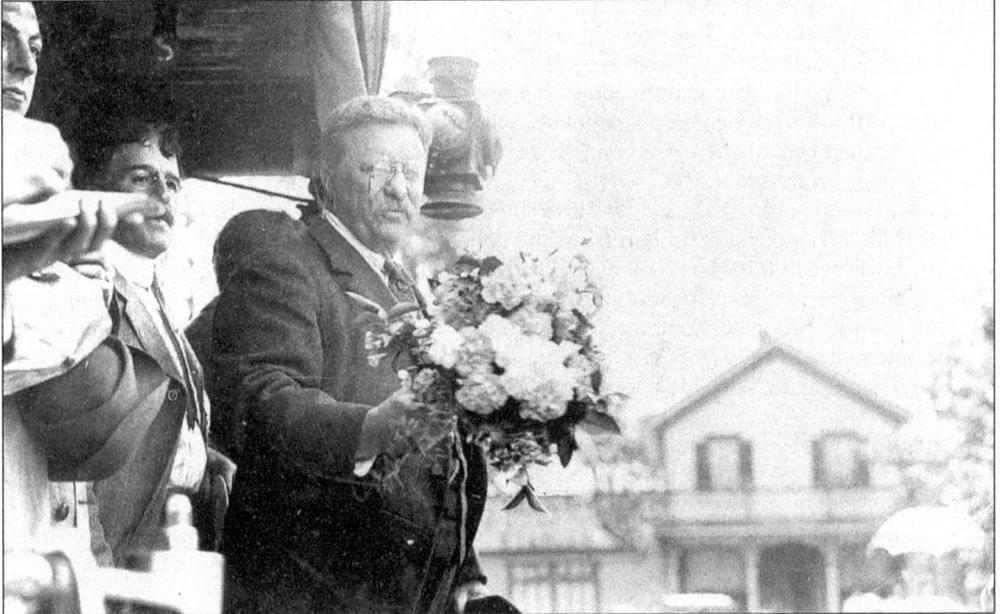

Hammontonians presented Roosevelt with a bouquet of flowers during his campaign in Hammonton. Roosevelt gave a speech as part of his unsuccessful Bull Moose party candidacy, which sought to challenge the Republicans and Democrats for the presidency. (Courtesy of the Hammonton Historical Society.)

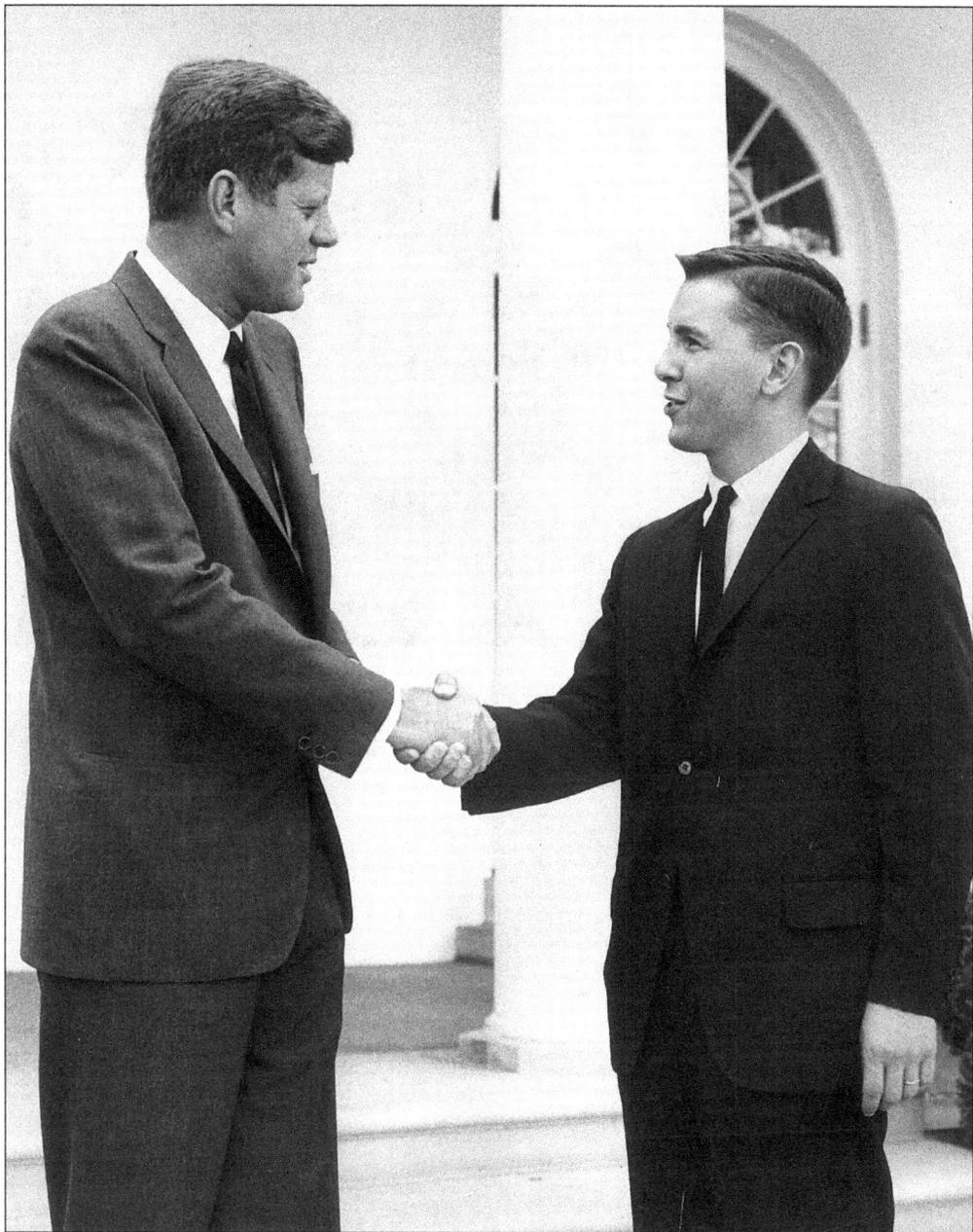

Local Democrat Albert Mazzo (right) meets with Pres. John F. Kennedy at the White House in 1960 or 1961. Hammontonians have a keen interest in politics, from the local to the international level. (Courtesy of the Hammonton Historical Society.)

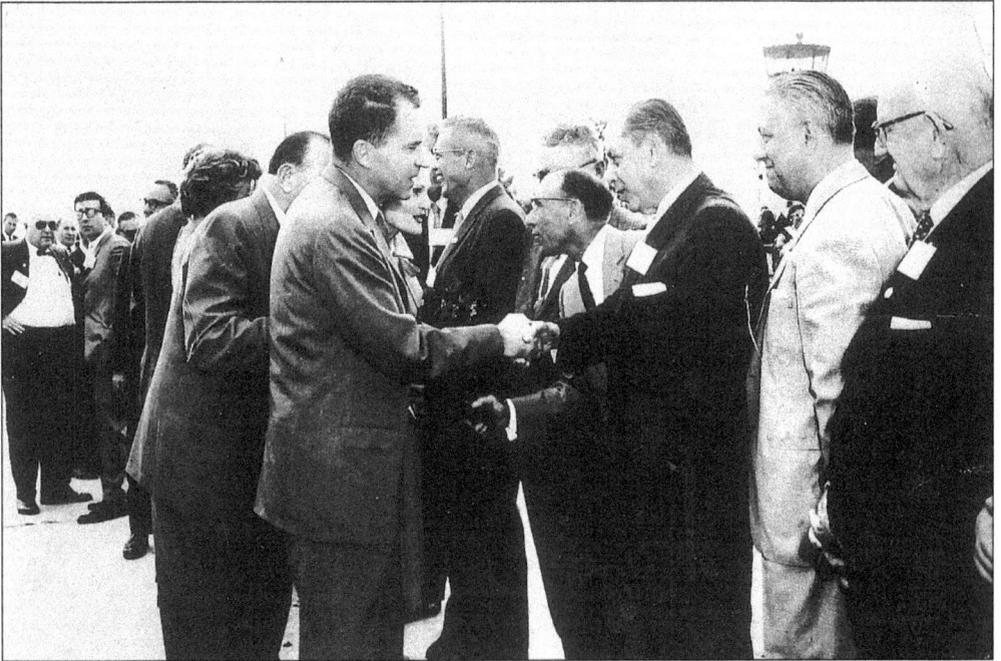

Charles Penza (right) shakes hands with Richard Nixon in the 1960s. Penza, who owned Eastern Brewery in Hammonton, was a key figure in local, county, and state politics. Former Hammonton Mayor John Machise is pictured to Penza's left. (Courtesy of Evelyn Penza.)

GUEST TICKET

PRESIDENT RONALD REAGAN DAY

Wednesday, Sept. 19, 1984
2 O'clock

Hammonton, New Jersey

Entrance at Intersection of Orchard & Horton Ave. — 2 O'clock

Paid for by Reagan-Bush '84, Paul Laxalt, Chairman

A select number of area residents and visiting dignitaries were allowed to enter the area closest to the stage where Reagan gave his speech on September 19, 1984. After handing in their tickets, the public had to be screened by metal detectors on the corner of Orchard and Horton Streets. (Courtesy of John Donio.)

90

Come See and Hear

PRESIDENT REAGAN

HAMMONTON, NEW JERSEY

ON

RONALD REAGAN DAY!

Wednesday, Sept. 19, 1984

2 O'clock

OFF ATLANTIC CITY EXPRESSWAY

EXIT 28

PUBLIC ENTRANCE AT BELLEVUE AVENUE

AND SOUTH EGG HARBOR ROAD

ENTERTAINMENT — AMPLE PARKING

Paid for by Reagan-Bush '84, Paul Laxalt, Chairman

Flyers like this one announced Pres. Ronald Reagan's visit to Hammonton in September 1984. The town issued an official proclamation naming the date as Ronald Reagan Day in Hammonton. Schools and businesses were closed early so locals could join the huge crowd in downtown Hammonton. (Courtesy of John Donio.)

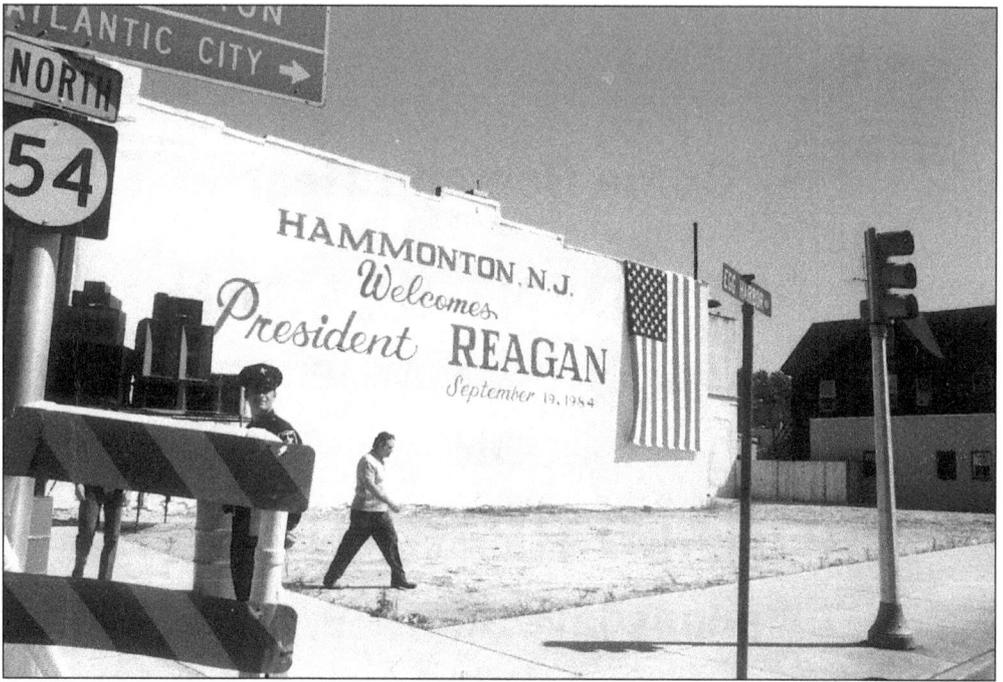

Rocco Colasurdo painted the wall of the Colasurdo Building on Bellevue Avenue. The sign was a local landmark for many years after the speech was given. It was eventually painted over in the late 1980s. (Courtesy of John Donio.)

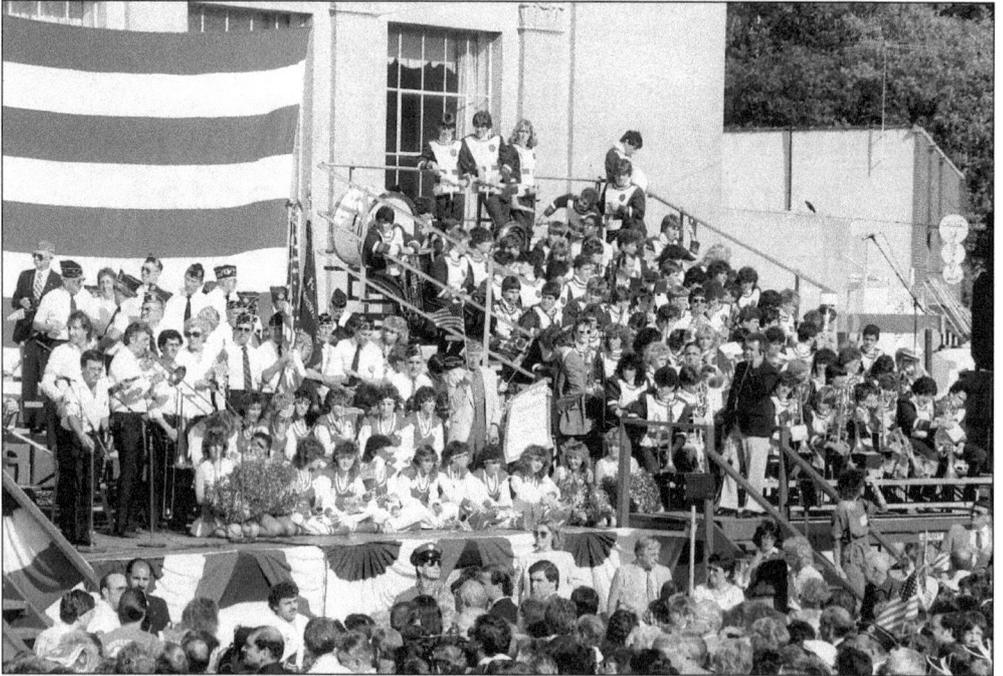

The Hammonton High School Marching Band awaited the arrival of Pres. Ronald Reagan in front of the People's Bank, at the corner of Bellevue and Central Avenues. Members of a veterans' band were also present on the stage. (Courtesy of John Donio.)

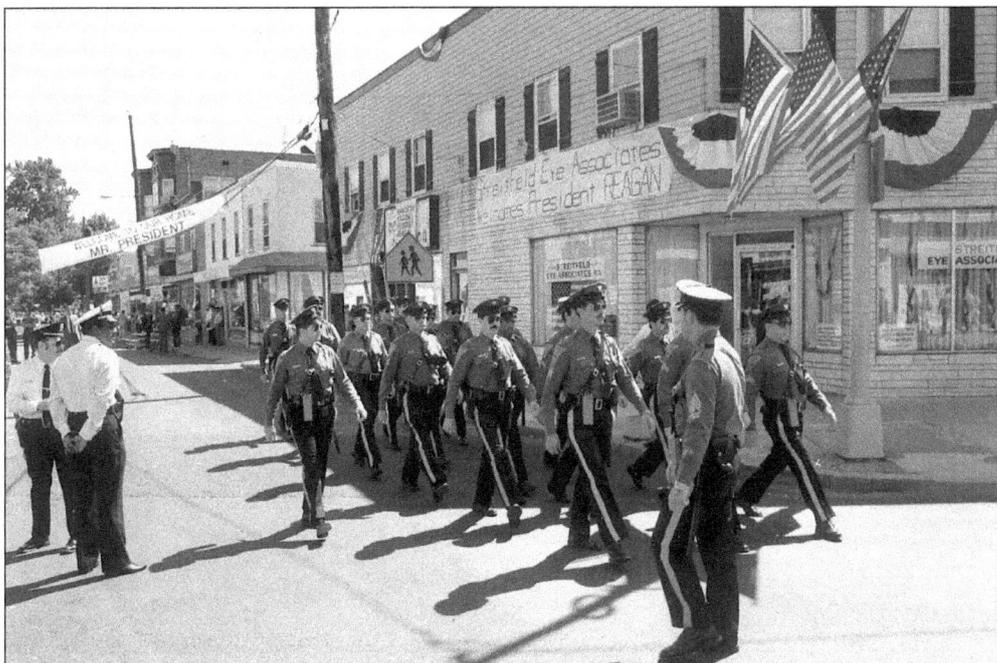
Members of the Hammonton Police Department prepared for the arrival of the president, marching past Streitfeld Eye Associates at the corner of Central and Bellevue Avenues in the downtown area. (Courtesy of John Donio.)

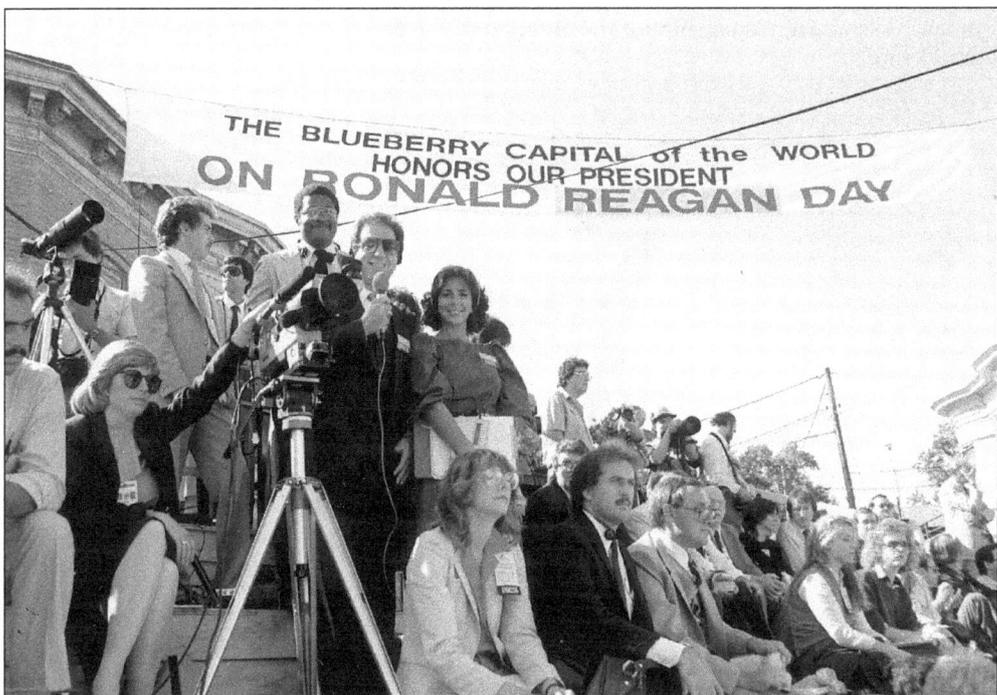
Reagan was at the height of his political popularity in September 1984. A huge media entourage followed every move of the campaign and arrived en masse in the Blueberry Capital of the World. (Courtesy of John Donio.)

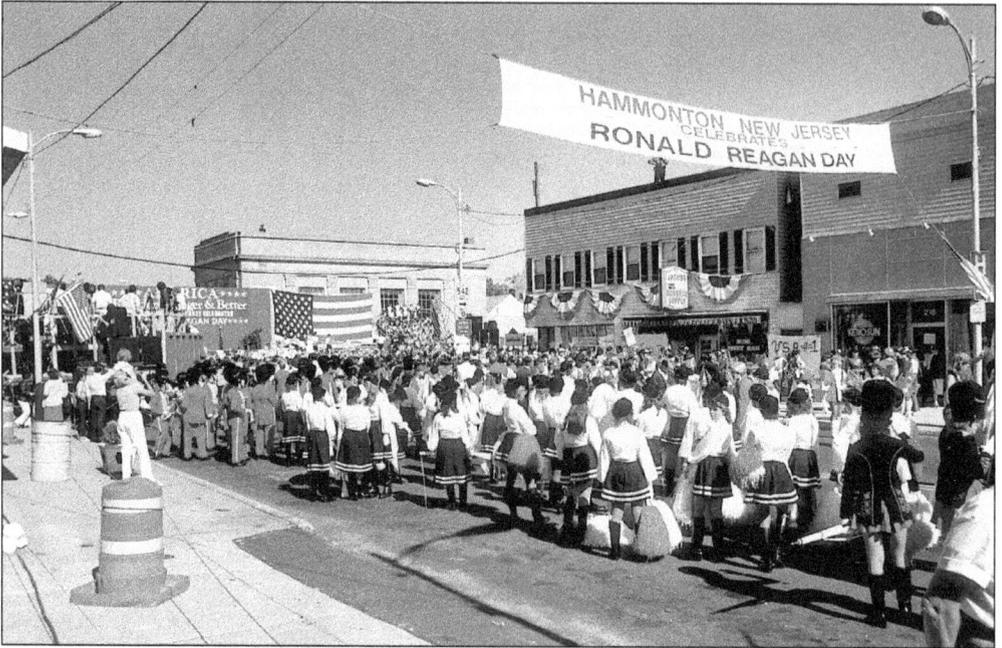

Another marching band prepared for Pres. Ronald Reagan's visit. The many banners stretched across Bellevue Avenue served a dual purpose—in addition to welcoming the president, they obscured the line of sight from the hundreds of downtown windows, deterring any possible assassination attempt. The Secret Service mandated the banners be put in place and all windows downtown remain shut for the duration of the president's time on stage. (Courtesy of John Donio.)

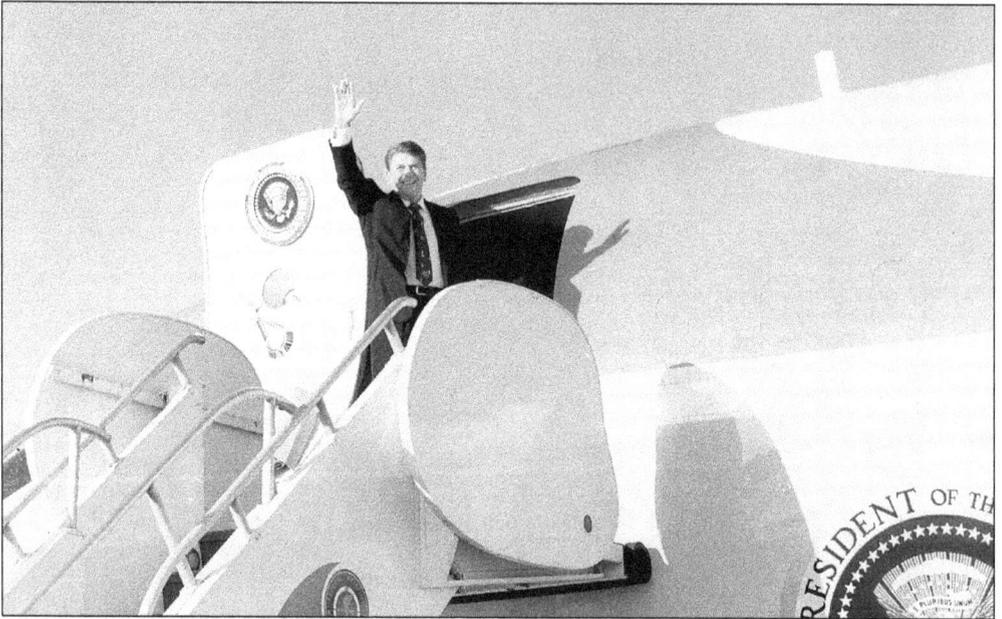

When Reagan stepped off Air Force One at Atlantic City International Airport in Pomona, he had no idea how large a crowd was waiting for him 30 miles away in downtown Hammonton. (Courtesy of Augie Sorrentino.)

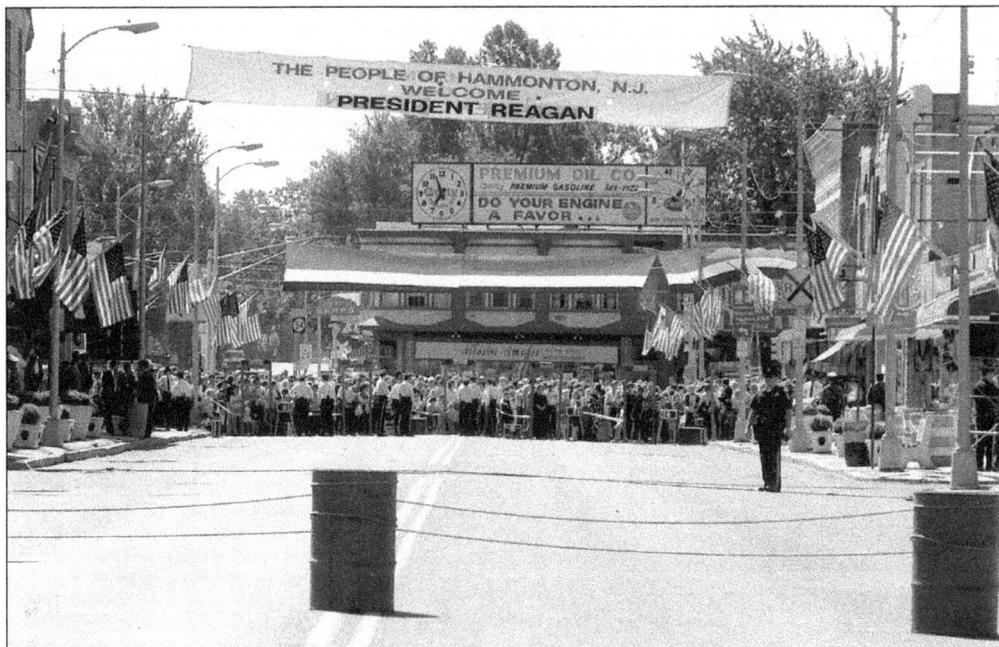

The largest crowd ever to pack downtown Hammonton begins to move up the street. First, the area between Egg Harbor Road and the railroad tracks was filled to capacity. (Courtesy of John Donio.)

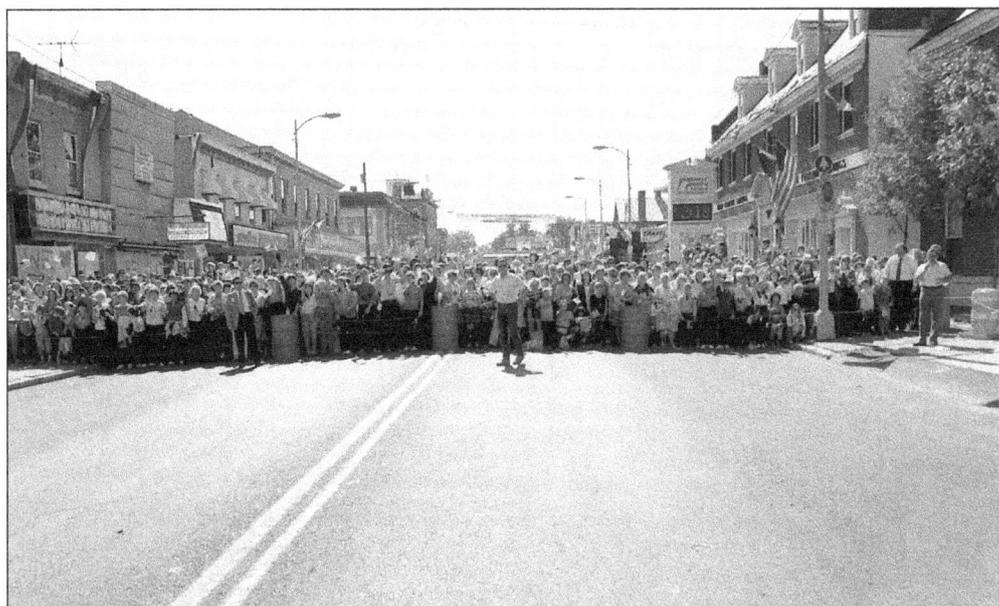

As the crowd filled in, the areas between Egg Harbor Road and Second Street were filled, passing the former sites of Rubba Furniture, Malinsky's store, William Black's store, and others downtown. It went past Dan's Stationery, K & H Auto Stores, and First Federal Savings. The crowd had swollen to more than 30,000 people by the time the area between Second and Horton Streets were filled. (Courtesy of John Donio.)

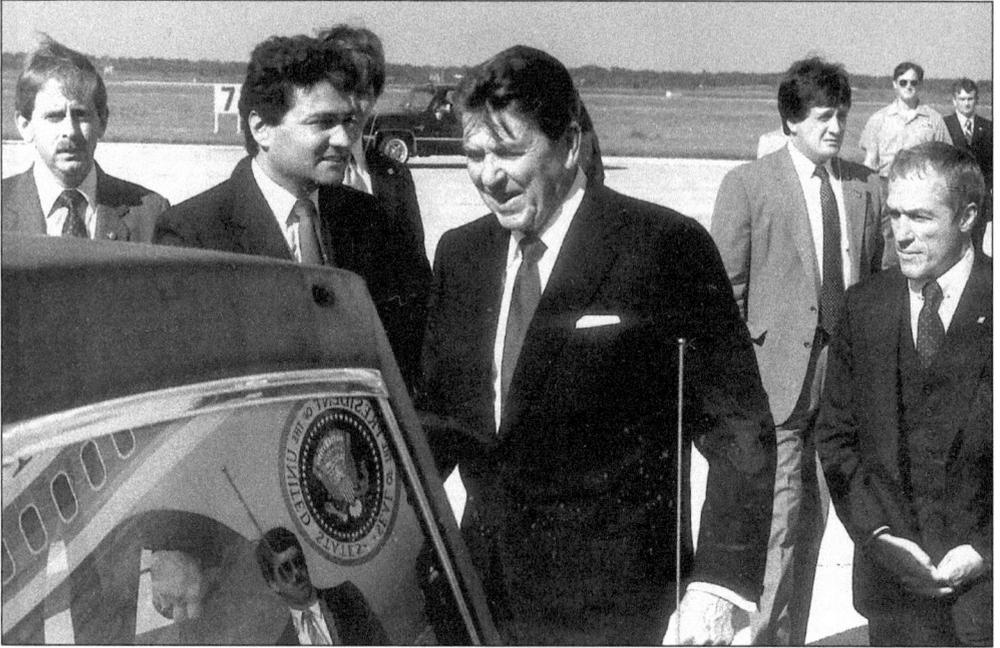

This rarely seen photograph shows a tousle-haired Pres. Ronald Reagan as Secret Service agents hustle him into his limousine for the drive to Hammonton. The presidential seal painted on the side of Air Force One is seen reflected in the car's bulletproof window glass. (Courtesy of Augie Sorrentino.)

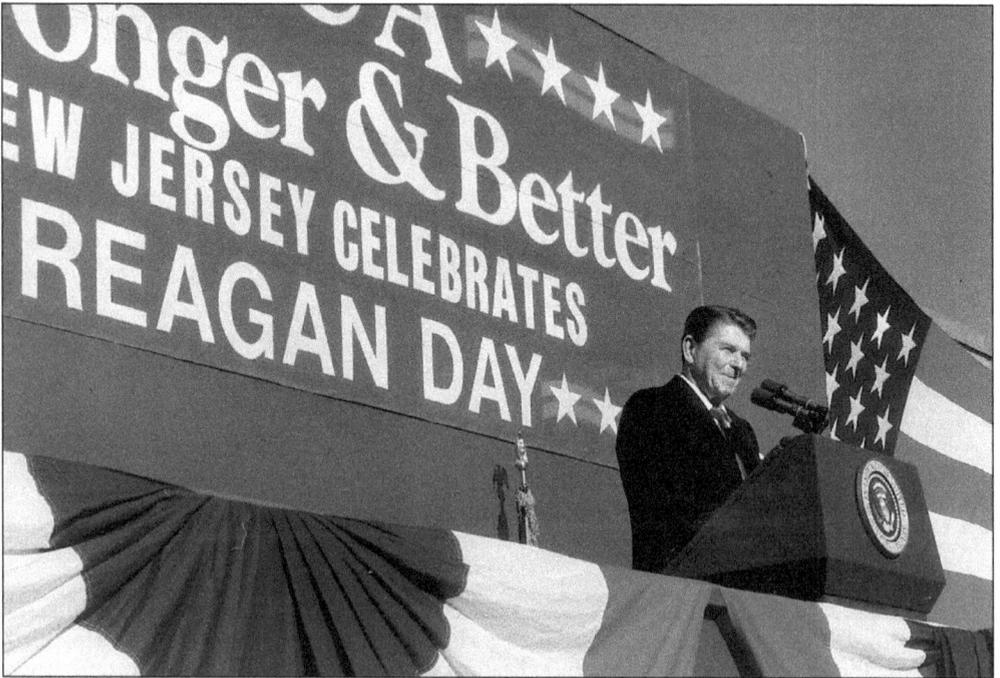

The crowd gave a thunderous roar when Reagan took the stage. "Today my treat is seeing for the first time the Blueberry Capital of the World, the home of the fighting Blue Devils and St. Joe Wildcats," Reagan said. (Courtesy of Augie Sorrentino.)

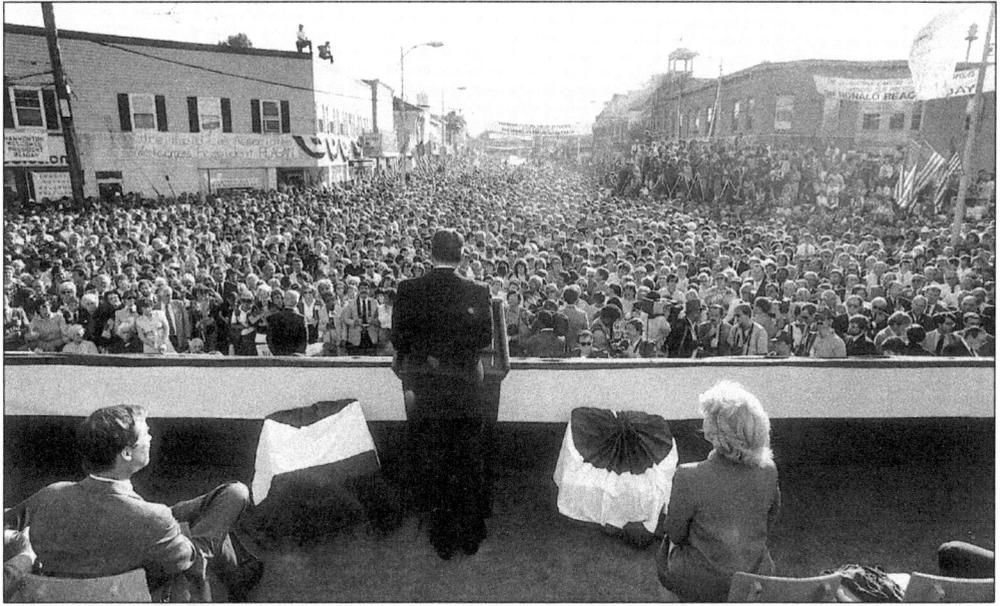

Thousands of people rolled to the horizon on Bellevue Avenue. A sea of people, packed body to body, paid rapt attention to the president as he delivered his address on an incredibly clear and beautiful September day. (Courtesy of John Donio.)

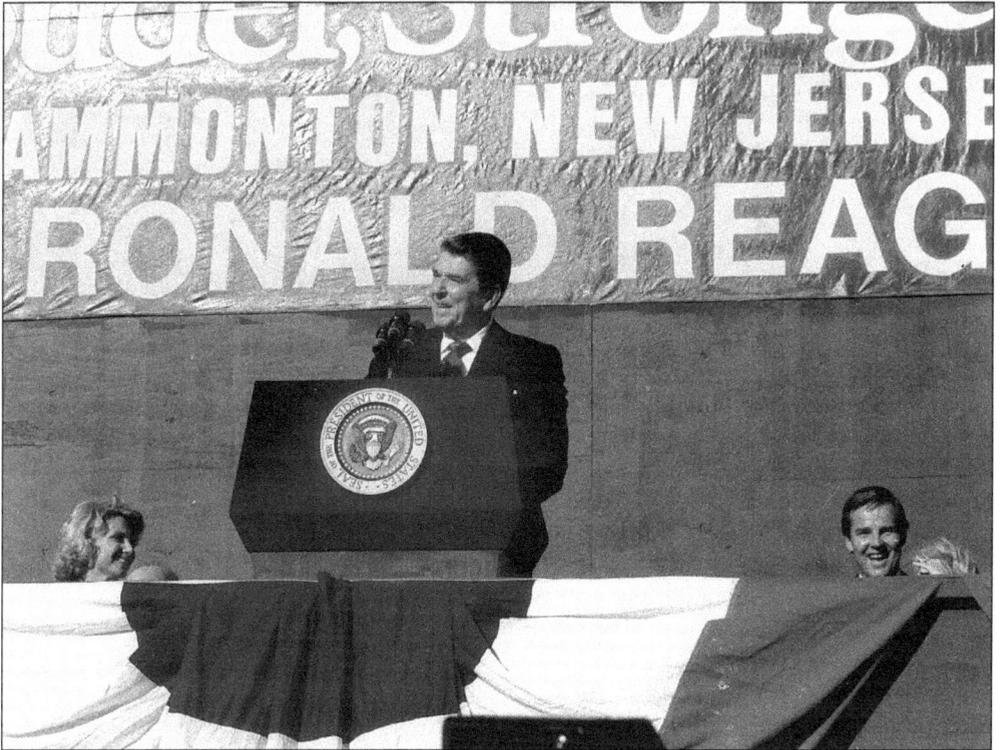

Reagan joked with the audience, throwing off trademark one-liners. "I'm afraid the age issue may be a factor in this election after all. My opponent's ideas are just too old," Reagan said. (Courtesy of Augie Sorrentino.)

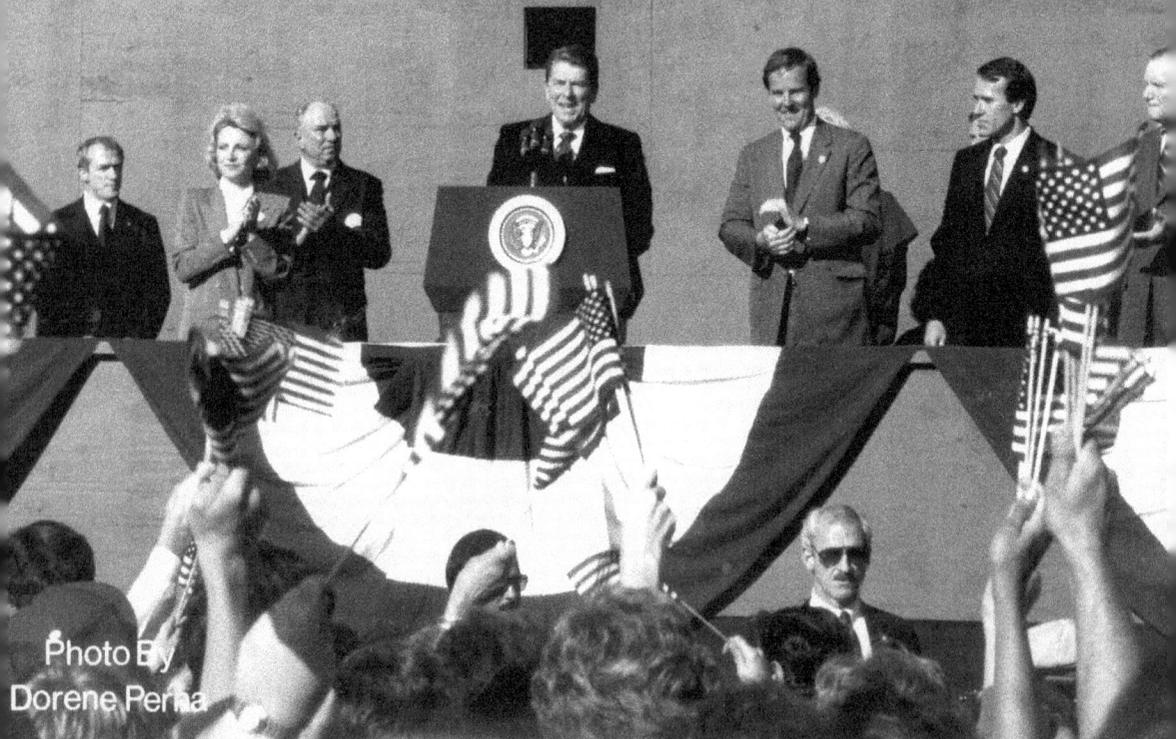

Photo By
Dorene Perna

Patriotic fervor reigned as Reagan seemed to push all of the right buttons. "America's future rests in a thousand dreams inside your hearts; it rests in the message of hope in songs of a man so many young Americans admire: New Jersey's own Bruce Springsteen." Springsteen later remarked how much he resented being co-opted by the Republicans, but the line drew peals of applause in Hammonton. Reagan told the crowd, "Americans like you, and your mothers and fathers and their parents—here in Hammonton I know that means many proud Italians and hardworking farmers who want to keep those farms in your families." (Courtesy of John Donio.)

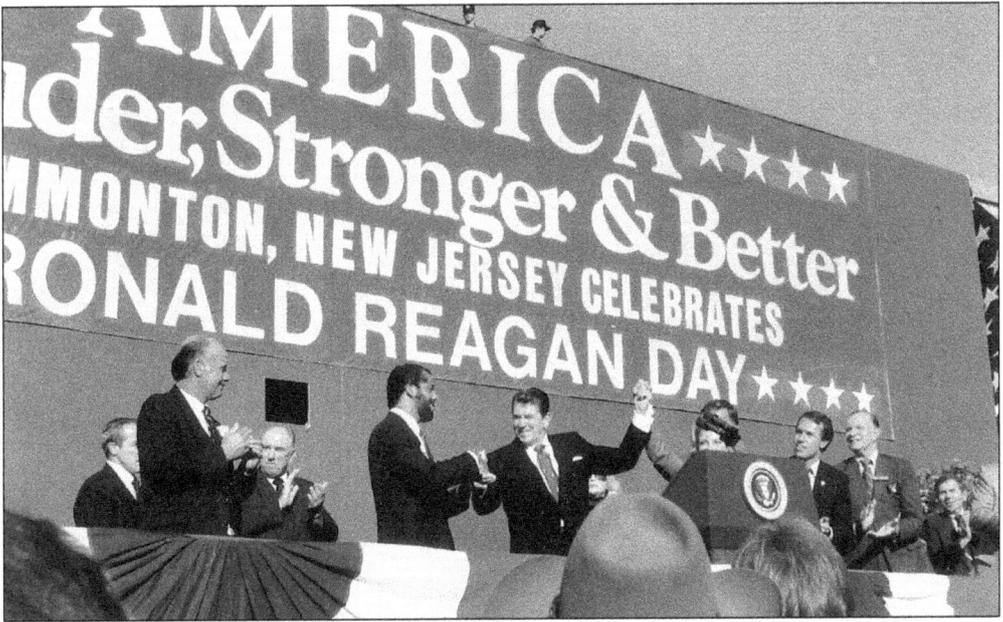

A huge stage was built across Bellevue Avenue for the occasion. It rose nearly as high as the buildings in the downtown area. After the speech, thousands of red-white-and-blue balloons were released from behind the stage. They were released with a bang, and Reagan instinctively ducked below his podium. (Courtesy of John Donio.)

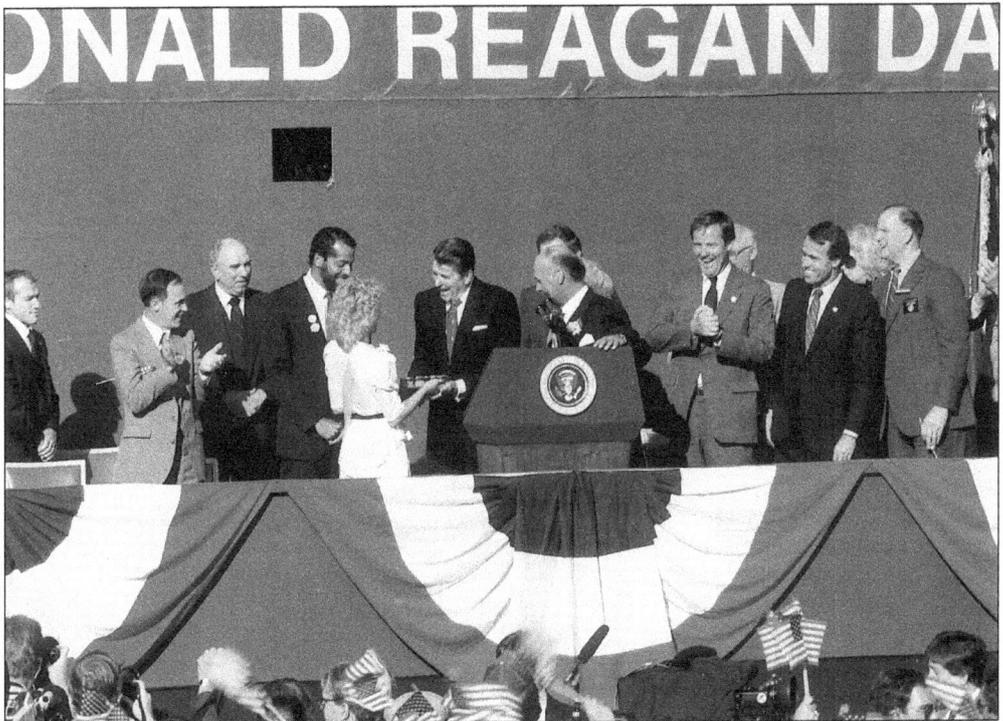

Blueberry Queen Stacy Smith presented Reagan with the signature Hammonton dessert: a freshly baked blueberry pie. (Courtesy of John Donio.)

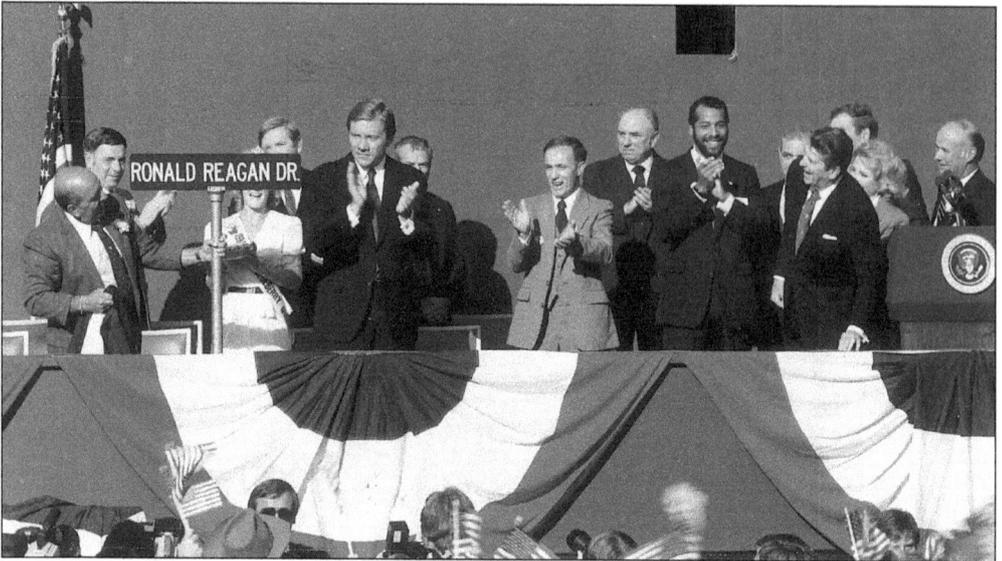

Councilman Andrew Berenato Sr. unveils a street sign with the words "Ronald Reagan Drive" on it. "That's never happened to me before. I'm very honored and very proud," Reagan said. Central Avenue between Vine Street and Bellevue Avenue was renamed in honor of the president. The sign is posted less than 100 feet from where Reagan gave his speech. (Courtesy of James Donio.)

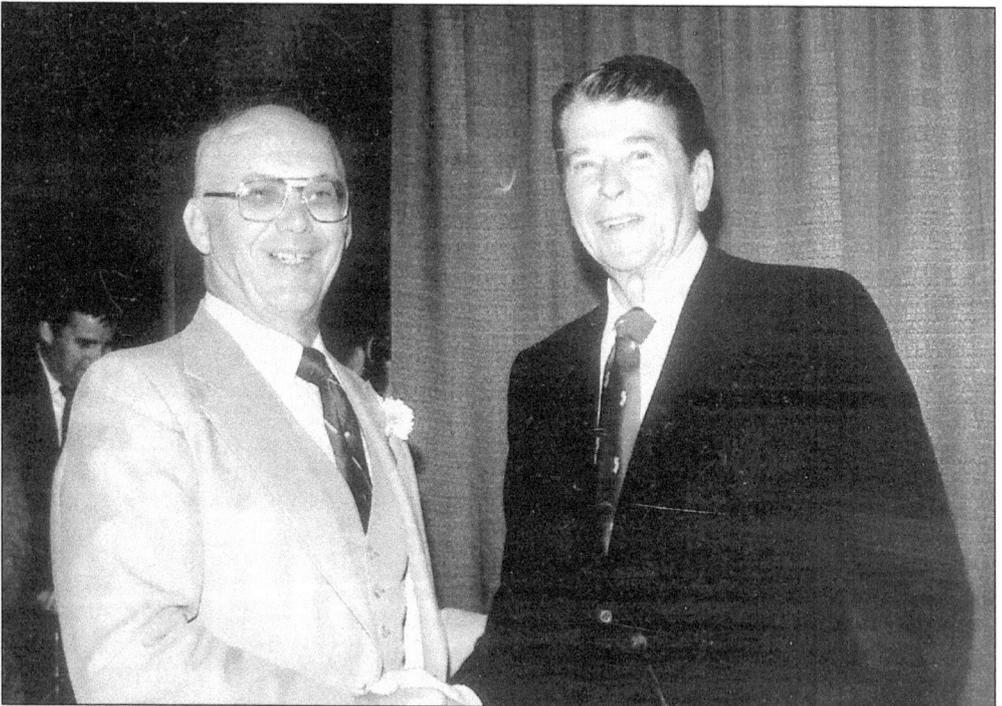

After addressing the general public, Reagan retired to the landmark downtown building once known as the People's Bank and met with local citizens. While inside the bank, the president gave a small speech thanking those who helped organize the event. He poses here with Councilman Frank Weiss. (Courtesy of Angelus and Frank Weiss.)

Eight

THE 1949 LITTLE LEAGUE WORLD SERIES VICTORY

It all began simply, with conversations during the workday at the J.J. Newberry's on Bellevue Avenue in the late 1940s. Albert Mulliner, manager of the store, talked about starting a youth baseball league. Herbert Juliano and William Ordille, who worked at the store, agreed that it was an idea worth pursuing.

One day, Robert Colucci, a police officer who had heard their conversations, came up with the answer: an advertisement in the *Philadelphia Inquirer* promoting Little Big League Baseball, with a photograph of a uniform.

"I think I found what you guys were looking for," Colucci called to Mulliner from across Bellevue Avenue.

Mulliner sent Juliano on a train to Williamsport. He returned with field measurements, and a local replica was built. In 1947, Hammonton founded the first Little League in the state of New Jersey, the first Little League founded outside Pennsylvania.

In the first year of its existence, Hammonton was a team in the tournament then known as the Little Big League World Series. They would go to the tournament three years in a row.

On their third trip, in 1949, with Robert Colucci and Barney Ricci as their coaches, the team from Hammonton, the smallest town in the tournament, dominated the competition. In baseball halls of fame in Cooperstown and Williamsport, the name of Hammonton joined that select group of Little League World Series Champions, and the dream of a few men and women in the 1940s has become a part of local, state, and national history.

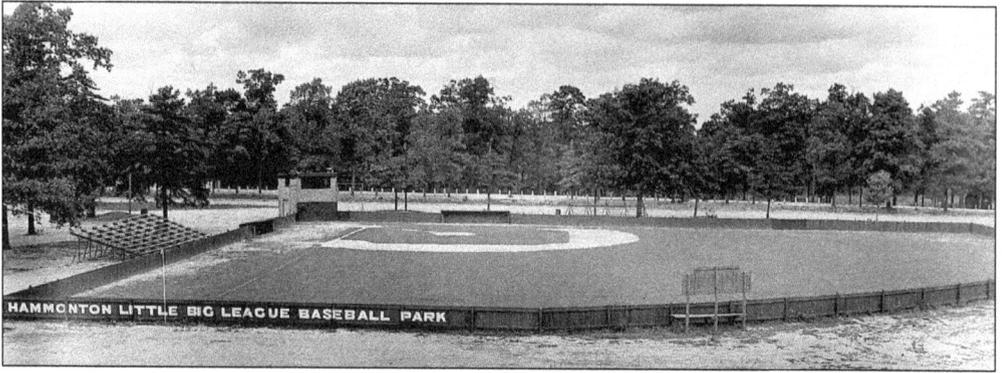

The Hammonton Little Big League Baseball Park at the Hammonton Lake Park is pictured in 1949. Dual Motors won the league championship during the 1949 season, defeating Kern's Drug Store in the league championship series three games to none. (Courtesy of William Ordille.)

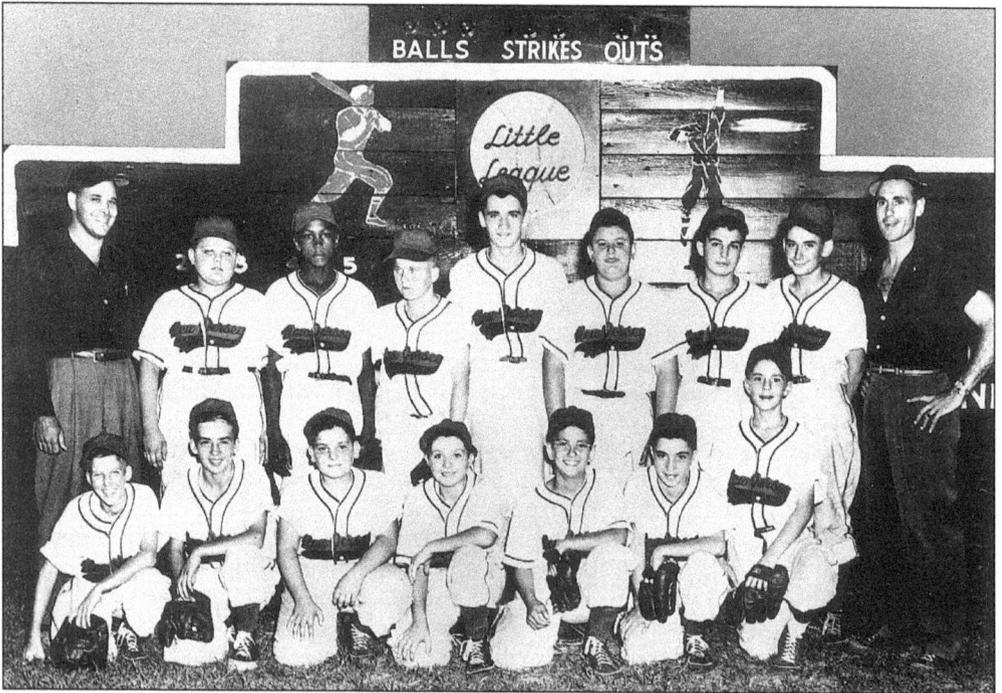

After the regular season, the league sent a team known as the Hammonton All-Stars into the tournament for the Little League World Series. In 1947, Hammonton was the first team outside of Pennsylvania to be invited to the tournament. Pictured from left to right are the members of the 1949 championship team: (front row) Ronnie DeMarco, John Tomasello, Phil DeMarco, Gayton Capelli, Anthony "Nuncie" Sacco, Alfred Marazzi, and Charles "Bucky" Craig; (back row) Barney Ricci (coach), Tom Cardia, Otha Crowder, Billy DeWees, Joseph DiGiacamo, Stephen Mazzeo, Anthony "Blitz" Bilazzo, Jackie Rubba, and Robert Colucci (manager). (Courtesy of William Ordille.)

Jerseys worn by the 1949 Hammonton Little League All-Stars were emblazoned with this felt emblem, which proclaimed their status as New Jersey champions. (Courtesy of Toppy Ricci.)

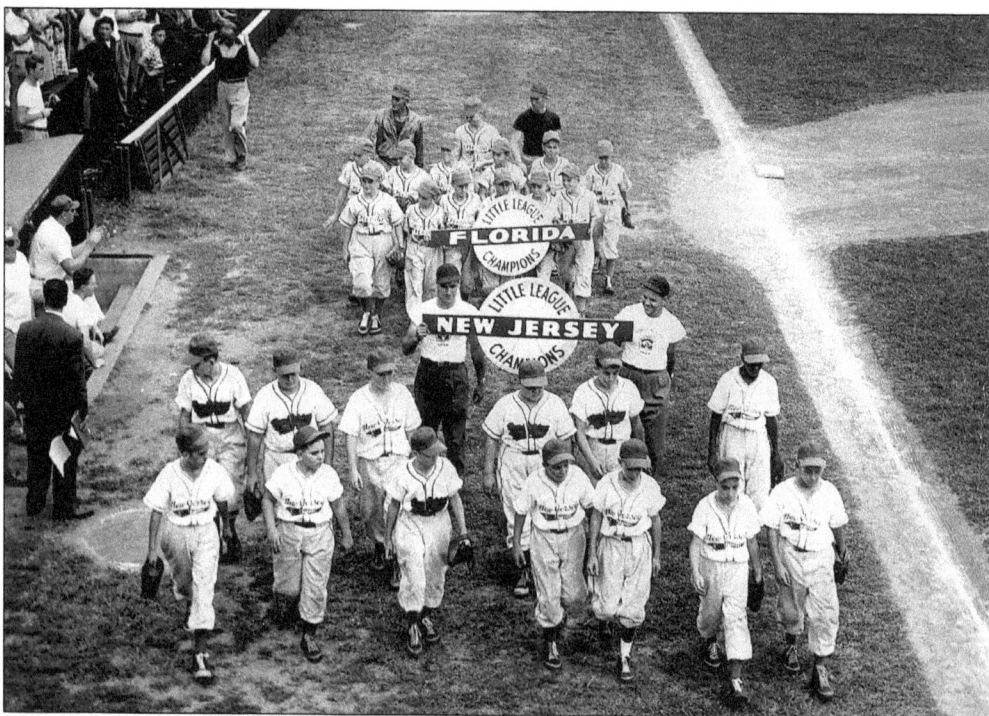

Prior to the championship game, the teams from Hammonton, New Jersey, and Pensacola, Florida, paraded onto the playing field. Robert Colucci (left) and Barney Ricci (right) hold the sign for the New Jersey Little League champions. (Courtesy William Ordille.)

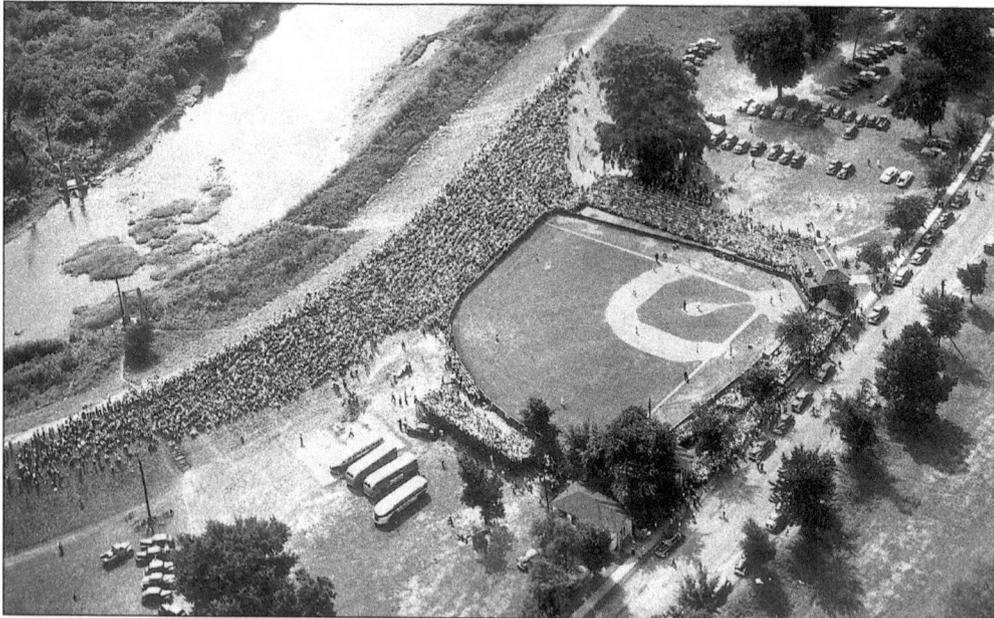

More than 12,000 people attended the final game of the Little League World Series between Hammonton and Pensacola in Williamsport, Pennsylvania, on August 27, 1949. Memorial Stadium and the grassy area in the outfield were filled to overflowing. (Courtesy of William Ordille.)

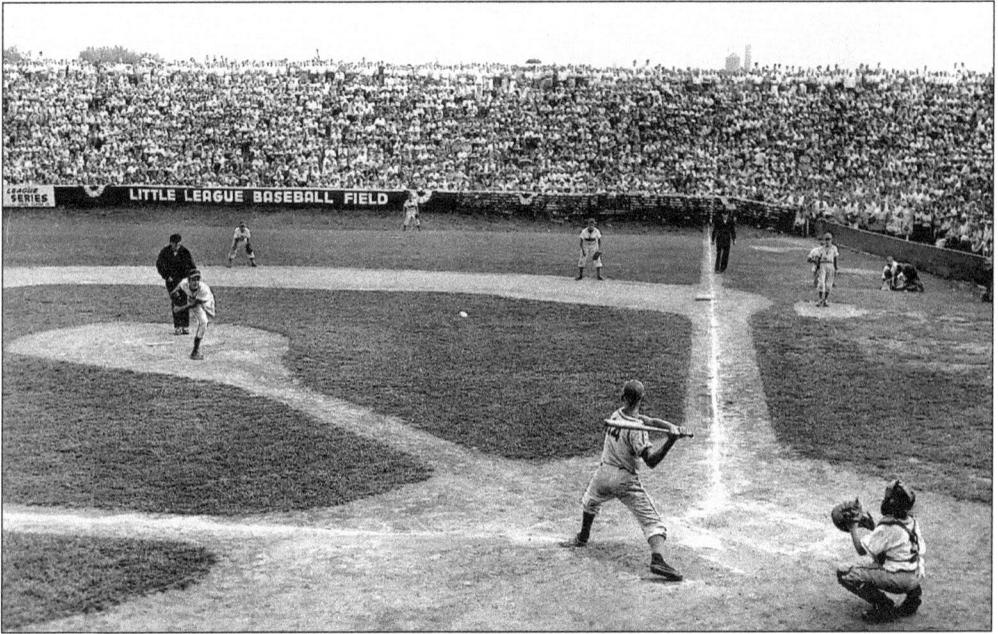

Joseph DiGiacamo fires a pitch during the Little League World Series. The 5-foot 10-inch DiGiacamo was an overpowering left-hander, pitching a 14-strikeout one-hitter. Because of his dominance in the series, the league changed the pitching distance in 1950 from 40 feet to 46 feet, the distance that is still used by Little Leagues throughout the world. (Courtesy of William Ordille.)

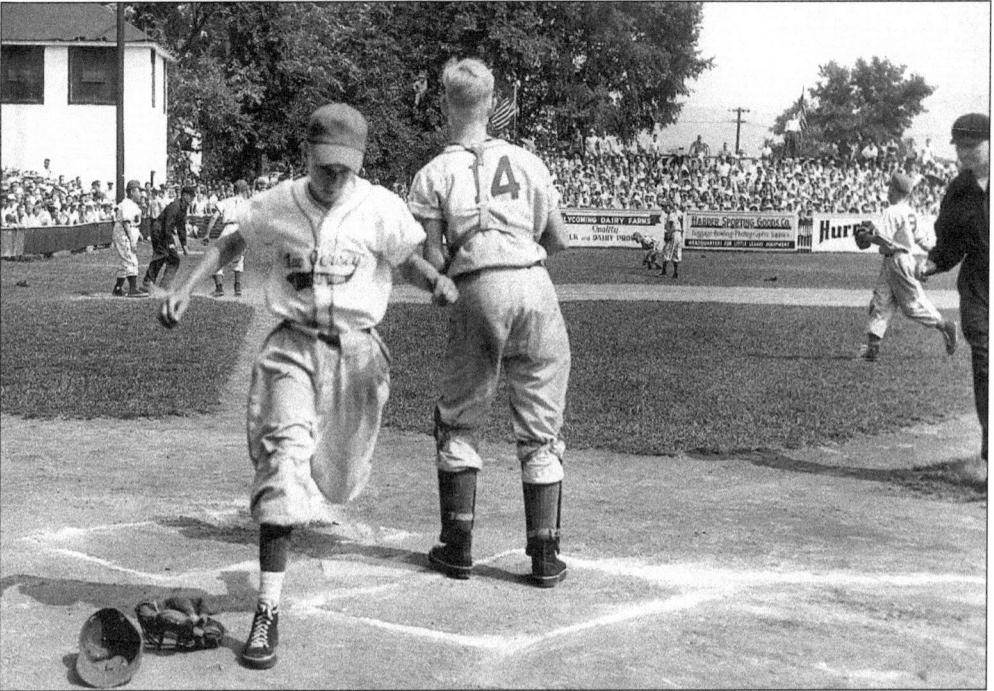

Charles "Bucky" Craig scores a run during the 1949 Little League World Series. Hammonton beat Pensacola 5-0, capturing the title. With a population of 7,668 people, Hammonton was the smallest community participating in the series that year. (Courtesy of William Ordille.)

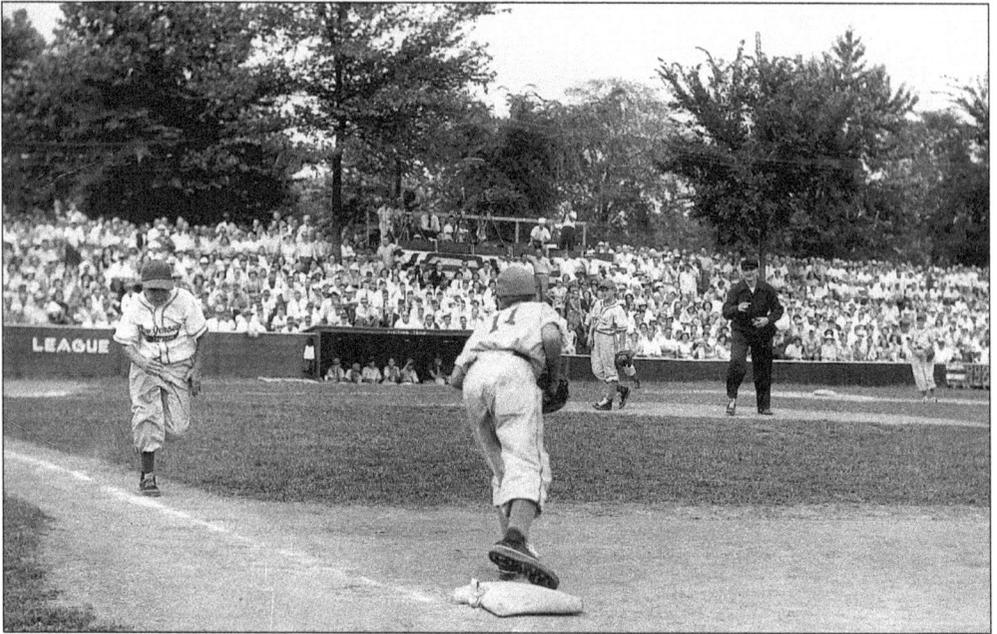

Charging down the first-base line, a Hammonton runner tries to beat the throw to the base. The other teams in the tournament finals that year, with their populations, were Lock Haven, Pennsylvania (10,810); Corning, New York (16,212); Lafayette, Indiana (28,708); Pensacola, Florida (37,449); North Charleston, South Carolina (71,275); Canton, Ohio (108,401); and Bridgeport, Connecticut (147,121). (Courtesy of William Ordille.)

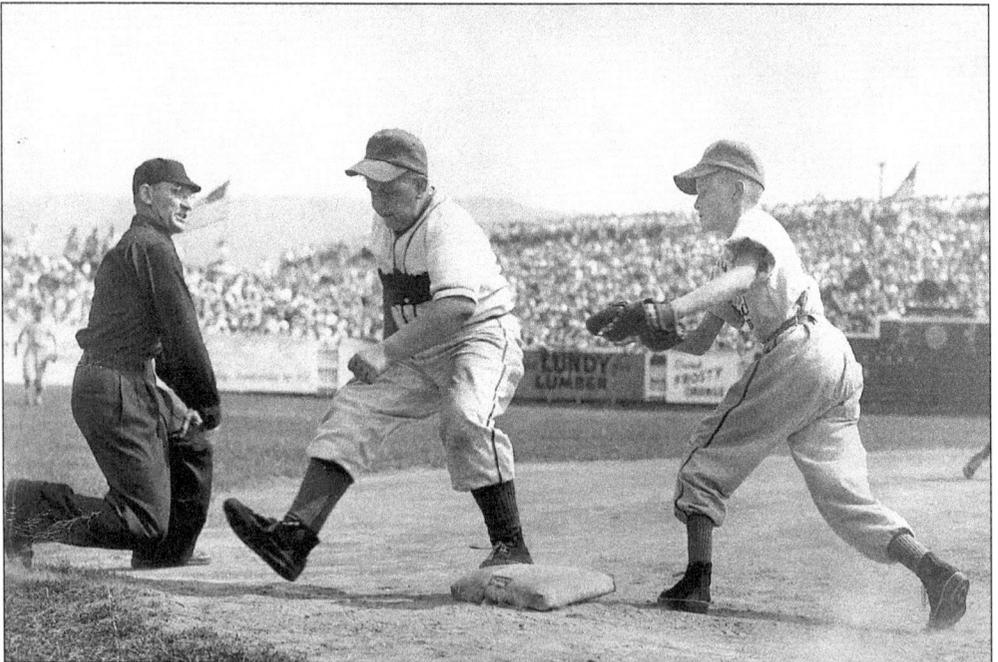

Steve Mazzeo beats the tag at third. Prior to the championship game, local ballplayers were introduced to National League president Ford Frick and Hall of Famer Wee Willie Keeler. (Courtesy of William Ordille.)

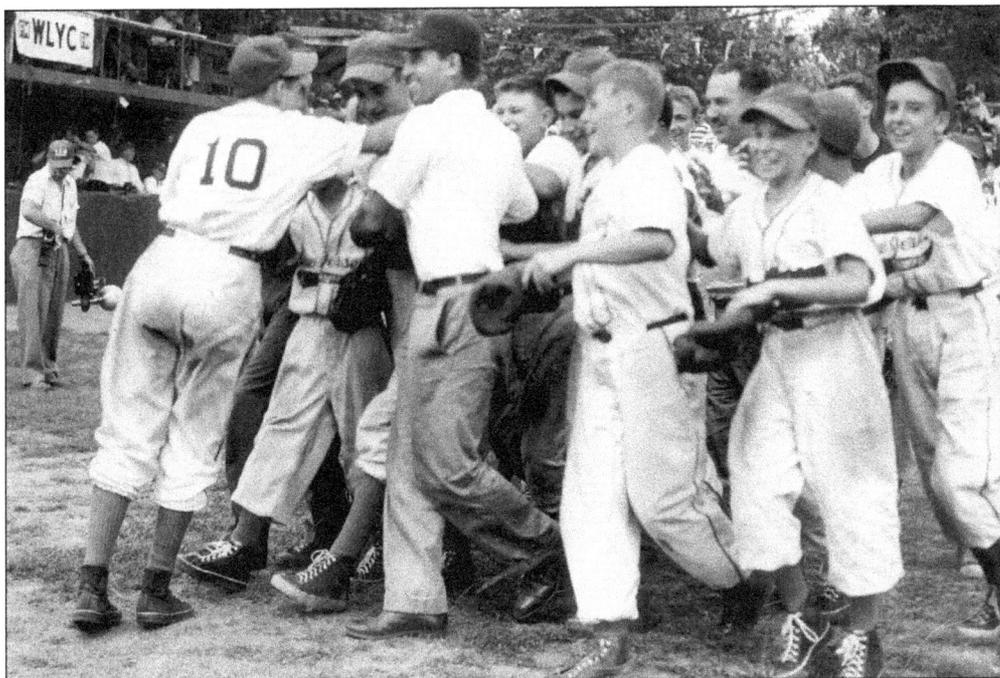

A jubilant Hammonton All-Stars squad celebrates after clinching the 1949 Little League World Series Championship. More than 300 residents of Hammonton made the trip to Williamsport to cheer them on from the stands. Phil DeMarco nearly broke down crying when he saw his father, who worked in construction and rarely took off from work, in the stands. (Courtesy of William Ordille.)

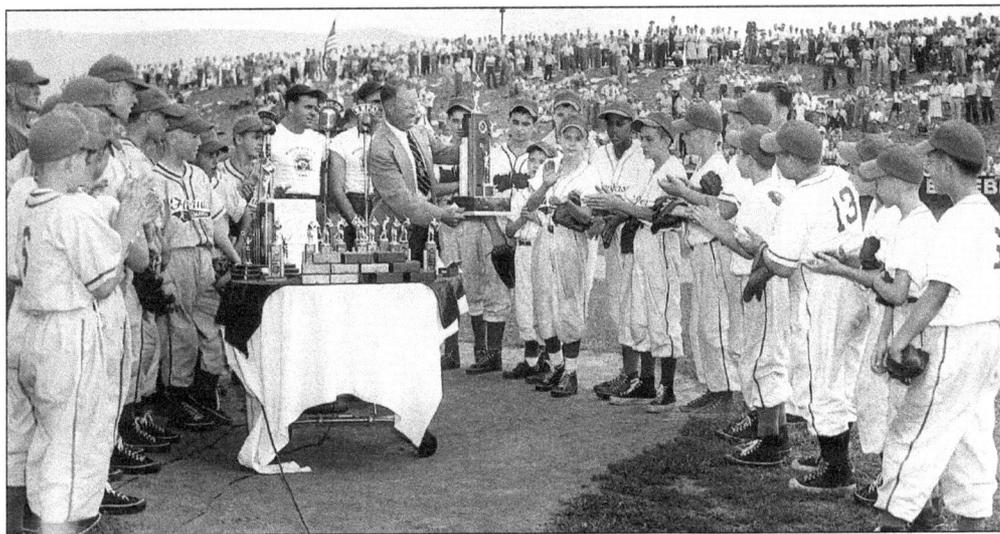

H.E. Humphreys Jr., president of United States Rubber Company (the major sponsor of the Little League World Series in 1949), presents the championship trophy to the members of the Hammonton All-Stars. Otha Crowder, seen near the center of the photograph, was one of the first African Americans to participate in a Little League World Series. He had been to the game for three years, starting in 1947, the year Jackie Robinson broke baseball's infamous "color line," which prohibited black players in the major leagues. (Courtesy of William Ordille.)

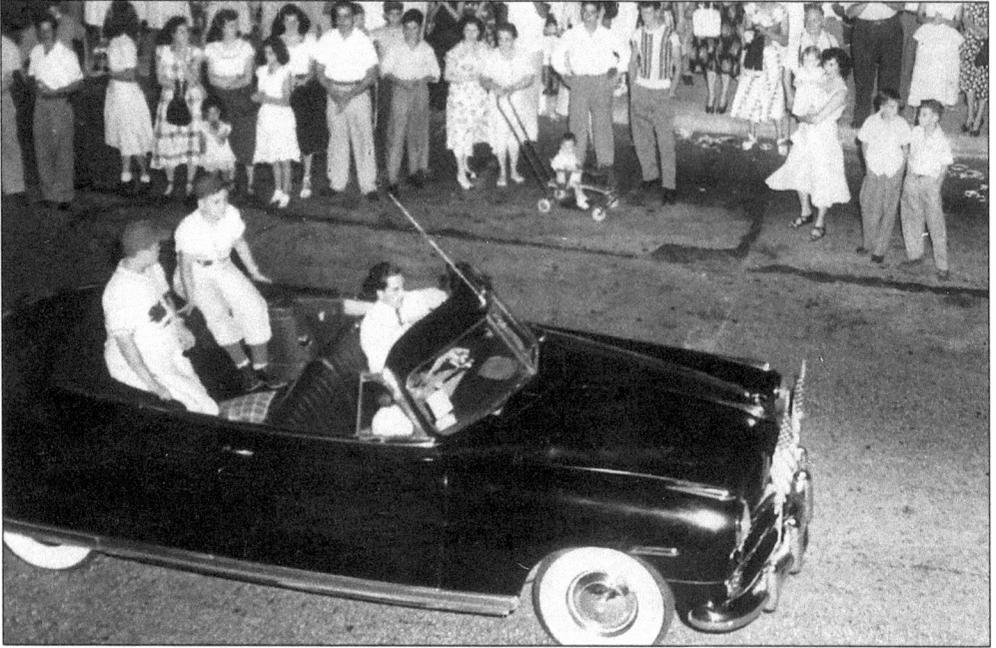

More than 8,000 people (more than the population of Hammonton at the time) lined the parade route downtown when the team made its victorious return from Williamsport. "As an 11-year-old," Anthony "Nuncie" Sacco recalled, "I just didn't realize the importance of winning the game. We were awestruck at the outpouring of affection from the town when we returned home." (Courtesy of Toppy Ricci.)

On the 40th anniversary of the team's victory, members of the 1949 Hammonton All-Stars paid homage to the team that won it all on the same field where Dual Motors defeated Kern's Drug Store four decades earlier. (Courtesy of William Ordille.)

Albert Mulliner, founder of the Hammonton Little League, received the chamber of commerce's Nice Going Award in 1989. When Mulliner was told that Otha Crowder could not attend the 1947 Little League Series because he was black, he told the league either Hammonton's entire team would go, or they would not come at all. The league relented, and Crowder went to the 1947, 1948, and 1949 World Series. (Courtesy of William Ordille.)

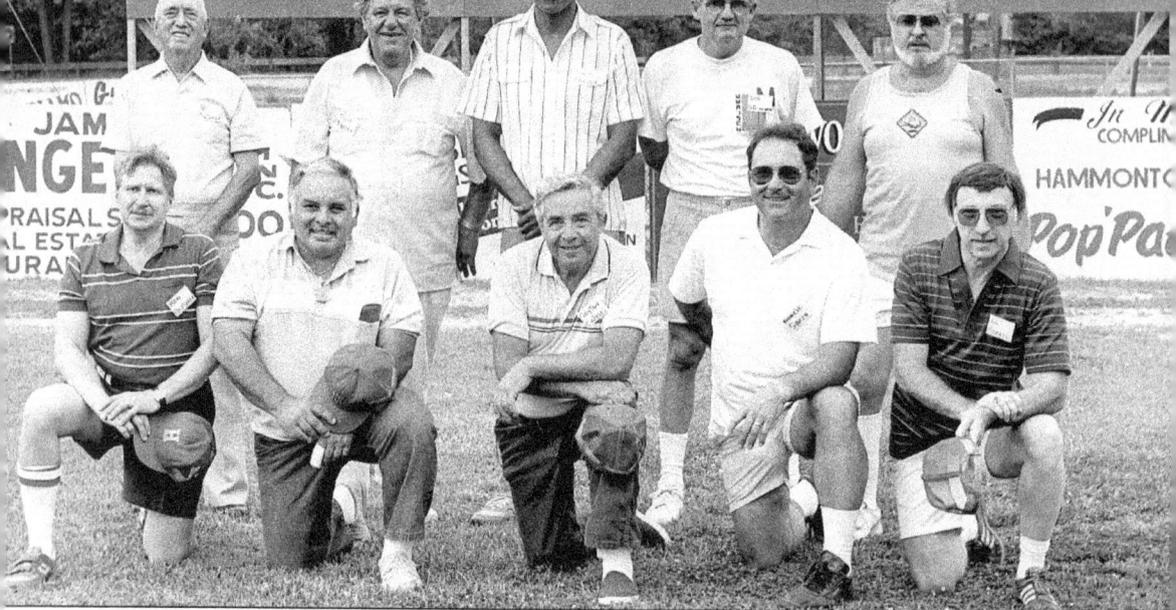

HAMMONTON LITTLE LEAGUE **1949 WORLD CHAMPIONS**

| 1 GAYTON CAPELLI | 2 RONALD J. DiMARCO, JR. | 3 PHILIP DiMARCO, JR. | 4 ALFRED J. MARAZZI | 5 JOHN R. TOMASELLO | 6 NUNCIE J. SACCO | 7 CHARLES CRAIG | 8 ROBERT DEWEES | 9 OTHER CROUDER, JR. |
| 10 JACKIE RUBBA | 11 ANTHONY BILAZZO, JR. | 12 JOSEPH DIGIACOMO | 13 THOMAS CARDIA | 14 STEPHEN MAZZEO | ANTHONY DiGIACOMO BATBOY | ALBERT MULLINER LEAGUE PRES. | BOB COLUCCI MANAGER | BARNEY RICCI MANAGER |

ROBERT LLOYD LEAGUE PRES. 1989

Members of the 1949 team returned to the Hammonton Little League field for the 40th anniversary of their victory in Williamsport. Pictured from left to right are the following: (front row) Ron DeMarco, Phil DeMarco, Gayton Capelli, Anthony "Nuncie" Sacco, and Alfred Marazzi; (back row) Albert Mulliner, Steve Mazzeo, Otha Crowder, Joseph DiGiacamo, and Charles "Bucky" Craig. (Courtesy of William Ordille.)

Nine

RELIGIOUS LIFE

Religion was paramount to the early Hammontonians. The Baptists, Presbyterians, and Methodists built the town's first churches. Successive generations added places of worship, including three Roman Catholic churches; two Assembly of God churches; the Temple Beth-El synagogue; Kingdom Hall of Jehovah's Witnesses; the Church of Christ, Scientist; and Victory Bible Church.

A tradition that spans three centuries, the annual Feast of Our Lady of Mount Carmel is the most prominent annual religious and social celebration in Hammonton.

The week-long festival has grown and changed since its inception in 1875, but its inherent goals have always been the same—to give prayerful thanks for life's blessings and to celebrate those blessings with friends and family.

Italian immigrants who had come to Hammonton to find work in the fields of its fruit and vegetable farms began the festa on Pine Road, where a monument now stands to mark those early celebrations, removed from the center of the town.

In later decades, as the Italian immigrants grew in number, the feast took on new dimensions. The feast moved to the center of the community. Plaster statues of saints from St. Joseph's Roman Catholic Church were removed from the church and placed on rolling carts. A solemn procession wound its way through the streets of Hammonton each year on the feast day, July 16.

The Our Lady of Mount Carmel Society, founded in 1875, still organizes the feast and its accompanying carnival. Food stands line the streets around the St. Joseph's Roman Catholic Church, and new immigrants (from Puerto Rico, Mexico, Haiti, and elsewhere) have joined the celebration.

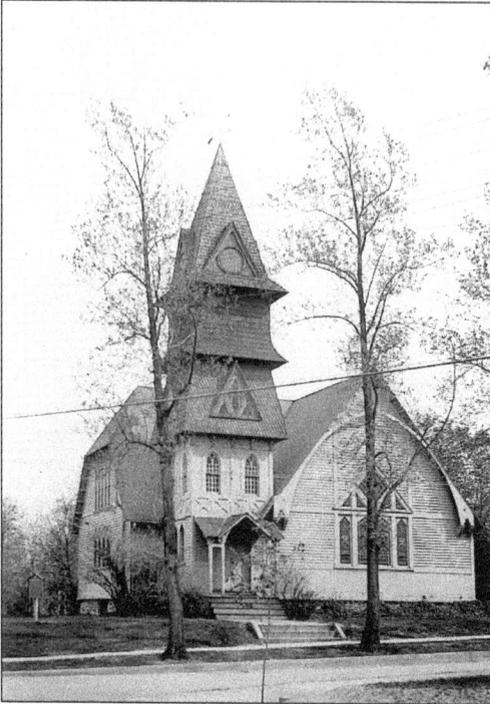

The Universalists and Unitarian Society built this church on the corner of Central Avenue and Peach Street in 1887. By the 1920s, when this photograph was taken, the church building had been sold to the Episcopalians and renamed St. Mark's. The unique steeple was later replaced. (Courtesy of Josephine and Vincent Giannini.)

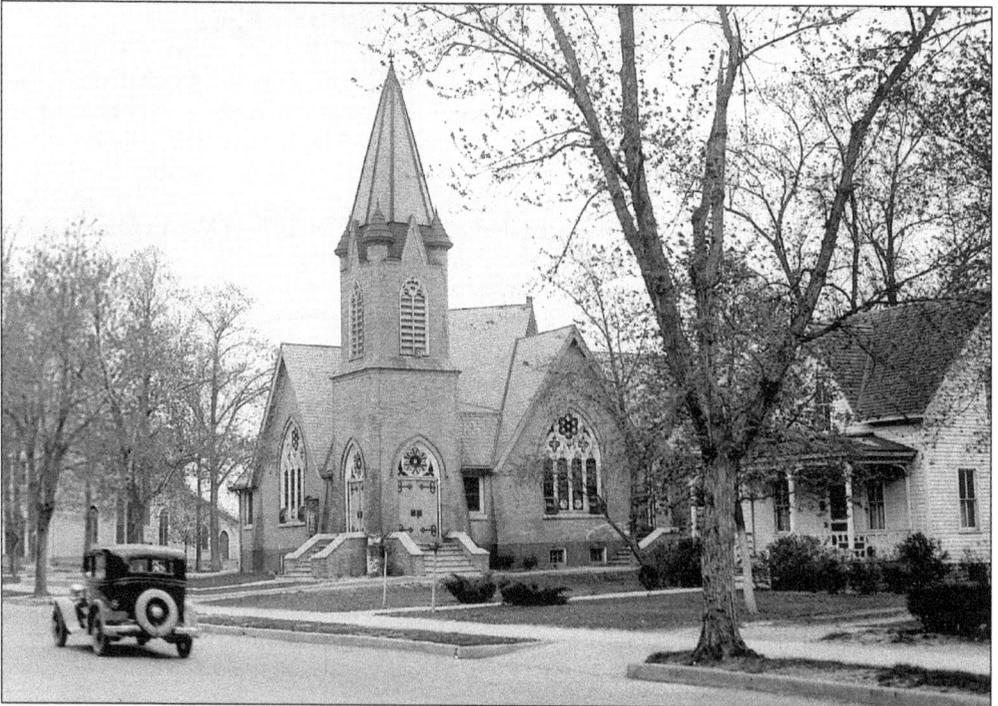

Hammonton Presbyterian Church and its parsonage are shown on Bellevue Avenue in the 1920s. The signature doors of the church were later replaced. In the summer, the doors were left open, and large screen doors allowed for ventilation. The copper on the steeple was replaced with new copper in 2001. (Courtesy of Josephine and Vincent Giannini.)

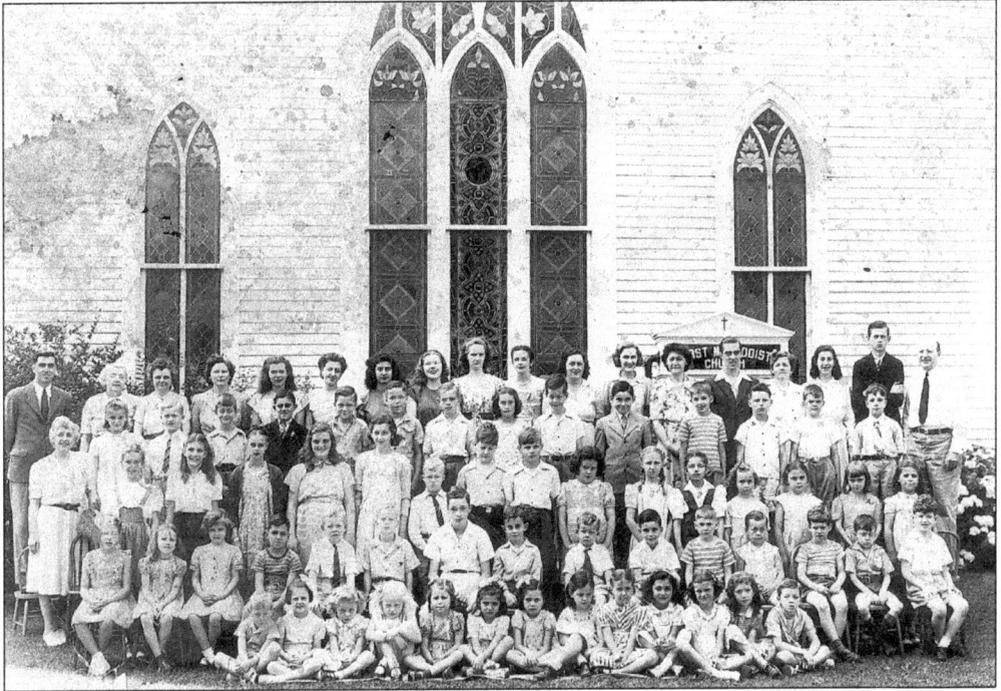

Vacation Bible school students pose in front of the First Methodist Church on Bellevue Avenue in the 1940s. The Methodists and the Presbyterians would often hold classes together during the summer. (Courtesy of Dorrine Esposito.)

This wintry scene on Central Avenue in the 1920s shows icicles hanging from the roof of the First Church of Christ, Scientist. Eventually, the Hammonton Arts Center was housed in the former church building. (Courtesy of Josephine and Vincent Giannini.)

St. Joseph's Roman Catholic Church was only a few years old when this photograph was taken in the mid-1920s. The church, built in 1919, was constructed of brick and featured an ornate altar with a large fresco painted above it. (Courtesy of Josephine and Vincent Giannini.)

Hammonton Baptist Church's original building is shown as it appeared when moved to the corner of Third and Vine Streets in April 1885. The church was formally organized in Hammonton in 1859, but a structure was not built until 1862. (Courtesy of the Hammonton Historical Society.)

The First Methodist Church, on Vine Street and Bellevue Avenue, originally had a much taller steeple. In the 1920s, that steeple was still visible. It was later removed, and the steeple was given its current appearance. (Courtesy of Josephine and Vincent Giannini.)

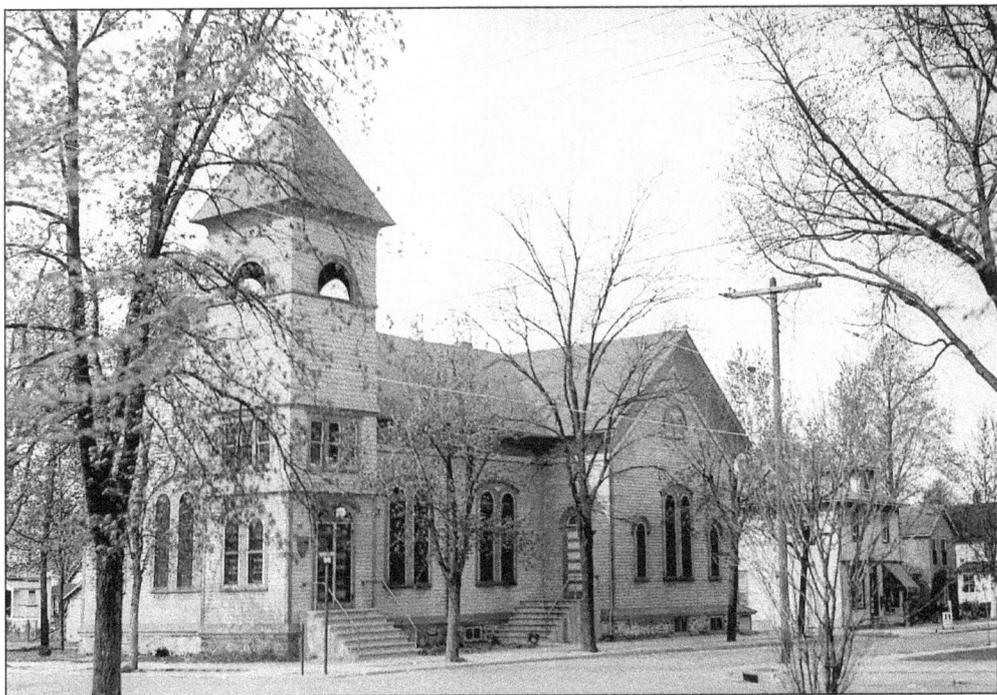

Later additions enlarged the Hammonton Baptist Church. By the 1920s, the building had a much larger steeple and an addition on the back. The homes on Vine Street behind the church were demolished to make way for a parking area. (Courtesy of Josephine and Vincent Giannini.)

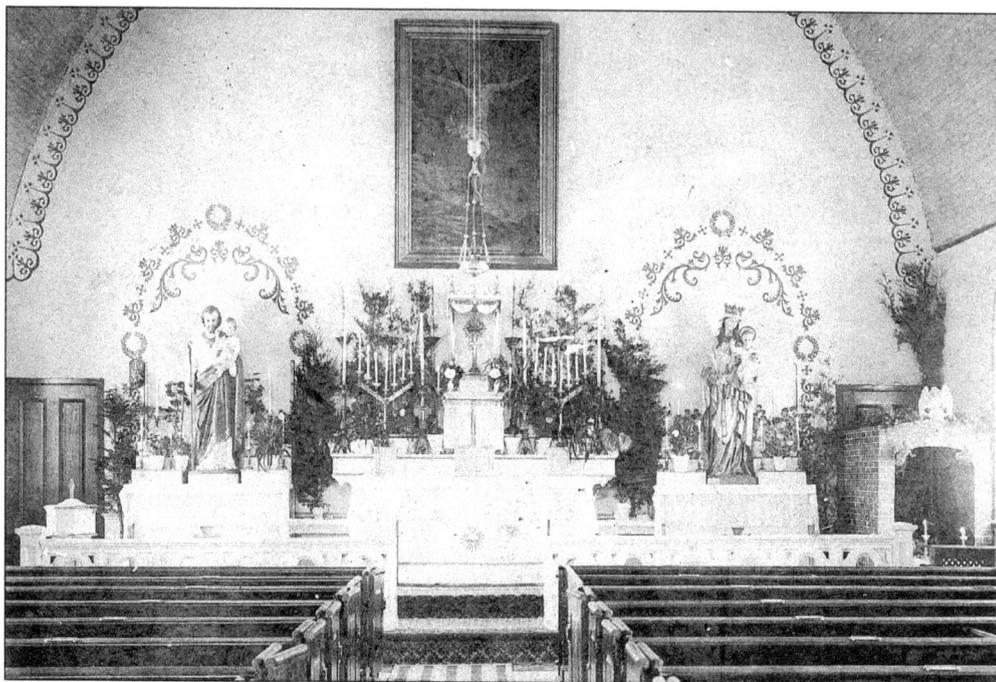

A view of the altar of the 1886 St. Joseph's Roman Catholic Church shows the plaster statues of St. Joseph and Our Lady of Mount Carmel that are still used in the current church, the third to bear the name of St. Joseph. (Courtesy of Anthony Macri and Connie Lindsey.)

Rev. Umberto Carta was the first pastor at St. Anthony de Padua Roman Catholic Church, on Route 206. St. Anthony's was built in 1968. It was the third and final Catholic church built in Hammonton.

St. Martin de Porres Church, on Egg Harbor Road, is pictured shortly after its completion and dedication on Sunday, December 13, 1964. (Courtesy of the Hammonton Historical Society.)

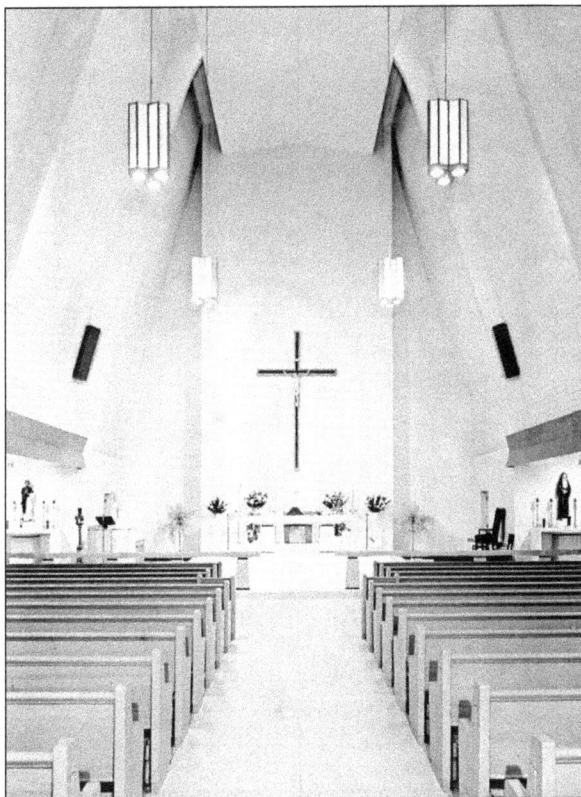

This view shows the St. Anthony de Padua Roman Catholic Church just before the new church's dedication on November 24, 1968. The church hall and its attached rectory were meant to serve the Catholic population in the northern area of Hammonton. (Courtesy of the Hammonton Historical Society.)

Temple Beth-El, on Bellevue Avenue, was dedicated on June 25, 1937. The synagogue was the third (and most permanent) place for Jewish worship in Hammonton. Originally, members of the congregation met in the town's Masonic Temple. Later, they met on the second floor of what was then known as the Malinsky building, at 100 Bellevue Avenue.

Kingdom Hall, the place of worship for local Jehovah's Witnesses, is pictured on Chew Road in the 1960s. The history of the local Jehovah's Witnesses begins in 1922, when Gaetano Galletta began the formation of a church on Messina Avenue.

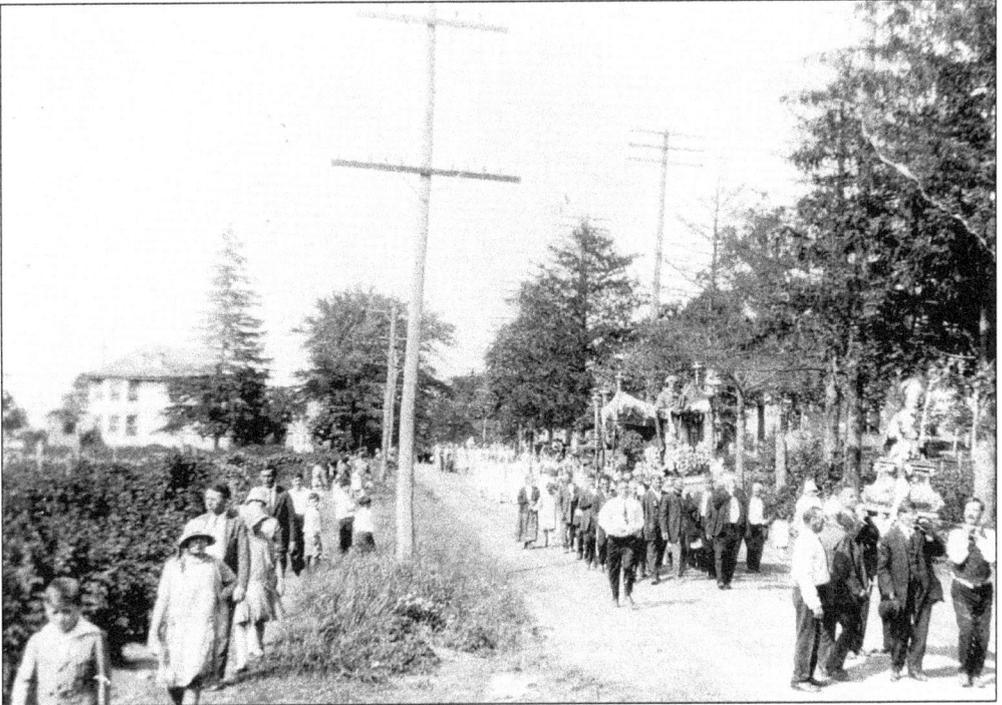

The Feast of Our Lady of Mount Carmel, with its procession of saints, is rooted in Italian tradition. It originated in 1875, at the home of Antonio Capelli at 232 Pine Road. This photograph was taken on Fairview Avenue in the 1920s. (Courtesy of the Our Lady of Mount Carmel Society.)

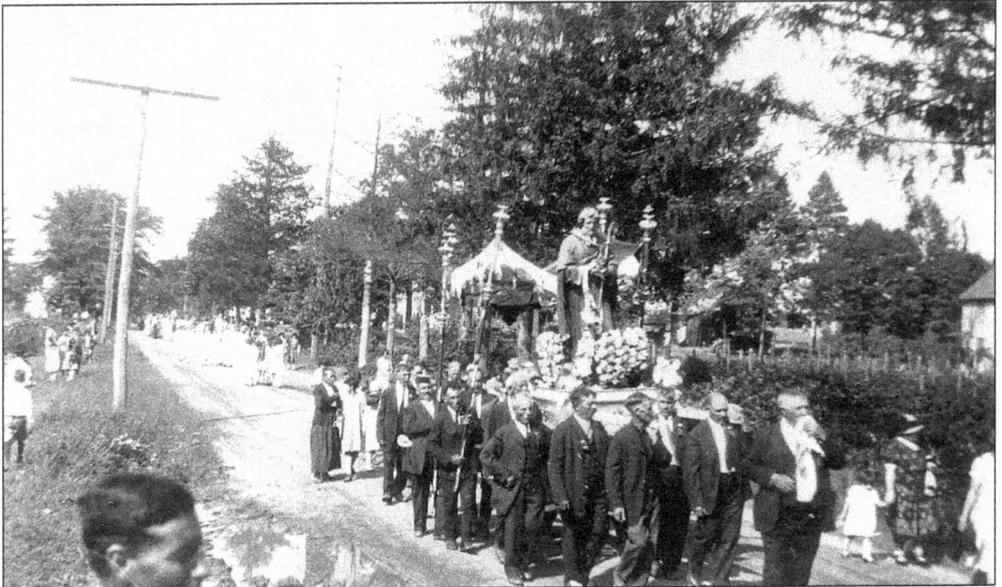

This 1920s photograph offers another view of the procession. The dress was formal, with men wearing full suits and carrying statues of the saints on their backs. Immigrants from Italy prayed in thanks for their safe passage to the United States and for prosperity and success in Hammonton. (Courtesy of the Our Lady of Mount Carmel Society.)

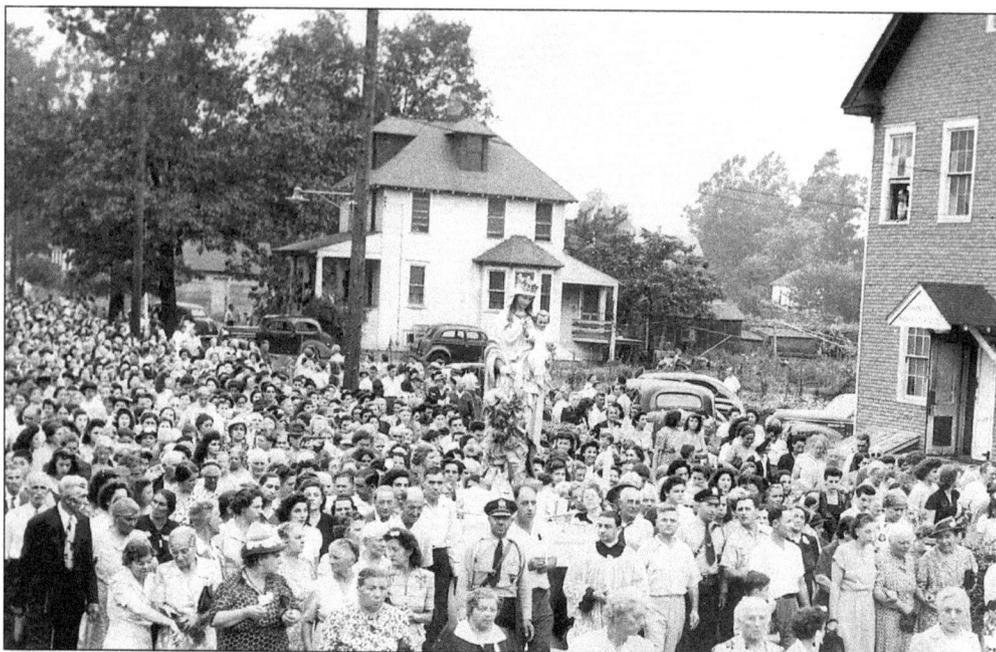

By the 1930s, the influx of Italian immigration in the surrounding area and Philadelphia had brought much larger crowds. Thousands descended on Hammonton, many arriving by train and walking to the area around St. Joseph's Roman Catholic Church, where they would follow the procession. (Courtesy of Augie Sorrentino.)

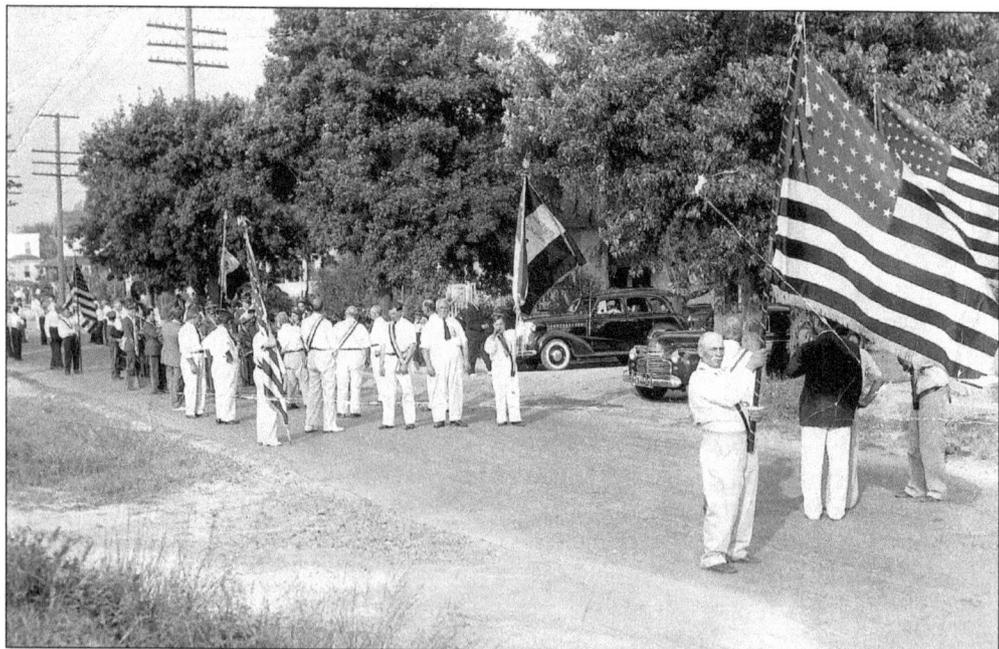

In the 1940s, tensions grew between the United States and Italy. The procession took on a more patriotic flair, and large American flags were added. It was a difficult time for local people of Italian descent—their children were going to war against a nation that many of them had once called home. (Courtesy of the Our Lady of Mount Carmel Society.)

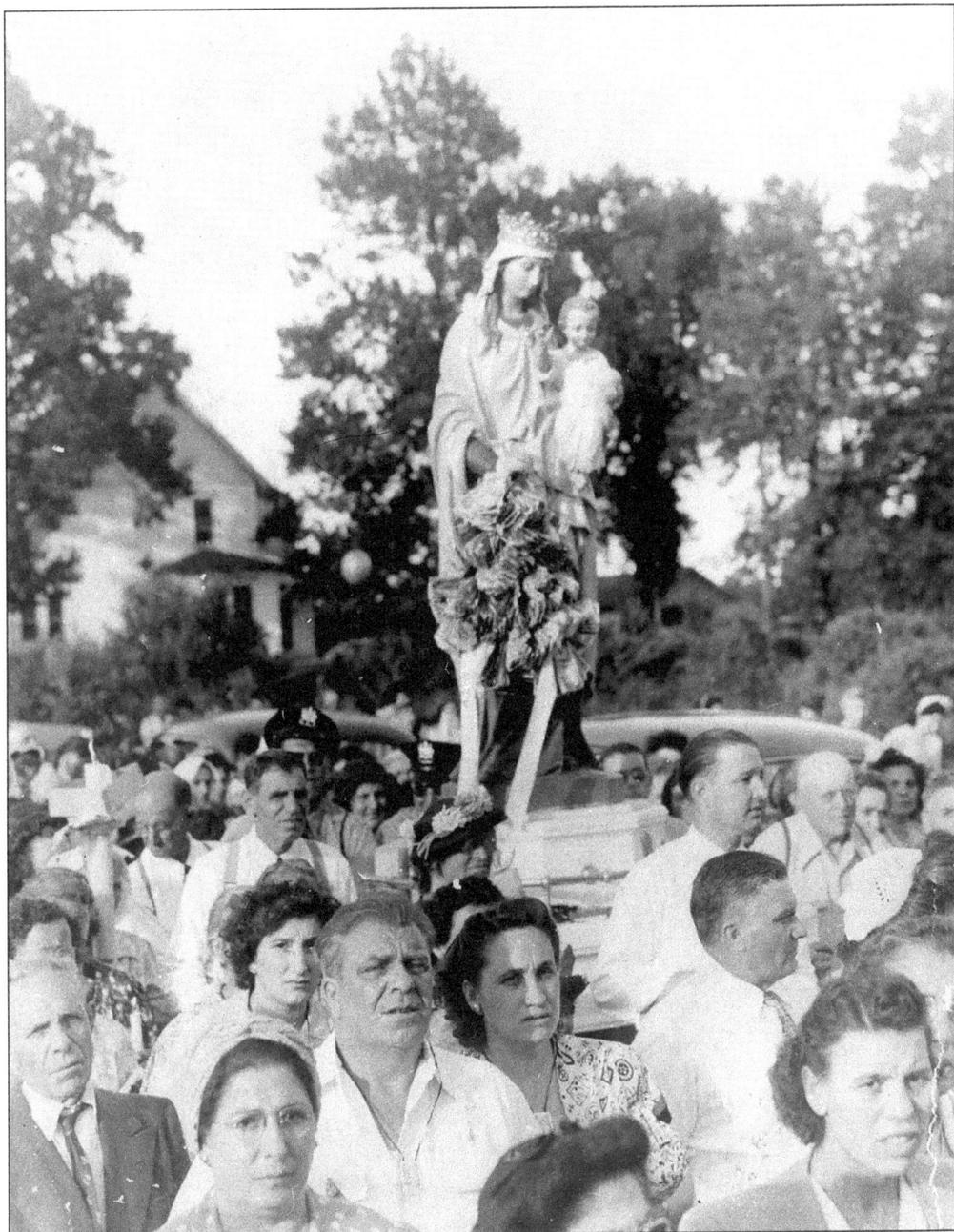

With so many of their children and family members away at war, tens of thousands of people attended the festival during World War II, praying for their loved ones' safe return. (Courtesy of the Our Lady of Mount Carmel Society.)

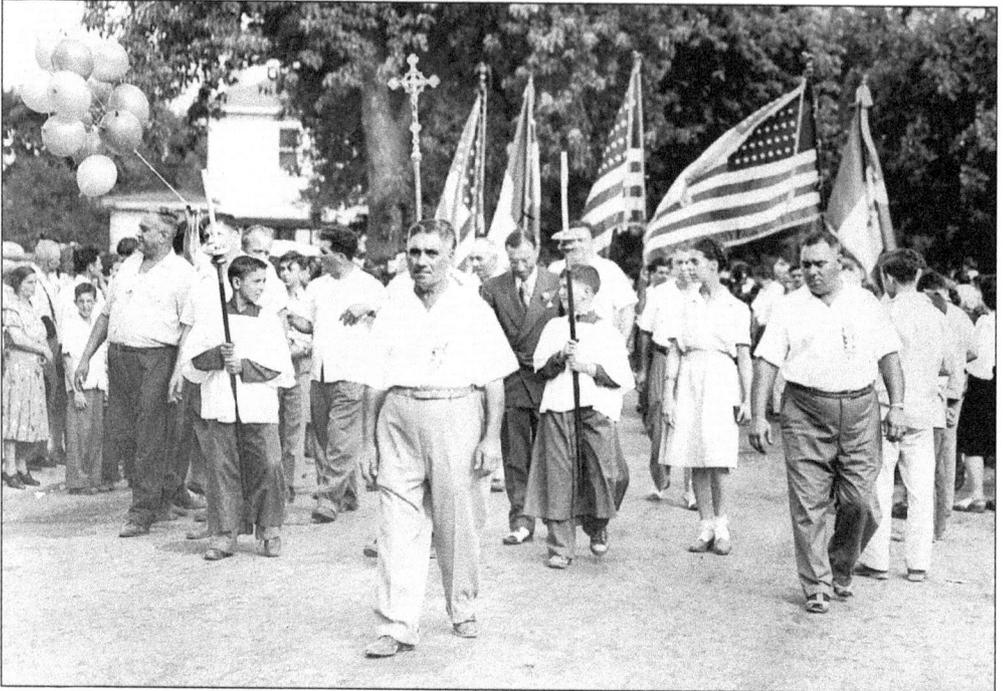

Altar boys carry candles in this view of the procession from the early 1940s. While the focus was on religion, there was always a carnival atmosphere around the feast, as evidenced by the balloons to the left. (Courtesy of the Our Lady of Mount Carmel Society.)

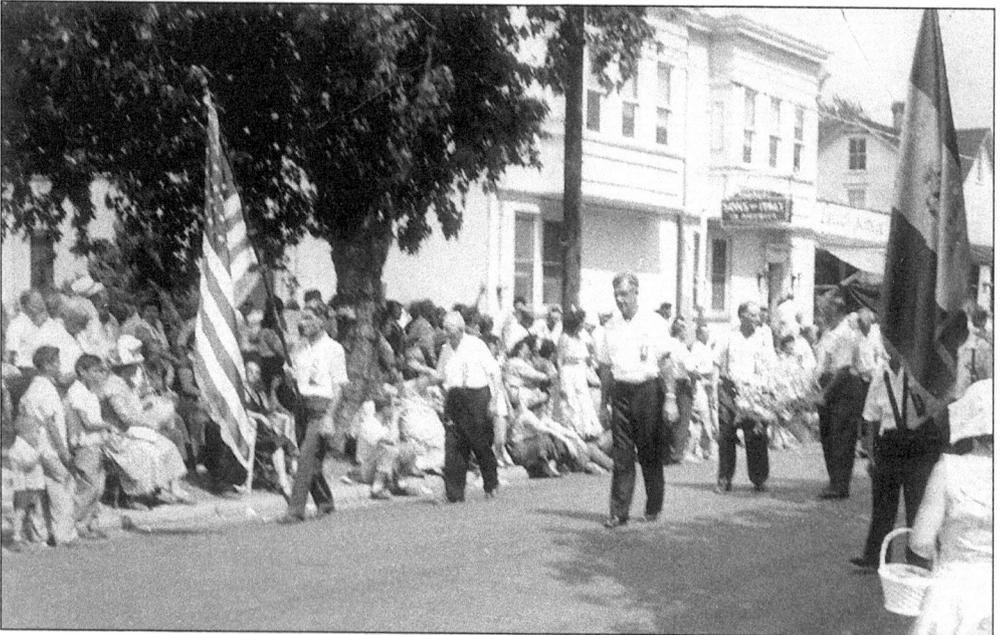

The procession passes by the Sons of Italy Hall on Third Street during the 1940s. The Assumption Society and the St. John the Baptist Society also hold processions and religious festivals in Hammonton, but neither rivals the longevity and scope of the town's largest festa. (Courtesy of the Our Lady of Mount Carmel Society.)

In 1950, members of the Our Lady of Mount Carmel Society pose with Fr. Mark Martorelli in front of the 1919 St. Joseph's Roman Catholic Church. The feast was celebrating its 75th anniversary. (Courtesy of the Our Lady of Mount Carmel Society.)

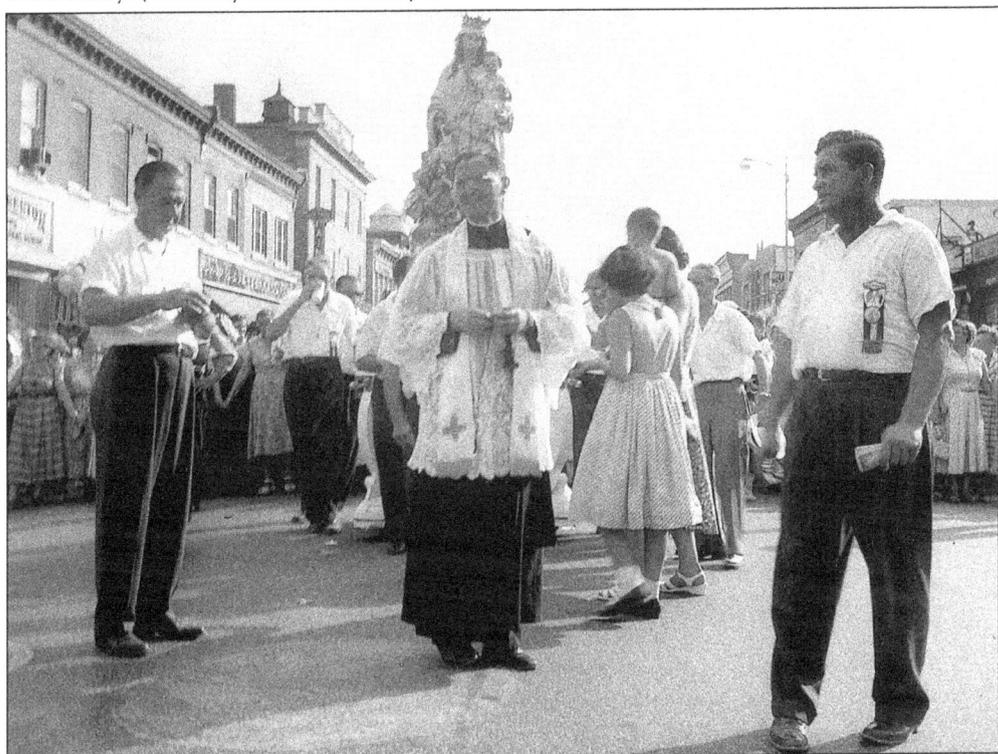

Fr. Nicholas Rinaldi walks before the statue of Our Lady of Mount Carmel as it passes through Bellevue Avenue in the 1950s. The badge worn by the society member shows an American flag and an Italian flag crossed together in the spirit of cooperation. (Courtesy of Dorrine Esposito.)

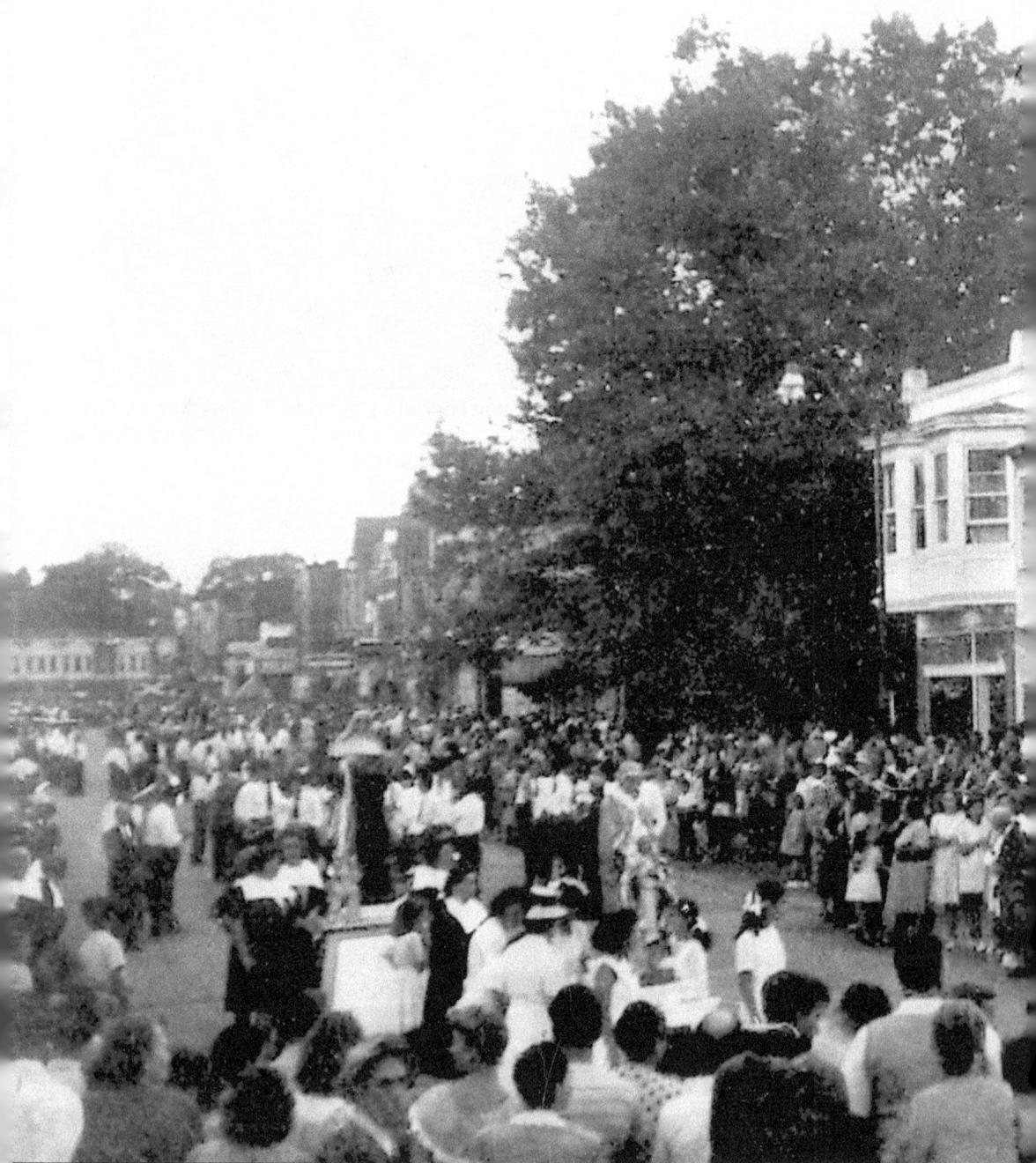

The Rivoli Theater, on the corner of Third Street and Bellevue Avenue, is the backdrop for this July 16 view. The streets along the procession's route (Third Street, Fairview Avenue, Egg

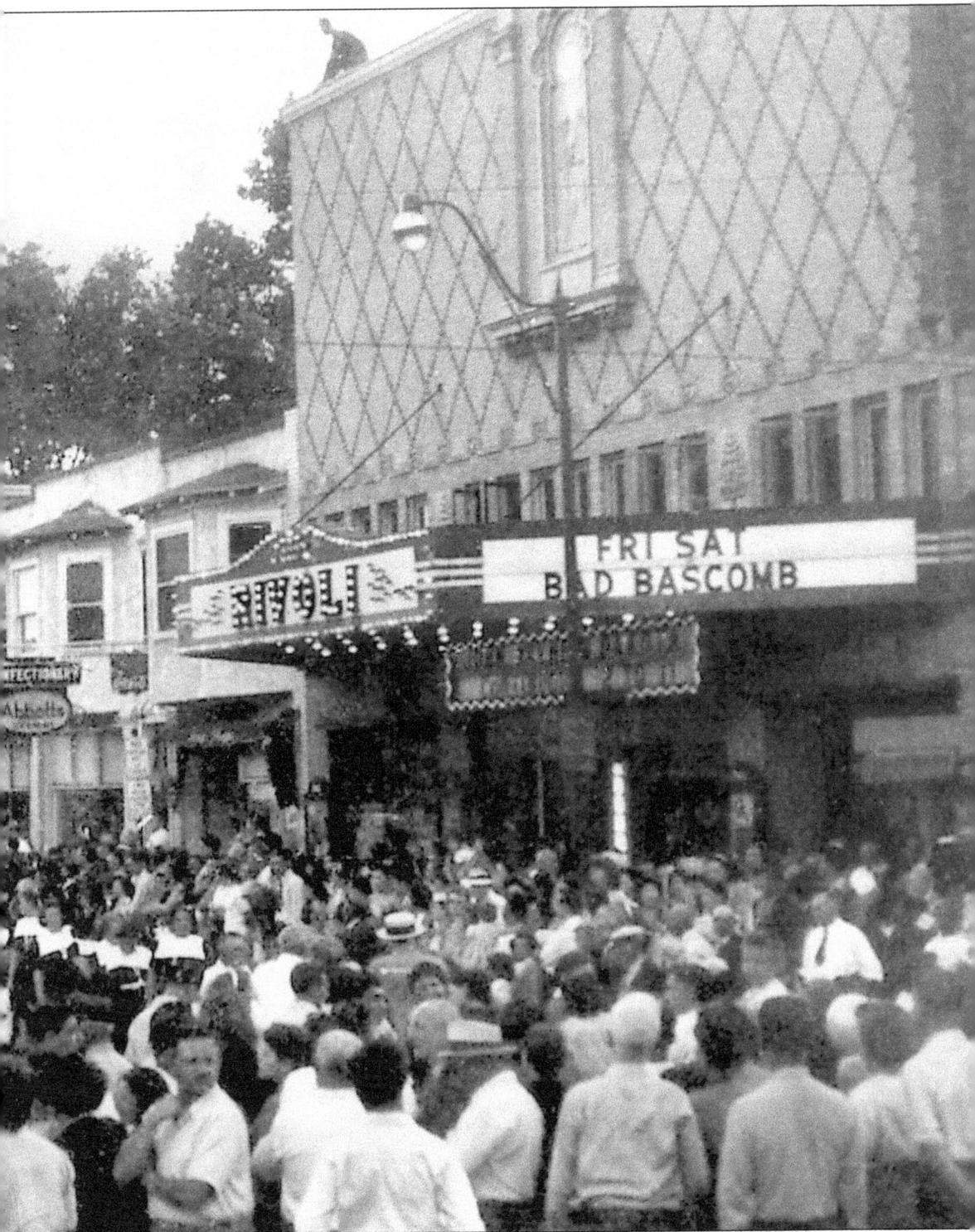

Harbor Road, and Bellevue Avenue) were lined with thousands of people. (Courtesy of the Our Lady of Mount Carmel Society.)

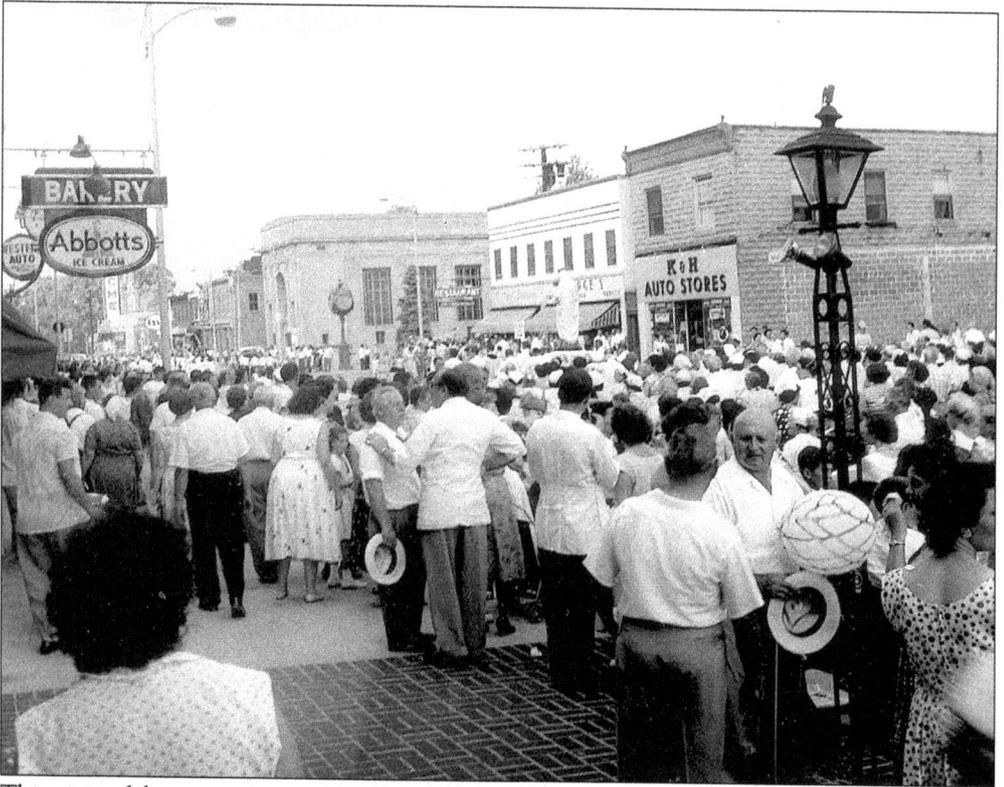

This view of the procession moving through the downtown area in the 1950s shows the crowds of people that used to come to Hammonton on the feast day, July 16. The numbers were strong regardless of what day of the week the feast day was. Many people took the day off work to attend. (Courtesy of Dorrine Esposito.)

In the 1950s, the Feast of Our Lady of Mount Carmel had become such an attraction that signs were posted on the Hammonton signs located on each roadway leading into town. (Courtesy of Josephine and Vincent Giannini.)

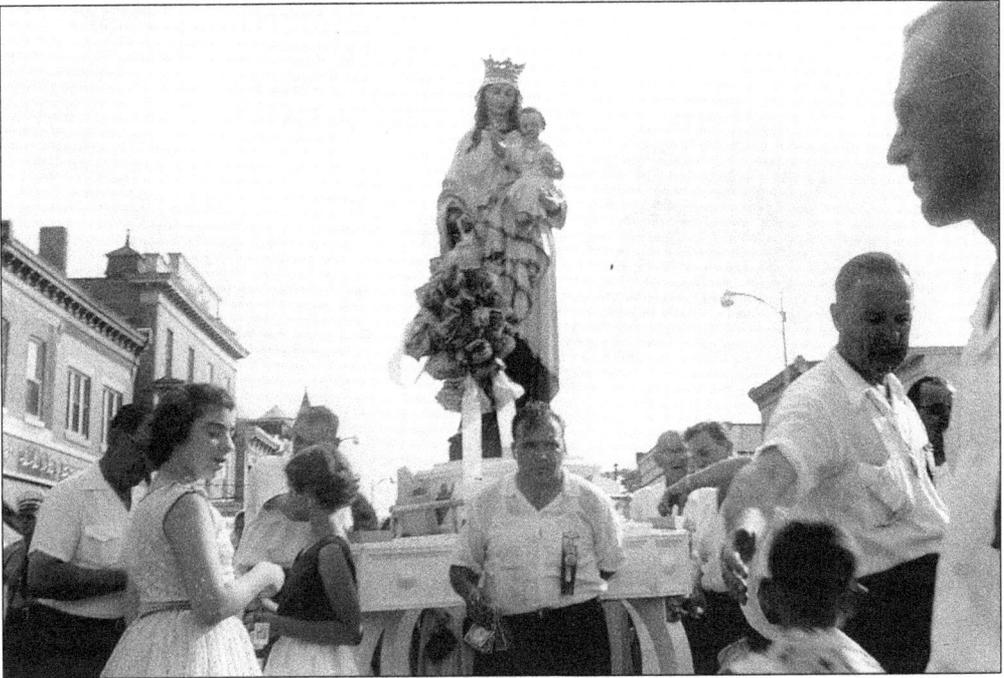

By the time the statue of Our Lady of Mount Carmel made its way down Bellevue Avenue, it was laden with the cash donations of the faithful, who received either a scapular or a card with a representation of one of the various saints in the procession. (Courtesy of Dorrine Esposito.)

It has been a local tradition for the faithful to follow behind the statue of Our Lady of Mount Carmel, praying the rosary. On occasion, women would walk on the baking summer streets of the town in bare feet, such as the woman holding the child in this 1950s view. (Courtesy of Dorrine Esposito.)

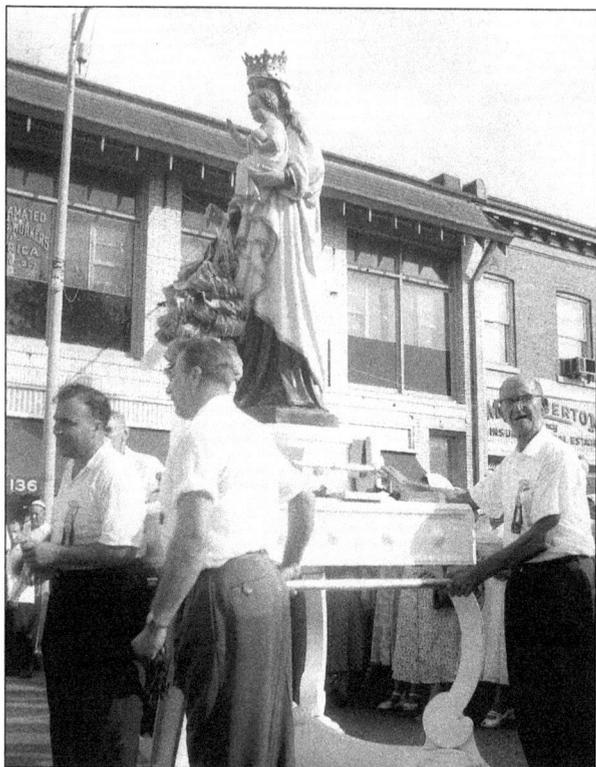

This 1950s photograph offers a side view of the statue of Our Lady of Mount Carmel. M.L. Ruberton Agency is in the background. A sign on a second-story window of the building behind the statue reads, "Amalgamated Clothing Workers of America," a clothing workers union of the era. (Courtesy of Dorrine Esposito.)

By the 1960s, the crowds for the procession had begun to dwindle, but that did not deter Lorenzo Silipino (left, with candle) and Anna Silipino (right, with candle) from making the trip through the downtown. They walked in the procession for 43 years. (Courtesy of Rita Geroni.)

www.ingramcontent.com/pod-product-compliance
Lightning Source LLC
Chambersburg PA
CBHW050653150426

42813CB00055B/1765